IT'S

ABSTRACTION,

CONCRETELY

John McGreal

Copyright © 2017 John McGreal

The moral right of the author has been asserted.

Apart from any fair dealing for the purposes of research or private study, or criticism or review, as permitted under the Copyright, Designs and Patents Act 1988, this publication may only be reproduced, stored or transmitted, in any form or by any means, with the prior permission in writing of the publishers, or in the case of reprographic reproduction in accordance with the terms of licences issued by the Copyright Licensing Agency. Enquiries concerning reproduction outside those terms should be sent to the publishers.

This is a work of fiction. Names, characters, businesses, places, events and incidents are either the products of the author's imagination or used in a fictitious manner. Any resemblance to actual persons, living or dead, or actual events is purely coincidental.

Matador
9 Priory Business Park,
Wistow Road, Kibworth Beauchamp,
Leicestershire. LE8 0RX
Tel: 0116 279 2299
Email: books@troubador.co.uk
Web: www.troubador.co.uk/matador
Twitter: @matadorbooks

ISBN 978 1788036 429

British Library Cataloguing in Publication Data.
A catalogue record for this book is available from the British Library.

Printed and bound in the UK by TJ International, Padstow, Cornwall

Matador is an imprint of Troubador Publishing Ltd

Also in this series:

The Book of It (2010)
In The Way of It (2013)
my it to you (2013)
The Poetry of It (2013)
The Point of It (2015)
In The Face of It (2015)
To Cap it All (2015)
It's Absence, Presently (2016)
It's Nothing, Seriously (2016)
It's Silence, Soundly (2016)
It's Figuration, Groundly (2017)
It's Representation, Really (2017)

Contents

Preface ... vii

The Bibliograph

Part 1: Conference Papers ... 3

Part 2: Books, Theses ... 37

Part 3: Articles ... 117

Preface

I am glad to publish *It's Abstraction, Concretely* conjointly with *It's Figuration, Groundly* & *It's Representation, Really*. Work on it began in September last year and has continued simultaneously with writing the other books. In order to underline the affinity of abstraction with figuration and representation, the Bibliograph in each book begins with the same reference to a paper by HENSEY Et al at the Neolithic Studies Group Seminar in Oxford, Visualising The Neolithic Abstraction - Figuration, Performance, Representation: *Assuming The Jigsaw Had Only One Piece: Abstraction, Figuration & The Interpretation Of Irish Passage Tomb Art. (*2012). In art historiography and writing on contemporary art the question of abstraction continues to be posed conceptually in relation to and figuration & representation.

It's Abstraction, Concretely thus begins Part 2 with the reference to Benjamin: *What Is Abstraction?* (1996). The concept has continued to be interrogated since the abstract art of the avant-gardes became a signifier of Modernity in the early 20th Century, whether based on optical & colour theory in science, religion, mysticism or music. The aesthetic pursuit of abstract ideal/ity and concrete real/ity (in the different forms of Painterly, Expressionist, Geometric or Conceptual Abstraction) has continued to take place in epistemological & ontological problematics all framed philosophically in terms of figuration and representation. An Exhibition of Hilma af Klimt, a Swedish pioneer of abstraction, was thus presented recently at The Serpentine Gallery (3rd March – 15th May).

With regard to abstraction and artist's books, Joanna Drucker for one has written on 'Artists' Books & The Early 20th Century Avant-Garde [*The Century of Artist' Books*, Granary 2004, pp45-67]. Combined with the poetic text of Blaise Cendrars, for example, she describes how the 'dynamic, colourful abstract painting of Sonia Delauney' played an important part in *La Prose du Transsibérien et de la petite Jehanne de France* in 1913 [Ibid, p50]. In 1923 El Lissitsky rendered Mayakovsky's *For The Voice* in book form, in which he used 'geometric devices to construct abstract images of highly formal arrangements printed in bright red and black ink' (Ibid, pp54-6].

Like the other new books, *It's Abstraction, Concretely* emerged out of my previous works on Nothingness, Absence and Silence. Part 3 thus begins with the reference to an article in Modern Painters by MELLERS, W. *The Silence of Nothingness & American Abstraction: On John Cage* (1998), 118. Other references to Nothing include (Ganguly: 2014) 58; (Varnedoe: 2006) 103; Absence (Toscano: 2014) 165, (Amada: 1995) 188; Hayes & Conway: 2000) 245; and Silence (Gamwell: 1991) 33; (Reniers: 2007) 140 & (Ledezma: 2005) 263.

In respect of silence, Poggioli for his part has suggested that the development of white abstract painting in the US in the 1960's was a silent reaction to the noise of capitalist expansion of American Consumerism. [See A.Moszynska, *Abstract Art*, Thames & Hudson, London 1990, p.182. See also my own, 'Commodity Fetishism & Aestheticisation Of The Commodity-Form' (March 1998), in *To Cap It All* (Matador, Leicester, 2015]

Emerging out of the initial works on the Bibliograph published last year, these new pieces on Abstraction, Figuration and Representation retain some of the same structural features, e.g. a similar double-page landscape format, an identical length of the whole text, the same tripartite structure, etc. The Bibliographs contain the same focus on repetition and variation in meaning of the dominant motifs; their chance placement interspersed with one another both displaying enhancing similarities and differences.

At the same time these works constitute a development in the aesthetic form of the Bibliograph. In response to the conceptual requirements of the earlier dominant motifs of Nothingness, Absence & Silence, it was just a question of finding & transferring given textual references to construct the Biographs containing them. In the recent works on Abstraction, Figuration & Representation, the concern rather has been with working on the line and shape of the references themselves in each Bibliograph, with *their* enhanced spacial form as well as that of the Bibliograph as a whole.

In this work on Abstraction, the curved line played a formative part in shaping the referential images. The curvature of space has been a feature of my abstract work since the initial adaption in the early 1990's of Hogarth's

Serpentine line in The To-r-i-ad (*The Poetry of It*, Matador, Leicester, 2013). Abstraction as such also featured in tentative early pieces like 'Abstract Poetry In Black & White (1992-95)' & 'Abstract Poetry in Red, Black & White (1995-95)' [*The Poetry of It*, Matador, Leicester 2014]. To play off the curvature of images against one another on the page the double column has been deployed throughout the text here as in *In The Way of It* (Matador, Leicester: 2013).

In shaping and spacing the referential images the place of words and letters became as important as their semantic & syntactical role. At first expansion and contraction of whole words was used to enhance this process. Under such detailed attention their breakdown into parts and single letters was a result. The recombination of elements produced new words & in a process of restrangement new sequences of letters with visual but no semantic value. The tmsesis of abstraction itself yielded ab/abstract/act/action/ion, etc.

This concern with the form of referential images does not preclude an equal commitment to their content. The references in the Bibliograph present varied aspects of an ongoing discourse today on Abstraction in all the arts, visual art, architecture, literature, poetry, music, cinema, theatre – in which readers are encouraged to think about use of the concept across their conventional boundaries; to consider the current use of abstraction in contemporary Philosophy and a range of sciences including Physics, Genetics, Linguistics, Logic and Mathematics. In this stage of the digital revolution they are asked to look at its technological application in Aeronautics, Artificial Intelligence, Computer Modelling and Robotics; its usage in fields varying surprisingly from data and rubbish collection, through landfill & transport planning to extraction in the water industry.

In conclusion, readers are asked to think about the important theoretical issue of levels of abstraction. At the psychical level, for example, the Bibliograph raises ongoing, relevant psychical questions of Emotional, Mental & Linguistic Abstraction in Psychoanalysis; at the social level of Political Economy, economic, political and ideological issues in the class struggle, including those of ethnicity, gender and religion in the current conjuncture.

J. McGreal
June 2016

x

IT'S

ABSTRACT(ION),

CONCRETELY

PART 1:

CONFERENCE PAPERS

HENSEY, R. Et al
Assuming The Jigsaw Had Only One Piece: Abstraction, Figuration & The Interpretation Of Irish Passage Tomb Art
Neolithic Studies Group Seminar Papers.Neolithic Visual Culture.Visualising The Neolithic: Abstraction, Figuration, Performance, Representation O, 161-178, November London, 2010
Oxbow Press
Oxford
2012

HEYMANN, M. Et al
On The Construction Of Human-Automation Interfaces By Formal Abstraction
JDS: Symposium On Abstraction, Re-Formation & Approximation O, 99-115, August Kananaskis,
Springer,
N.York
2002

HINTIKKA, J.
A Proof of Nominalism: An Exercise In Successful Reduction in Logic
Internat'l Wittgenstein Symposium: Reduction, Abstraction, Analysis O, 1-14, August, Wechsel
The Austrian LW Society
Ontos Verlag, Frankfurt 2009

HOLTE,
R. Et al
A Study Of Represent-Ation-Dependency Of Abstraction Techniques
Artificial Intelligence & Computer Science, Dublin O, 143-150, September 1994
Dublin University 1994

HUTCHES, D.J.
Raisins, Sultanas &
Currants : Lexical
Classification-
And Abstr-
Action
Via
Cont-
Ext Priming
31st Annual Meeting
Assn For Computational
Liguistics, O, 292--294
HORSTEN, L. & LEITGEB, H. Columbus OH, June
How Abstraction Works ACL Online 1993
International Wittgenstein
Symposium: Reduction, IYENGAR, S &
Abstraction, Analysis ARABNIA, H.
O, 217-26, August *A Theory On*
Wrechsel, 2008 *The Abstraction*
Ontos Verlag, *And Cognition Based*
Frankfurt *On Musical Note Patterns*
2009 International Conference
On Artificial Intelligence,
O, 342-50, Las Vegas
Nevada, June
CSREA Press,
Athens
2004

HUGHES, G. Et al JOHNSTON, A. Et al
Abstraction, *Gendering Abstr-*
Idealism, Euphemism *Actions:*
& Physicality in British & *The*
American Linguistic Cultures *Portr*
British & American Variation In *Ayal Of*
Language Theory & Methodology *Women In*
O, 7-26, Bologna, Italy Feb 1995 ***The Castle***
CLUEB Publishing Bologna 1998 ***Of Perseverance***
European Medieval Drama: O
123-134, July 2001 Groningen
Brepols, Turnhout Belgium 2002

JUNG, B. Et al
Narrative Abstraction Model For Story-Oriented Video
ACM Multimedia Conference 2004, O, 828-35, October New York City
ACM Press
N. York
2004

KHAN, J. & MIYAMOTO, I.
Formalism For Hierarch-Ical Organisation & Flexible Abstr-Acton Of Program Knowledge
SEKE - Conference Proceedings: Software Engineering & Knowledge Engineering, O, 301-303 San Francisco CA, June
EEKE Institute
Digital Archive
Online
1993

KAUSHAL, R. & GRATTAN-GUINNESS, I.
Abstraction & Structural Analogies In Mathematical Sciences
International Conference on The History of Mathematical Sciences O, 33-52, New Delhi, December 2001
Hindustan
Book Agency
N. Delhi,
2004

KIDRON, I. Et al
Abstraction In Context: Combining Cons-Tructions, Justif-Icat-Ion & En-Light-Enment
MERGA 31 Conf. Proceedings, O, 303-10, Brisbane, Aus. June
Mathematics Education Research Group of Australasia, Online 2008

KOCH, G. & JAAKKOLA, H.
*A Discussion
Of Semantic
Abstraction*
Information
Modelling &
Knowledge Bases
O, 350-56, Amsterdam
IOS Press, Amsterdam 1994

KUPFERSCHMID, S. Et al
*Fast Directed Model
Checking Via
Russian
Doll
Abs-
Traction*
JDS -14th
Internation-
Al Conference:
Tools & Algorithms
For The Construction
& Analysis of Systems/
Theory & Practice Of
Software, O, 203-17,
Budapest, March
Springer–Verlag
Berlin 2008

KORTH, H.F. Et al
*The Double Life Of The
Transaction Abstraction:
Fundamental
Principle &
Evolving
System
Concept*
Proceedings
Of The International
Conference On Very
Large Databases, O, 2-6
Zurich, September 1995
M. Kaufmann, Burlington
Massachusetts 1995

LANCASTER, L. Et al
*Mediating Modes: A
Child's Route to
Abstraction*
ORAGE
2001: O
Ralité Et
Gestualité:
Communication
O, 65-70, Aix-en-Provence, June
Harmattan Publisher, Paris 2001

LEHMAN, J. Et al
*Revising The Evolutionary
Computation Abstraction:
Minimal Criteria Novelty Search*
GECCO Conference: Genetic &
Evolutionary Computation
O, 103-110, July
Portland OR,
ACM Pubs
N.York
2010

LEVINSON, J.
& MAG UIDHIR, C.
*Indication, Abstraction
& Individuation*
American
Society
For Aesthetics;
Art & Abstract Objects
O, 49-61, Denver Col. 2009
Oxford University Press 2012

LI, Y.
*Mechanized Proofs For The
Parameter Abstraction & Guard
Strengthening Principle
In Paramaterized
Verification
Of Cache
Coher-
Ence
Protocols*
Symposium:
Applied Comp-
Uting, O,1534-35
Seoul, March
ACM Pubs
N. York
2007

LIERNUR, J.F. &
BRILLEMBOURG, C.
*Abstraction, Architecture
& The "Synthesis
Of The Arts"
Debates In
The Rio
De La
Plata
1936-
1956*
**Latin
American
Architecture:
Contemporary
Reflections 1929-60**
O, 74-99 Oct. 2002, New York,
Monacelli Press, New York 2004

LIGEZA, A. Et al
*Granular Sets
& Granular
Relations:
Towards
A Higher
Abstraction
Level In Know-
Ledge Representation*
Intelligent Information Systems,
O, 331-340, June Sopot, Poland
Physica-Verlag, New York 2002

LISKOV, B.
The Power Of Abs-Traction
JDS: Distributed Computing O, 3, September, Cam. Mass. Springer-Verlag, Berlin 2010

LOWE, E. & ROCKMORE, T.
Abstrac--Tion, Prop-Ert-Ie-S & Im-Ma-Nent Realism
Proceedings Of The World Congress Of Philosophy: Meta-Physics, O, 195-206, August 1998 Boston Massachussets, US
Philosophy Document Center Charlottesville, Vancouver 1999

LOVE, B.C.
Learning At Different Levels Of A-Bs-Tra Action-
Proceedings Of The Annual Conference Of The Cognitive Science Society O, 800-05, Aug. Philadelphia Erlbaum, Mahwah, NJ 2000

LUHN, G. Et al
Abstraction & Experience: Engineering Design In New Contexts Of Cognitive & Philoso-Phical Scie-Nce
WDK Works-Hop De-Sign Konstrukion Internationalen Conference On Engineering Design, O, 947-958, August Munich Technische Universitat 1999

MAK, T.W. & SHU, L.H.
DnO2-Abstraction Of Biological Analogies For Design
CIRP Annals International Institution For Production Engineering Research Manufacturing Technology, O,117-20, August Krakow, Technische Rundschau Wabern Pubns, Switzerland 2004

MAYER, H. & STEGER, C.
A New Approach For Line Extraction & Its Integration In A Multi-Scale, Multi-Abstraction-Level Road Extraction Scheme
Schriftenreihe-Osterreichischen Computer Gesellschaft: Remote Sensing & Mapping: Mapping Buildings, Roads & Other Man-Made Structures From Images O, 331-48, Sept. 1996 Graz OCG OnLine Publishing 1997

MAYER, H. Et al
Abstraction & Scale-Space Events In Image Under Standing
International Archives Of Photogrammetry & Remote Sensing O, 523-528, July Vienna, Austria The Congress Committee 1996

MEURERS, D. Et al
On The Automatic Analysis Of Learner Corpora. Native Language Identification As Experimental Testbed of Language Modelling Between Surface Features & Linguistic Abstraction
Linguistic Insights: Diachrony & Synchrony In English Corpus Linguistics O, 285-314, Jaen, March 2014 Peter Lang Publishers, Bern 2014

MISHRA, P. Et al
Functional Abstraction Driven Space Exploration of Heterogeneous Programmable Architectures
International Symposium on System Synthesis, O, 256-61, Sept. Montreal, ACM Publishing, New York 2001

MISTREE, F. & ALLEN, J.K.
Design
At
The
Fun-
Ction-
Al Level
Of Abstraction
Proceedings Of The NSF Design & Manufacturing Grantees Conference O, 71-72, Jan. Cam. Mass. Society of Manufacturing Engineers Dearborn 1994

MITCHELMORE, M. & BELL. G.
Abstraction As The Recognition Of Deep Similarities: The Case Of The Angle Concept
Proceedings of Annual Conference Of The Mathematical Education Research Group Of Australia: Challenges In Mathematical Education Constraints on Construction, O, 429-436, Lismore, July 1994
MERGA/Emerald, Bradford 2006

MURRAY, J.H. Et al
Narrative Abstraction For Organizational Simulations
Organizational Simulation, O, 299-322, Hoboken NJ, Dec. 2003
J. Wiley & Sons Publishing 2005

NETZER, Y. & ELHADAD, M.
Bilingual Hebrew-English Generation of Possessives & Partitives: Raising The Input Abstraction Level
Proceedings Of The 37th Annual Meeting Of The Assn For Computational Lingusitics, O, 144-151, Stroudburg, PA
ACL On-Line Publishing 1999

NEUMAYR, B. Et al
*Modelling
Techniques For
Multi-Level Abstraction*
JDS/The Evolution of Conceptual
Modelling, Dagstuhl Seminar,
O, 68-92, April 2008, 2011
Springer-Verlag, Berlin 2011

NOURBAKHSH, I.R.
*Using Abstraction
To Interleave
Planning & Execution*
Technical Report of The
AAIWS: On-Line
Research
O, 666-72
Providence, RI, July
AAAI Press, Palo Alto CA 1997

ORBAY, G. Et al
*Shape Spirit: Deciphering
Form Characteristics
& Emotional
Associations
Through
Geometric
Abstraction*
Proceedings
ASME 20th
International
Technical Conference
On Design Engineering: Design
Theory & Methodology,
August 2013
Portland,
ASME,
N.York
2014

PASCHOS, T. & FARMAKI, V.
*The Reflective Abstraction
In The Construction of
The Concept Of
The Definite
Integral:
A Case Study*
Proceedings of
The International
Group For The Psychology
Of Mathematical Education
O, 337-44, Prague, July 2006
Charles University, Prague 2006

PASZTORY, E. & BERLO, J.
*Abstraction & The Rise
Of A Utopian State
At Teotihuanan*
Art, Polity &
The City Of
Teotihuanan,
O, 281-320
October 1988
Washington DC,
Dunbarton Oaks
Research Library &
Collection, Washington, 1992

PELAEZ, V. Et al
*Multilevel Hybrid
Architecture For
Device Abstra-
Ction & Con-
text Informa-
Tion Mana-
Gement I-
N Smart
Home Environments*
JDS: Ambient Intelligence
O, 207-216, November Malaga
Springer-Verlag, Berlin 2010

PEPLINSKI,
 J. Et al
*Design
For
Ma-
Nu-
Fac-
Ture
At The
Function
Level Of
Abstraction*
Conference On
Flexible Automaton &
Intelligent Manufacturing,
O, 488-98, May Atlanta GA,
Begell House
Danbury,
Conn.
1996

PERINI, G. Et al
*Hogarth's Visual
Mnemotechnics:
Notes On Abs-
Traction As
Aide-Me-
Moire F-
Or Fig-
Urat-
Ive
P-
Ain
-Ters*
Inter-
National
Congress of
The History of
Art: Memory And
Oblivion, O, 837-846
September 1996 Amsterdam,
Kluwer Academic, Boston 1999

PICKETT, M.
*Using Analogy
Discovery To
Create
Abstr
-Acti
Ons*
JD
S
:A
-B
-St
-Rac
Tion,
Refor-
Mulation,
Approximation
O, 405-06, July Whistler,
Springer-Verlag, Berlin 2007

PINDER, K.N.
Deep Waters: Rebirth,
Transcendence
& Abst-
Act-
Io-
N
In
Ro-
Mare
Bearden's,
Passion of Christ
Studies In The History of Art,
Symposium: Roamare Beardon,
American Modernist, O, 143-66
Washington DC, October 2003
Yale UP New Haven Conn 2011

PORTO, A. Et al
Structural Abs-
Traction
& Application in
Logic Programming
JDS: Functional Logic
Programming, O, 275-289
Aizu, Japan September 2002
Springer-Verlag, Berlin 2002

PIPE, A.G. Et al
An Experience in Knowledge
Abstraction From
Cognitive
Maps
To
Beha-
Viours
Adaptive
Computing
In Engineering
Design & Control,
O, 65-70, March Plymouth
University of Plymouth 1996

POULIN, J.S.
Software Architecture - Product
Lines & DSSA's: Choosing
The Appropriate Level
Of Abstraction
Annual Workshop
On Software Reuse, O, 46
Columbus OH, March 1997
Ohio State University Press 1997

PULKKINEN, M. &
SPRAGUE, R.H.
Systematic Man-
Agement Of
Achitect-
Ural
De-
Cis-
Ions
In En-
Terprise
Architecture
Planning: Four
Dimensions And
Three Abstraction Levels
Hawaii International Conference
On System Sciences (HICSS 39),
O, 179, Kauai HA, January 2006
IEEE-J. Wiley Publications 2006

QUANT, M.V. Et al
Quantum Information
Theory For Mod-
El Abstraction
Techniques
(4367-05)
Proce
-Edi
-Ng
-S
Of
The
Inter
National
Society For
Optical Engineering,
Enabling Technology
For Simulation Science
O, 52-61, Orlando, April 2001
SPIE, Bellingham, WA 2001

PRAGUE, R.H.
Systematic Management Of
Architectural Decisions
In Enterprise Ar-
Chitecture
Plann-
Ing:
Four
Dimens-
Ions & Three
Abstraction Levels
Hawaii International Conference
On System Sciences (HICSS 39)
O, 179, Kauai, January 2006
IEEE J.Wiley Hoboken NJ 2006

RADFORD, A. Et al
Issues of Abstraction,
Accuracy & Realism
In Large-Scale
Computer
Urban
Mod-
Els
C-
Aad
Futur-
Es: Com-
Puter-Aided
Architectural Design
Futures, O, 679-690
Munich, Germany August
Kluwer Publishing, London 1997

RASKIN, J-F. Et al
Real-Time Logics:
Ficticious Clock
As An Abstr-
Action of
Dense
Time
JDS: 14th International Confer-
Ence: Tools & Algorithms For
The Construction & Analsis Of
Systems/ Theory & Practice Of
Software, O, 165-82 Enschede,
April 1997 Springer Berlin1997

RIBES-INESTA, E.
Behaviour Is Abstraction, Not
Ostension: Conceptual &
Historical Remarks
On The Nature
Of Psychology
Behaviour &Philosophy: Beh-
Aviour As The Subject Matter
Of Psychology – Philosophical
& Theoretical Issues, O, 55-68
Guadalajara 2000, Feb. 2004 Beh-
Avioural Studies Cmbrdge 2004

#
ROGERS, D.F. &
EARNSHAW, R.A.
Abstraction,
Context &
Constraint
State of The Art In Computer
Graphics: Aspects Of Visual-
ization, O, 89-102, July 1992
Reading, Springer Berlin 1994

ROWLANDS, S. Et al
Proof, Reason,
Abstraction
& Leaps: A
Cultural-
Historical
Approach To
Teaching Geometry
Proceedings Of The Day
Conference, O, 71-76
Coventry February 2006
BSRLM Publication 2006

SALVIANO, C.F. Et al
A Simple Approach
To Improve The
Abstraction
Level of
Object
Repr
-Ese
-Nta
Tion
JDS:
Comp
UterAid
-Ed Systems
Theory, O, 349-
62 Ottawa, May 1994
Springer-Verlag, Berlin 1996

SANATI, F. Et al
Multilevel Life-Event
Abstraction
Frame-
Work
For
E-G
Over-
Nment
Service
Integration
European Conference
On E-Government, O,
550-8, June 2009 London
Academic Jrnls, Reading 2009

SCHLEICHER, S. Et al
Abstraction of Bio-Inspired
Curved-Line Folding Patterns
For Elastic Foils &
Membranes
In Archi-
Tect
Ure
WIT
Trans
-Actions
On Ecology
& The Environ-
Ment International
Conference On Design
& Nature: Comparing Design
 In Nature With Science &
Engineering, O, 479-90,
Pisa, Italy 2010
The WIT Press,
Ashurst Ldge
New Forest
2010

SCHLEPPEGRELL, M.J.
& BANG, J.C.
Abstraction
& Agency
In Middle School
Environmental Education
AILA Proceedings/ Language
& Ecology – Eco-Linguistics
O, 27-42, Jyvaskyla, August1996
Odense University Denmark 1996

SCHULZ, A. Et al
A High-Level Constraint
Coefficient Multiplier
Power Model For
Power Estimat-
Ion On High
Levels Of
Abstrac-
Tion
JDS:
Power
& Timing
Modelling,
Optimization &
Simulation: Integrated
Circuit & System Design
O, 146-155 September 2005
Leuven, Belgium
Springer
Berlin
2005

SEWELL, P.
Memory,
An Elusive
Abstraction
ACM Sigplan Notices:
Memory Management,
O, 51-2, Toronto,
June 2010
ACM
2010

SHAHRI, S.H. Et al
A Bayesian Approach
To Attention Control &
Concept Abstraction
JDS: International
Workshop On
Attention In
Cognitive Systems/
Theories & Systems From
An Interdisciplinary
Viewpoint, O, 155
-70, Hyderabad,
January 2007
Springer,
Berlin
2007

SHARPANSKYKH, A. Et al
Group Abstraction For
Large-Scale Agent-
Based Social
 Diffusion
Models
With
Un-

SHAHAR, Y. & CHITTARO, L.
Dynamic Temporal Inter
Pretation Contexts
For Temporal
Abstr-
Act-
Io-
N
In
tern
ational
Workshop
On Temporal
Representation &
Reasoning, O, 64-71Key
West FL, May 1996 IEEE 1996

A
F-
Fe-
Cted
Agents
JDS:Agents
In Principle,
Agents In Practice
O, 129-142, Nov 2011
Wollongong, Australia
Springer Pubns, Berlin 2011

SHEARD, T. & NIVAK, M.
*Increasing The Level Of
Abstraction In Tradi-
Tional Functional
Languages By
Using Co-
Mpile-
Time
Ref-
Lection
Algebraic
Methodology &*
Software Technology,
O, 145-52 Enschede, June
Springer-Verlag, London 1993

SMULDERS, F.E. Et al
*Interactions Between
Product Devel-
Opment &
Product
Ion II
Clashes In
Cross-Cultural
Abstraction Levels*
European Conference On Creat-
ivity & Innovation: Cross-Cult-
Ural Innovation. New Thoughts,
Empirical Research, Practical
Reports, O, 131-48, Sept. 2003
Mainz,Oldenbourg Munich 2007

SMAILL, A. &
ANAGNO-
STOPO
ULO-
U, C.
*Abst-
Rac
Tion
& Music
Representation*
ICMPC – Proceedings
Music Perception & Cognition
O,187-88, Aug, Evanston Illinois
Causal Productions, Sydney 2004

SNYDER, R.M.
*Using Childr
-En's So
-Ngs
To
T-
Ea
-Ch
Abst
-Racti
-On Tec
-Hniques In
An Introductory
Programming Course*
Journal Of Computing In Small
Colleges - Consortium, O, 92-100
Jefferson City Mis. Nov1998 1999
CCSC Pn, Evansville Indiana 1999

SOLDANO, H.
Closed Patterns &
Abstraction
Beyond
Lattices
JDS: Formal
Conceptual Analysis,
O, 203-18, June Cluij-Napoca
Springer-Verlag, Berlin 2014

STEINKE, W.R. Et al
Dissociation of Music
& Cognition Abstr-
Action Abilities
In Normal &
Neurolog-
Ically
Imp-
Ai -
R-
Ed
Sub-
Jects
ICMPC-
Proceedings:
Music Perception &
Cognition O, 425-426
Liège Belgium July 1994
ESCOM Publishing 1994

STJERNFELT, F. Et al
Schemata, Abstraction
& Biology Man As
The Abstract
Animal
Rather
Than
The
Sym
-Bolic
Species?
International
Wittgenstein Symposium:
Rationality & Irrationality
Kirchberg am Wechsel
August 2000/2001
Hölder-Pichler
-Tempsky,
Vienna,
Austria
2001

STEIN, A.R. Et al
Knowledge
Acqui-
Sit-
Io-
N
For
Temp-
Oral Abstraction
AMIA Annual Symposium:
Beyond The Superhighway;
Exploiting The Internet With
Medical Informatics O,204-208
Washington DC. October 1996
Hanley & Belfus, Philadelphia 1996

SUDOL-DELYSER, L.A.
Encouraging Students To Think Of Code As An Algorithmic Symph-Ony: The Effect Of Feedback Regarding Algorithmic Abstraction During Code Production
International Computing Education Research: ICER 11, O, 147; Providence, Rhode I. Aug.
ACM Journals, New York 2011

TEACHOUT, Z.
Facts in Exile: Corruption & Abstraction In Citizens v Federal Election Commission
Loyola Univ-Ers-Ity Law Journal Conference On The Scandal of Political Corruption & The Law's Response O, 295-326, April 2010
Chicago School Of Law 2010

SWANN, J. Et al
The Abstraction of Language: Jayanta Mahapatra & A.K, Mehrotra As Indian "Post-Modernists"
Cross/
Rea-
Di-
N-
G-
S
In
The
Post/
Coloni-
Al Literatur-
Es In English:
Fusion of Cultures? O, 49-60, Munich September 1993
Rodopi Journals, Amsterdam 1996

TOMASSEN, S.L. Et al
Query Terms Abstract Ion Layers
JDS Confere-Nce: On The Mo-Ve To Meaningful Internet Systems, O, 1786 - 1795
October 2006
Montpellier
Springer
2006

VARZI, A.
Do We Need Functional Abstraction?
15th International Wittgenstein Symposium, O, 407-416, Kirchberg am Wechel, August 1993
Holder-Pichler-Tempsky
Vienna
1993

VON GLASERSFELD, E. Et al
Sensory Experience, Abstraction & Teaching
Constructivism In Education, O 369-84, Athens, February 1992
Erlbaum, Mahwah N.York 1995

WANG, Y.C. & ZHOU, G.D.
Automatic segmentation Of Chinese Words & Automatic Abstraction & Classification Of Chinese Scientific Documents
Conference of The International Federation For Information & Documentation: Finding Values & Uses Of Information A71-01 05 Omiya, Japan, October
FID, Brussels, Belgium 1994

WARBURTON, D.A.
Time/Space in Ancient Egypt: The Importance Of The Creation Of Abstraction - Beginning In Ancient Egypt: Thoughts On Agency, Materiality & Cognition, 0, 83-95, Copenhagen Sept 1995
Archaeopress, Oxford 2009

WARWICK, S. & KIZZA, J.M.
Abstraction, Ethics & Software:
Why Don't The Rules Work?
Ethics In The Computer Age,
O, 10-15, Nov,1994 Gatlinburg
ACM Journals, New York 1994

WOZNIEWSKI, M. Et al
SPATOSC – Provid-
Ing Abstraction
For The Auth
-Oring Of I
-Nteract
-Ive Sp
-Atial
Stu
-D
Io
-Ex
Peri
Ences
Proceed
-Ings of The
International
Computer Music
Conference, O, 512-517,
September 2012 Ljubljana
ICMA Pubn, San Francisco 2012

WOLZ, U.
Abstraction To Implementation:
A Two-Stage Introduction
To Computer Science
Proceedings Of
The National
Educational
Computing
Conference,
O, 208-212
Boston June
ISTE Journals
Wiley & Sons, Hoboken NJ 1994

ZELLER, A.
When Abstr-
Action
Fails
JDS
14th
Intern
-Ational
Conference
Theory & Practice
of Software, O, 1-9, April
2005 Edinburgh, Springer, 2005

ZIMMERMAN, T. Et al
Information Model For The Mechatronic Product Focusi-Ng The Functional Abstraction
Proceedings - The International Design Conference, O, 571-84, May, 2004 Dubrovnik
Faculty of Mechanical Engineering & Naval Architecture,
Zagreb
2004

AKIYAMA, S. Et al
An Abstraction of Functional Boundary Lines Through Space-Time Pattern Of Neural Activities
Neural Information Processing & Intelligent Information Systems: Progress In Connectionist-Based Infrmtn Systems, O, 22-5
September 1997
Dunedin, NZ
Springer
1998

AJROUD, H. & JAOUA, A.
*Abstraction
Of Obj-
Ects
By
Con-
Ceptual
Clustering*
Joint Conference of Information Sciences, O, 446, Research Tri-Angle Park NC, March 1997
Intelligent Machinery Assn 1997

ALVES, L.B. Et al
*The Circle, The
Cross & The
Limits of
Abstr-
Act
Ion
& Fig-
Uration In
North-Western
Iberian Rock Art*
Neolithic Studies Group Seminar Papers. Neolithic Visual Culture.Visualising The Neolithic:Abstraction, Figuration, Performance Representation
O, 198-214, Nov. London
Oxbow Pubrs
Oxford
2012

ANON
Abstraction
& Artifacts In
Cyberspace:
Getting
Real
Inter-
National
Conference
On Cyberspace
O, 118, Santa Cruz CA
GSVS Publishing 1991

BELL, S.
Et al
Data
Abstraction
Architecture For
Spacecraft Autonomy
Aerospace Conference: Unman
Ned... Unlimited, O, 2170-81,
Seattle, April 2009
American Institute
Of Aeronautics
& Astronautics
Reston VA
2009

APRAHAMIAN, M.W.
The Effect of Abstract
Ion On
Fish &
Fisheries
Annual Study
Course, Institute
Of Fisheries Management
O, 205-219 ,Cardiff, September
IFM Hull United Kingdom1993

BELLINZONI, G. Et al
Digital Dynamic
Cavernography
With Abstr-
Action
Ori
-M
-A
-Ge
Diag
-Nosing
Impotence,
O, 191-2, Rome,
June, Masson, Milan 1989

BERLIN, K. E al
*The Methodology
Of Socratic Di-
Alogue: Reg-
Ressive A-
Bstractio -
How To Ask
For & Find Phil
Osophical Knowledge*
International Conference -
Socratic Dialogue & Ethics,
O, 88-111, Loccum July 2000/5,
Lit-Verlag, Munster 2000 & 2005

BILLS, C.
*Indicators
Of Abstraction
In Young Child-
Ren's Descripti-
Ons Of Mental
Calculations*
Conference
Proceedings/B
-Ritish Society For
Research Into Learning
Mathematics: Mathematics
Education, O, 75-85
Keele July 2001
BSRLM UK
2001

BIGAND,
E., CROSS, I.
& DELIEGE, I.
*The Influence Of Implicit
Harmony, Rhythm
& Music-
Al Tr-
Ain-
In -
G
On
The
Abs -
Traction
Of "Tension-
Relaxation Schemas"
In Tonal Musical Phrases*
Contemporary Musical Review;
Music & The Cognitive Sciences
O, 123-138, Cambridge 1990,1993
Hardwood, Charlotte NC 1993

BRAUN, G. Et al
*Processor/Memory
Co-Exploration
On Multiple
Abstract-
Ion L-
Evels*
DATE
Proceedings
Design, Automation
& Test in Europe, O, 966-73
Munich, March 2003
IEEE Computer Soc.
Wiley & Sons,
Hoboken
N. York
2003

BUI, H. Et al
*Probabilistic Querying
At Multiple Levels
Of Abstract-
Ion In
Large
Spatial
Dimensions*
DICTA – Conference:
Digital Image Computing
Techniques & Applications
O, 285-290, December
Curtin University Of
Technology
Perth
1999

BULITKO, V.
*State Abstr-
Action In Real-
Time Heuristic Search*
JDS: Abstraction, Reformulation
& Approximation, O, 1, July,
Whistler, Springer, Berlin 2007

CHRISTIE, F. Et al
*The Development
Of Abstraction
In Adolescence
In Subject English*
Advanced Literacy In First &
Second Languages, Meaning
With Power. O, 45-66, February
Irvine, California, Lawrence
Erlbaum, Wahah NewYork 2000

27

CHU, W.W. &
CHIANG, K.
*Abstraction
Of High
Level
Concepts
From Numerical
Values In Databases*
Technical Report – American
Assn For Artificial Intelligence:
Knowledge, Discovery In
Databases, O, 133-144,
Seattle WA, August
The AAAI Press
MIT Press,
Camb.
Mass.
1994

CORTOIS, P.
*Paradigm &
Thematization
In Jean Cavani's
Analysis Of
Mathematical
Abstraction*
15th International
Wittgenstein Symposium,
O, 343-50, Kirchberg
Am Wechel, August
Holder-Pichler
-Tempsky
Vienna
1993

COPELAND, R.
*Abstraction &
Hysteria
: The
Place
Of The
Body In
American
Non-Literary Theatre*
Border Tensions Dance & Disc-
Ourse, O,77-86, April,Guildford
Dept of Dance, Surrey Un. 1995

COWAN, E. Et al
*Mistress & Mother
As Political Abstraction:
The Apostrophic Poetry Of
James Graham, Marquis Of
Montrose & William Lithgow*
Medieval & Scottish Language
& Literature: The European Sun
O, 534-35, August 1993 Glasgow
Tuckwell, E. Linton Scotland 2001

CRAMPES, M.
Adaptive
Narra-
Tive
Ab
-Str
Action
Hypertext &
Hypermedia, O, 97-105
Pittsburgh PA, June 1988
ACM Press, New York City 1998

DAMOUTH, D. Et al
The Search For Co-
Ordination: K-
Nowledge-
Guided
Abstr-
Act-
Ion
& Re-
Search
In a hier-
Archical be
Haviour Space
Journal on Data
Semantics, Artificial
Intelligence Systems, O, 187-206,
San Martino al Cimino,
Italy, July 1992
Springer-
Verlag
Berlin
1994

DEAK, G.
Abstraction of Function: The
Experiential & Conc
-Eptual Foundati
-Ons Of Tool
-Use In
Hum
-An
Ch
-Il
-D
Ren
Inter
National
Conference
On Development
& Learning, O, 28
Bloomington IN, May 2006
Dept Of Psychological & Brain
Sciences, Indiana University 2006

D'HAENENS, A.
L'Abstraction Concrete:
Son Essor En L'Europe
Du Nord Au XII Siècle
Miscellanea
-Centro
Di Studi Medioveli
L'Europe Dei Secoli XI e XII
Fra Novita Di Una Cultura,
O, 123-134, Mendola,
August 1986,
Vitae Pensiero,
Milan
1989

DELIEGE, I. Et al
*Cue Abstraction
In The
Repres-
Entation Of
Musical Form*
Music Perception &
Cognition, O, 387-412,
Liège July 1994
The Psychology
Press, Hove
1997

ECKER, W. Et al
*Impact of Description
Language, Abstraction
Layer& Value Representation
On Simulation Performance*
DATE Proceedings,
Design, Auto-
Mation
& Test
In Europe
O, 767-772
Nice, Fr. Apr 2007
ACM, New York City 2007

DE PAOLI, F. & TISATO, F.
*Architectural Abstractions
& Time Modelling In
HyperReal*
Euromicro
Workshop On Real
Time Systems, O, 222-
28, Odense, June
IEEE Pubns.
On-Line
1995

EIJSBOUTS, T.
*The Politics of
Abstraction:
Multilingualism, An
Asset of Legal Evolution*
The European Legacy, Towards
New Paradigms. Graz, 1994
International Society For The
Study of European Ideas
Taylor & Francis Ltd, UK 1997

ESCH,
J. Et al
*Contexts
& Concepts:
Abstraction Duals*
JDS/Conceptual Structures: Current Practices, O, 175-84, College Prk Md, Aug Springer1994

FERNANDEZ, M.
& GABBAY, M.J.
*Nominal Re-
Writing
With Name
Generation:
Abstraction
Versus Locality*
Proceedings Of The International ACM Sigplan Conference On Principles & Practice Of Declarative Programming O, 47-58, Lisbon, July
ACM Publications
New York 2005

ESPINEL, C.H. Et al
*The Autonoetic Hypothesis
On Creativity: Memory
& Cognition In
Pollock's
Abstract Art*
The Annual Conference of The Cognitive Science Society O, 1002, Fairfax, August 2002
Linden Lea Publications UK 2002

FOLTZ, C.
Et al
*Analysing
Chemical
Process Design
Using An Abstraction-
Decomposition Space*
Computer-Aided Chemical Engineering/ Process Systems Engineering, O, 457-62, Kunming,
Elsevier Publns
Amsterdam
2003

FOWLER, J. Et al
Experience With The Virtual Notebook System: Abstraction In Hypertext
C S C W Conference: Computer Supported Cooperative Work O, 133-144 Chapell Hill NC, October 1994
ACM Pubs
N. York
1994

FRANTZ, F. K.
A Taxonomy Of Model Abstraction Techniques
Proceedings of The Winter Simulation Conference, O, 1413-20 Arlington VA. Dec IEEE 1995

FRANKE, H-J.
Hierarchy of Figurative Presentations With Different Levels of Abstraction To Support The Creative Mental Process In Engineering Design
WDK Workshop Design Konstruktion O, 181-186, Tampere, August
TUT
Fin
1997

GAMWELL, L. Et al
A Century of Silence:
Abstraction &
Withdrawal
In Modern Art
Psychoanalyis & Culture
At The Millenium, 0, 219-238
January 1991, Stanford CA
Yale UP, New Haven,
London 1991

GNAEDIG, I. & KIRCHNER, H.
Narrowing, Abstraction &
Constraint For Proving
Properties of
Reduction
Relations
Journal
On Data
Semantics,
Rewriting,
Computation & Proof,
O, 44-67, June Cachan, France
Springer-Verlag, Berlin 2007

GARBE, J.
Valuing
The Effects
Of Freshwater
Over-Abstraction
On Fish Species
Proceedings of The International
Assocn For Hydro-Environment
Engineering & Research O, 127
Sept. Chengdu IAHER Pub 2013

GREENE, R. Et al
Abstraction/
Translation
/Materiality: The
Cultural Dilemmas Of
Deliberative Democracy
Conference on Argumentation
O, 97-103, Alta l UT Aug. 2001
NCA, Washington DC 2002

GUILBAUT, S. Et al
*A Plea For
Parisian
Abstr-
Action*
Artistic
Exchange, O, 259-268
Berlin July 1992
Akademie
Verlag,
Berlin
1993

HALE,
B.
*The
Meta-O
Ntology Of
Abstraction,*
New Essays on
The Foundation
Of Ontology-Sydney
0, 178-212, June 2005
Clarendon Press,
Oxford 2009

HALEY, D.C.
*Rule-Based
Reasoning
Via Abstr
-Action*
Journal
On Data
Semantics
Abstraction,
Reformulatio-
N, Approxima-
Tion , O, 399,
July., Whistler
Canada, Spr-
Inger Berl-
In 2007

GURFINKEL, A.
& CHECHIK, M.
*Why Waste A
Perfectly
Good A-
Bstrac-
Tion?*
Journal
On Data
Semantics:
International
Conference:
Tools & A-
lgorithms
For The
Consttruction & Analysis Of Sy-
Systems/Theory & Practice Of
Soft-Ware, O, 212-226, Vienna,
March, Springer, Berlin 2006

34

HARDY,
S. Et al
*Painted
Petri
Net
&
Fun-
Ctional
Abstract-
Ion To Visualize
Dynamic Modelling*
Conference on Dynamic
Modelling & European
Simulation O, 340-344
Toulouse, October 2006
Eurosis-Eti, Ghent 2006

HAYS, K.M.
& SOMOL, R.
*Abstraction's
Appearance
(Seagram
Building)*
Autonomy
& Ideology:
Positioning
An Achitectural
Avant-garde in America,
1923-1949, O, 271-291
New York Feb 1996
Monaccelli Press,
NY 1997

HEFFERNAN, J.A.W. Et al
*Speaking For
Pictures:
Langu-
Age
&
A
-B
-Str
-Act Art*
Writing &
Seeing: Essays
On Word & Image,
O, 25-46, October 2003
Rodopi Pubns Amsterdam 2006

PART 2:

BOOKS, THESES.

Benjamin, A.
What
Is
A-
Bs
Tra-
Ction?
Acade-
My Editions,
London 1996

 Binard, F.
 Abstract-
 Ion-
 Based
 Genetic
 Programming
 VDM Verlag,
 Saarbrucken 2009

Benton, C. Black, J.& Ayres, S.
Figuration/ *Abstraction &*
Abstraction: *Reality*
Strategies For *:The*
Public Sculpture *Sculpture Of*
In Europe 1945-1968 *Ivor Roberts-Jones*
Ashgate, Aldershot 2004 Philip Wilson, London 2013

Blacklock, G.
*Colour &
Abstraction*
The Crowood Press,
Ramsbury, Wiltshire 2015

Blazwick, I.
Et al (Eds)
*In Cloud Country:
Abstracting From Nature*
Harewood Hse Trust, Leeds 2013

Bogen, A.
*The Abstraction Of
A City: An Exam
Ination Of
The Oxb
-Ridge
Novel,
1880-1945*
Sussex University
Falmer, Sussex 1997

Bois, Y-A. Et al
*Abstraction,
Gesture,
Ecriture:
Painting
From The
Davos Collection*
Scalo Pubns, Zurich 1999

*Geometric
Abstraction:
Latin American
Art From The Patricia
Phelps de Cisneros Collection*
Harvard University
Art Museums,
Cambridge
Mass.
2001

Borja-Villel, M. &
Giunta, A.
Concrete
Invention:
Reflections
On Geometric
Abstraction From
Latin America & Its Legacy
Ediciones Turner, S.A. 2013

Bowman, H.
Semantic
Modulation
Of Temporal
Attention: Distributed
Control & Levels of Abstraction
In Computational Modelling
Computing Laboratory,
University of Kent,
Canterbury 2006

Boyanoski, C.
To-
Wards
A Lyrical
Abstraction:
The Art of L.A.C. Panton
Art Gallery of Ontario, 1990

Bovy, P. H.
Spacial
Abstraction
In Transportation
Planning: Preliminary
Classified Bibliography
Transportation Research
Laboratory, Delft 1971

Boyle, J.
Abstraction &
The Judgement Of Taste
Queen's University, Belfast 1991

Brodie, M.L.
Data Abstraction,
Databases &
Concept-
Ual
M-
Od-
Elling:
Annotated
Bibliography
Gov Print Off.
Washington 1980

Brown, D.
Abstraction
Of Image & Pixel:
The Thistle Display System
Computer Laboratory,
The University of
Cambridge
1991

Brennan, M.
Modernism's
Masculine
Subjects:
Matisse, The
New York School &
Post-painterly Abstraction,
MIT Press Mass., London 2004

Brüderlin, M.
Ornament &
Abstraction:
The Dialogue
Between Non-
Western, Modern
& Contemporary Art
Fondation Beyeder, Basel 2001

Bruning,
P.
Et al
*The Art
Of German
Drawing VII:
Free Abstraction*
Goethe Institute, London 1990

Bundy,
A.
*An In-
Complete-
Ness Theorem
Via Abstraction*
The Department of AI,
University of Edinburgh 1996

Butterfield, A.
*The
Car-
Eful
Memory
Abstraction
In Stable Storage*
Dept of Computer Science,
Trinity College, Dublin 1993

Bruns,
G.R.
*Process
Abstraction
In The Verification
Of Temporal Properties*
University of Edinburgh 1997

Campbell, R.L. (Ed) *Studies In Reflecting Abstraction* Psychology Pr. Hove, Sussex 2001

Cabeza De Vaca, M.V. *Surviving The Modernist Paradigm: A Fresh Approach To The Singular Art Of Anglada-Camarasa, From Symbolism To Abstraction,* Oxford Brookes University 2009

Cantini, A. *Logical Frameworks For Truth & Abstraction: An Axiomatic Study* Elsevier, Amsterdam 1996

Carmean, E.A.
The Great Decade Of American Abstraction: Modernist Art 1960 to 1970
The Museum Of Fine Art, Houston, Texas
1974

Carrano, F.M.
Data Abstraction & Problem Solving With C++: Walls & Mirrors
Pearson Addison Wesby
Boston, Mass. 2007

Chave, A.C.
Mark Rothko: Subjects In Abstraction
Yale UP, New Haven, 1989

Castine, P.
Set Theory Objects: Abstractions For Computer-Aided Analysis & Composition Of Serial & Atonal Music
Peter Lang Pub, Frankfurt 1994

Cochin, A.D.M.
*Abstraction
Révolutionnaire
Et Réalisme Catholique*
Desclée de Brouwer, Paris 1960

Cheetham, M.A.
*Abstract Art
Against
Auton-
Omy:
Impe-
Rfection,
Resistance,
Cure Since The 1960's*
Cambridge University Press 2006

Choueiry, B.Y. &
Walsh, T. (Eds)
*Abstraction,
Reformulation
& Approximation,
Proceedings Of The
Fourth International
Symposium SARA 2000,*
Horseshoe Bay, July,
Springer, Berlin
& London
2000

Cochrane, A. &
Meirion, A.
(Eds.)
*Visual
Izing The
Neolithic: Abs-
Traction, Figuration,
Performance, Representation*
Oxbow Publishing, Oxford 2012

Cockton, G.
*Architecture
& Abstraction In
Interactive Systems*
Heriot-Watt University
Edinburgh, Scotland 1992

Collier, M.
*An Evaluation of The Link
Between Abstraction,
Representation &
Language
Within
The
Context of
Current Theories
Of Environmental
Aesthetics & Phenomenology*
University of Sunderland 2011

Collins, T.
*Hybrid
Neutral:
Modes of
Abstraction
& The Social*
Independent
Curators
N.York
1988

Coeurdevey, A.
*Josquin
Desperez:
De L'Abstract-
Ion À L'Expression*
Cité de La Musique, Paris 2011

Collis, S.
Phylis Webb &
The Common Good:
Poetry, Anarchy, Abstraction
Talonbrooks, Vancouver 2007

Cook, R.T.
The Arché Papers On The Mathematics Of Abstraction
Springer, Berlin 2010

Colpitt, F.
Abstract Art In The Late Twentieth Century
Cambridge University Press 2002

Coniglione, F. Et al
Idealization XI: Historical Studies On Abs -Traction & Idealization
Rodopi, Amsterdam 2004

Corzo, F.A.
Abstraction & Structure In Knowledge Discovery In Databases
University College, London 2011

Courtney, D.W. & Kenis, J.
Dutch Ge-
Ometric
Abstr-
Act-
Io-
N-
In
The
80's
SDU
Uitg-
Evers,
The Hague 1988

Cramer, C.A.
Abstraction
& The
Classical
Ideal, 1760-1920
University of Delaware,
Eurospan, Biggleswade 2006

Coventry, K.
Between
Letters &
Abstraction
Wordsworth Trust, Grasmere 2004

Cregan,
K. *The*
Sociology
Of The Body:
Mapping
The
Abst-
Raction
Of Embodiment
Sage Publishing, London 2006

Cox, A.
Art
As
P-
O-
Li-
Tics:
The A-
Bstract-
Expressionist
Avant-garde & Society
UMS Research, Ann Arbor 1982

Crone, R.
*Jonathan
Lasker - Telling
The Tales of Painting:
About Abstraction At The
End of The Millenium*
Edition Cantz,
Stuttgart
1994

Crowther, P. & Wünsche, I.
*Meanings
Of Abstr
-Act Art
:Betw
-Een
Nat
-Ur
-E
&
T
-He
-Ory*
Rout
Ledge,
NY 2012

*Similia/
Dissimilia
:Modes Of
Abstraction In
Painting, Sculpture
& Photography Today*
Rizzoli, New York 1989

Cummins, T.B.F.
*Toasts With
The Inca: Andean
Abstraction & Colonial
Images on Quero Vessels*
University of Michigan,
Ann Arbor, USA
2002

Damerow, P.
*Abstract-
Ion and
-Repre
Senta
Tion
:Ess
Ays
On
-Cul
Tural
Evolution
Of Thinking*
Kluwer Publishing,
Dordrecht & London 1996

49

Danto, A.
Et al
Re-Pict-Uring Abstraction: The Politics of Space
The Anderson Gallery, Richmond, Virginia 1995 Darabi,

Deitch, J.
Painting Factory: Abstraction After Warhol
Skira, Rizzoli 2012

K.
User-Centred Video Abstraction
Brunel University 2015

De Libera, A.
L'Art Des Généralités: Théories de L'Abstraction
Aubier Publications, Paris 1999

Davies, A.
From Realism To Abstraction: The Art of J.B. Taylor
Calgary UP, Alberta 2014

De Sana, J.
*Abstraction In
Contemporary
Photography*
The Emerson Gallery,
Hamilton College, NY 1988

Dickerman, L.
*Inventing
Abstra-
Ction,
1910
-25:
H-
Ow
A Ra-
Dic Al Idea
Changed Modern Art*
Thames & Hudson, London 2012

De Zegher, C.
& Teicher, H.
*3 X Abstraction:
New Methods of Drawing*
Drawing Center, NY, YUP 2005

Dietmar, E. & Rosenblum, R.
*The Abstraction of
Landscape:
From
Northern
Romanticism To
Abstract Expressionism*
Editorial de Arte y Ciencia, 2007

Donahue, N. H.
Forms
Of
Dis-
Rup-
Tion:
Abstr-
Action
In Mod-
Ern Ger-
Man Prose
University of Michigan Pr. 1993

Dozhd, S.
Sergei Dozhd:
Psy-Abstraction: Psy-Art
Russian Saisons, Berlin 2003

Doney, W.
Berkeley
On
Abs-
Traction
& Abstract Ideas
Garland, London 1989

Du Pont, D.C.
Risk-
Ing The
Abstract:
Mexican
Internatio-
Nalism &
The Art of
Gunther
Gerzco
Santa
Barbara
Museum of Art,
California 2003

Douglas, C.
Swans of
Other
Worlds
:Kazimir
Malevich &
The Origins Of
Abstraction In Russia
UMI, Ann Arbor, Michigan 1980

Dyshlenko, Y.
Yurii Dysh-Lenko: Moder-Nity, Ab-Straction & Mass Media
Rutgers State University
New Jersey, New York 2003

Elger, D.
The Masters Of Abstraction
Taschen, London 2008

Edling, A.
Abstraction & Authority in Textbooks: The Textual Path Towards Specialised Language
Acta Universitatis Upsaliensis, Uppsala, Sweden 2006

Ehmann, S. & Klanten, R.
NeoGeo :A New Edge To Abstraction
Die Gestalten Verlag, Berlin, 2007

Elson, L.G.
Paradox Lost: A Cross-Cultural Definition of Levels of Abstraction
Hampton Press, Cresskill NJ 2010

Evans,
M.
*The
Painted
World: From
Illumination to Abstraction*
V & A Publications, London 2005

Farquharson, R.G.
*Foetal
Abs-
Trac-
Tion Of
Placental
Steroid Hormones*
University of Aberdeen 1985

Fazi, M-B.
*The Aesthetics
Of Contingent
Computation:
Abstraction,
Experience
& Indeterminacy*
Goldsmiths College,
University of London 2015

Fer,
B.
*On
Abstract Art*
Yale University Press
New Haven & London 1997

Fatonade, O.V.
*The Application of Knowledge
Based Systems To The
Abstraction Of
Design &
Cost-
Ing
Ru-
L-
Es
In
Be-
Spoke
Pipe Joi-
Nting Systems*
University of Glamorgan 2011

Fermon, A.J.
*Post-war To Pop
:Modern British Art -
Abstraction, Pop & Op Art*
Whitford Fine Art, London 2008

Fine,
K.
*The
Limits
Of Abstraction*
Clarendon, Oxford 2002

Feyerabend, P.
*Conquest
Of Abundance:
A Tale of Abstraction
Versus The Richness of Being*
University of Chicago Press, 2001

Field, J.
*Mute
Painting
:The Late
Abstraction
Of Gerhard Richter*
University of Lancaster 1998

Fischer, H. & Rainbird, J. (Eds)
*Kandinsky: The
Path To
Abstr
-Act
-Io
-N
Ta
-Te
Gal
-Lery*
London 2006

Fisher, S. &
Reges, S.
*Pascal &
Beyond:Data
Abstraction & Data
Structures Using Turbo Pascal*
J.Wiley & Sons, Chichester 2006

Fochessati, M. &
Mattiauda, E.
*In Asttratto:
Abstraction In
Italy, 1930-1980*
Silvana, Milan 2012

Fontanais-Cisneros, E.
& Fajardo-Hill, C.
*Sites of Latin
American
Abstr-
Act-
Io-
N
Ed-
Izioni*
Charta Sri,
Milan, Italy 2008

Fortune, B. & Reeves, W.
*Face Value:
Portr-
Ait-
Ur-
E
In
The
Age Of
Abstraction*
D. Giles Ltd, London 2014

Foster, C.L.
*Algorithms,
Abstraction &
Implementation:
Levels of Detail In
Cognitive Science*
Academic Press,
London 1992

Foster, S.C.
*The Critics
Of Abstract
Expressionism*
UMI Research Pubn,
Ann Arbor, Michigan 1980

Fowler, A.
*Elem-
Ents
Of
Abs-
Traction:
Space, Line &
Interval in Modern British Art*
Southampton City Gallery 2005

Fromm-
Berger, L.
Qualitative
Spacial Abstraction
In Reinforcement Learning
Springer-Verlag, Berlin 2013

Gage, J.
Colour
& Culture:
Practice & Meaning
From Antiquity To Abstraction
Thames & Hudson, London 1993

Fuenmayor, J. &
Fajardo, C.
Pulses of
Abstra-
Ction
In L
-At
-In
Am
-Erica
:The Ella
Fontanals-
Cisneros Collection
Turner Ediciones, Madrid 2012

Galenson, D.W.
Towards
Abstr-
Action:
Ranking
European
Painters of The
Early Twentieth Century
National Bureau of Economic
Research, Cambridge Mass. 2005

Two Paths
To Abstract Art:
Kandinsky & Malevich
NBER, Cambridge Mass. 2006

Furberg, M. Et al (Eds.)
Logic & Abstraction:
Essays Dedicated
To Per Lindström
Acta Universitatis
Gothoburgensis, Göteborg 1986

Galindo, C.
Multiple
Abstra-
Ction
-Hier
-Archies
For Mobile
Robot Operation
In Large Environments
Springer-Verlag, Berlin 2007

Ganguly, S.
Abstraction In Theory - Laws Of Physical Traction: The Theory Of Everything
Create Space 2012

Abstraction & The Standard Model: Studying Unanswered Questions in Physics
Kindle Edition 2014

Abstraction In Theory: Zero Postulation Results Theory Of Everything (Book 2)
Create Space 2014

Abstraction Of Observables: Zero Postulation Results
Kindle Edition 2014

Abstraction & Structures in Energy: The Fundamental Model
Kindle Edition 2014

*A Few Implications
Of The Laws Of
Transactions:
From The
Abstraction Theory*
Kindle Edition 2014

*Condensation States
& Landscaping
With The
-The
-Or
Y
Of
Ab
-St-
-Acti
On: Ze
-Ro Postul
Ation Results*
Kindle Edition 2014

*Analysis of
The Theory of
Abstraction: Zero
Postulation Results*
Kindle Edition 2014

*Complex
Fuzzy
Abstraction:
The Brain Logic*
Kindle Edition 2014

*Essentials Of
Abstrac
-Tion
The
-Or
Y:
Ze
-Ro
Post
-Ulatio
-N Results*
Kindle Edition 2014

Gibson, R.
Political Abstraction
University Of Texas, Dallas 2015

Giunchiglia, F.
A Theory Of Abstraction
The Department of AI, University of Edinburgh 1993

The Use of Abstraction in Automatic Inference
The Department of AI University of Edinburgh 1990

Girgin, S.
Abstraction In Reinforcement Learning: Using Option Discovery & State Similarity
VDM Verlag Saarbrucken 2009

Gleeson, T.J.
Aspects of Abstraction In Computing
University of Cambridge 1989

 Goldwater, R.J.
 Abstra
 -Cti
 -On
 -N
 In
 Art
 Art Treasures Book Club
 Beaverbrook, London 1957

Godfrey, M.
Abstract-
Ion
&
The
Holocaust
Yale UP, New Haven 2007

 Goehring, N.
 Phosphatidylinositol
 Transfer Proteins:
 Does The
 Typology
 & The
 Stored
 Curvature
 Elastic Stress
 Of Limpid Bilayers
 Regulate Membrane-
Assn & Limpid Abstraction? Gooding,
Imperial College, London U. 2012 M.
 A
 -Bs
 -Tra
 -Ct Art
 Tate Publishing, London 2001

Granda-Padron, J.
Abst-
Rac-
Tio-
N:
A
No-
Vel
Lulu.
Com 2005

Grosenick, U. (Ed)
Abstract Art:
Dietmar Elger
Taschen, Cologne 2008

Green, A.
Abst-
Raction,
Experience,
Reduction: Time
& Periodicity in The
Work of Myro Stout And
Post-war American Art History
Oxford Brookes University, 2005

Grundberg, A. & Saltz, J.
Abstract-
Ion
In
Co-
Ntem-
Porary
Photography
Anderson Gallery,
Des Moines, Iowa USA 1989

Grieve, A. I.
Constructed
Abstract
Art In
England
After World War II:
A Neglected Avant-garde
Yale UP, New Haven Conn. 2005

Hale, N. C.
Abstr
-Act
-Io
-N
In
Art
& N
-Ature
Constable
London 1993

Guilbaut, S.
How New
York Stole The
Idea of Modern Art:
Abstract Expressionism,
Freedom & The Cold War
University of Chicago Press, 1983

Haldemann, M. & Zug, K. (Eds)
Richard
Tuttle:
Repl-
Ace
The
Abstract
Picture Plane
Art Books Int., London 2001

Hannay, J.
Abstraction
Barriers
& Refi
-Nem
En
-T
In
The
Poly
Morph
Ic Lambda
University Of
Edinburgh, 2001

Haddad,
S.
The
Abst-
Raction
Of Arabic
Musical Voc-
Abulary, Spiritual
& Cultural Values Into
Contemporary Western Music
The University of London 2005

Harmer, R.S.
Games & Full Abs
Traction For
Non-Det-
Ermi-
Nis
Ti
C
La-
Ngu-
Ages
The University of London 1999

Harrison,
C. Et al
Primitivism,
Cubism, Abstracti-
On: The Twentieth Century
Open University, London 1993

Haskell, B. (Ed)
Georgia
O'Keefe:
Abstraction
Yale University Press
New Haven Conn, London 2009

Harrigan, C.
Abstract & Colour
Techniques In Painting
Batsford Pubns, London 2007

Harrison, A.
(Ed)
Phil-
Osophy &
The Visual Arts:
Seeing & Abstracting
Reidel Pubns, Lancaster 1987

Hawasly, M.
Policy Space
Abstr
-Act
-Io
-N
F
-Or
A L
-Ifelo
-Ng Le
-Arning
Agent Un-
Niversity Of
Edinburgh 2014

64

Hawthorne, D.W.
Beyond
Rep-
Re-
Sent-
Ation:
Theories
Of Abstraction
In America Art 1960-70
University of Oxford 1988

Herbert, J.
Temporal
Abstraction
Of Digital Designs
The Computer Laboratory,
University of Cambridge, 1988

Herbert, J.D.
The Political
Origins of
Abstract-
Expres-
Sion-
Ism-
'S
Art
Crit-
Icism:
The Ea-
Rly Theor-
Oretical And
Critical Writings
Of Clement Greenbe-
Rg & Harold Rosenberg
Humanities Honours Program,
Stanford University, Calif. 1985

Herrmann, M.
John Von
Wicht
1888
-1970:
The Way
To Abstraction
Peter Lang, Frankfurt 1995

Hess, B.
Abstract
Expressionism
Taschen, Cologne 2005

Hieke, A. Et al
Reduction,
Abstr
-Act
-Io
N
,A
-Na
Lysis
OntosVerlag, Frankfurt 2009

Hien, P.T.
*Abstraction
& Transcendence:
Nature, Shintai & Geometry
In The Architecture
Of Tadao Ando*
Dissertation
.com 1998

Hilfinger, P.N.
*Abstraction
Mechanisms
& Language Design*
MIT Press, Cam. Mass. 1983

Hiscock,
K.A.
*Axis
&
A-
Uth-
Entic
Abstraction
In 1930's England*
University of York 2005

Hodson, C.
& Laffan, R.
Representational & Abstract #1
Bare Hill Publishing, GB 2013

Representational & Abstract #2
Bare Hill Publishing, GB 2014

Hill Szckely, G.M.
*The Beginning of
Abstraction In
America: Art
& Theory In
Alfred Stieglitz's
New York Circle*
University of Edinburgh 1971

Hofmann, M.
*On Behavioural
Abstraction &
Behavioural
Satisfaction In
Higher Order Logic*
The Laboratory For The
Fndn Of Computer Science
University Of Edinburgh 1995

Houle, R.
*Troub-
Ling
Abs-
Tr-
Action*
McMaster
Museum of Art
Hamilton, Ontario 2007

Hughes, G.
*Resisting Abstraction:
Robert Delaunay
& Vision
In The Face
Of Abstraction*
University of Chicago Press, 2014

Horowitz, D.
*Letters
Of Credit,
Demand Guarantees
& The Spectrum Of Abstraction*
Oxford University
Oxford
2009

Humblet,
C.
*The
New
Ame-
Rican
Abstrac-
Tion, 1950-1970*
Thames & Hudson, London 2007

Hutton, C.
Abstra-
Cti-
O-
N
&
Ins-
Tance:
The Type-
Token Relation
In Linguistic Theory
Pergamon Press, Oxford 1990

Iglesias,
P.N.
Polytypic
Functional
Programming
& Data Abstraction
University of Nottingham 2005

Import, A.
Abstraction &
Representation of
Structure in Implicit Learning
Of Simple Remote
Contingencies
University
Of Sussex
Falmer
1993

Inglis, L.
Being
Inter-
Nat-
Ion-
Al
In
Paris
& London:
International Style
Abstraction of The 1930's
The University of London 2007

Jacobs, J.
Abstr
-Action
In Question
John & Mable
RinglingMuseum
Of Modern Art
Sarasota,
Florida
1989

Jacques, E. &
Gibson, R.
*Levels of
Abstraction In
Logic & Human Affairs*
Heinemann, Portsmouth NH 1978

Jahan, B.
*Abstr
-Act
-Io
-N
In
-In
Dian
Painting:
Post-Independence Era*
Kaveni Books, New Delhi 2008

Janssen, H. &
Joosten, J.
*Mondrian
1892-1914: The
Path To Abstraction*
W. Uitgever, Amsterdam 2002

Jenkins, D. F.
*John Piper
In
The
1930's:
Abstraction
On The Beach*
Merrell, London 2003

Johnson, C.
*C.R.W.
Nevinson,*
**The Soul
Of The
Soulless**
*-City: 'New York
An Abstraction'? 1920*
Tate Gallery, London 2001

Jones, M.R. & Cartwright, N.
Idealization XII –
Correcting
The Model:
Idealization
& Abstraction
In The Sciences
Rodopi, Amsterdam 2005

Joyce,
E.W.
Cultural
Critique &
Abstraction:
Marianne Moore
& The Avant-garde
Bucknell UP, Lewisburg
Assoc. UP's, London 1998

Kaltofen, C.
Erlen-
Bispolitik
Between The
Virtual & The
Actual: Technologies
Of Lived Abstraction
& The Posthuman Condition
Aberystwyth University 2015

Jonkers, H.B.M.
Abstraction,
Specif-
Cat-
Io-
N
&
Im-
Ple-
Men-
Tation
Techniq-
Ues With An
Application To
Garbage Collection
Mathematisch Cntrm,
Amsterdam 1983

Karmel, P. & Pissarro, J.
Conceptual Abstraction
Hunter College
Art Galleries
2012

Kaul, A.N.
The Action Of An English Comedy: Studies In The Encounter Of Abstraction & Experience From Shakespeare to Shaw
Yale University Press,
New Haven,
London
2001

Keefer, C. & Guidemond, J.
Oskar Fischinger, 1900-1967 Experiments In Cinematic Abstraction
Eye Filmmuseum & Center For Visual Music
Amsterdam
2013

Kelly, D.
The A -Bs -Stra Ction
Lulu.C -Om 2010

Kelly, W.
Abstraction & Its Processes
Lambert Pubns. 2011

Kennedy, L.A.
Abstr -Act -Io N & Ill- Umi- Nation In The Doctrine Of St Albert The Great
Nabu Press, Charleston, SC 2011

Kleeblatt, N.L. (Ed)
Action/Abstraction:
Pollock,
De Kooning
& American
Art, 1941-1971
Yale University Press
New Haven, Conn. 2008

Kline,
F.
The
Colour
Abstractions
Pridemark Press,
Stamford CT, US 1979

Koenig, S. & Holte, R.C. (Eds)
Abstraction,
Reformulation
& Approximation,
Proceedings of The 5th
International Symposium,
Kananaskis, Alberta August 2012
Springer, Berlin & New York 2012

Koffman,
E.B.
Objects,
Abstraction,
Data Structures
& Design Using C++
Wiley, Hoboken NJ 2006

Koffman, E.B. & Wolfgang, P.A.
Data
Stru-
Ctures:
Objects,
Abstraction &
Design Using Java
John Wiley & Sons, GB 2005

Knoblock, C.A.
Generating
Abstracti
On Hier-
Archies
:An Aut-
Omated
Approach
To Reducing
Search In Planning
Kluwer, Boston 1993

Kolenberg, H.
*Intensely
Dutch:
Image,
Abstract-
Ion & The
Word Post-war & Beyond*
Art Gallery of NSW Sydney 2009

La Berge, L.C.
*Scandals &
Abstraction:
Financial Fiction
Of The Long 1980's*
Oxford University Press 2015

Konvisser, M.W.
*Mathematical
Doings:
A Concrete
Introduction
To Abstraction*
Ardsley House, New York 1977

Korner, S.
*Abstraction in
Science & Morals*
CUP, Cambridge 1971

Lafitte, P.
*The
Per-
Son In
Psychology:
Reality or Abstraction?*
RKP Bloomsbury, London 1957

Lai, V.M.H.
The Influences Of Taoism On Post War American Abstract Express-Ionism (1940's-1960's)
The University of Lancaster 2001

Landau, E.G. (Ed)
Reading Abstract Expressionism: Context & Critique
Yale University Press
New Haven, Connecticut 2005

Landau, R.
The Arabesque: The Abstract Art of Islam
American Academy of Asian Studies, San Francisco CA 1955

Larionov, M.
Mikhail Larionov: La Voie Vers L'Abstraction Oeuvres Sur Papier 1908-1915
Edition Hatje Cantz, Paris 1987

Leclerc, D.
The Crisis Of Abstraction In Canada: The 1950's
National Gallery, Ottawa 1992

Lee, C-O.
On The Three Problems of Abstraction, Reduction & Transformation in Marx's Labour Theory of Value
University of London 1990

Lee, J.S.
Abstraction & Aging: A Social Psychological Analysis
Springer-Verlag, Berlin 1991

Lind, M.
Abstraction
The MIT Press
Cambridge, Mass. 2013

Le Lannon,
J-M.
*La Forme
Souveraine:
Soulages, Valéry
& La Puissance De
L'Abstraction*
Hermann,
Paris
2008

Linton, J.
*What
Is Water?
The History Of
Modern Abstraction*
UBC Press, Vancouver 2010

Levin, G.
*Synchronism
& American Colour
Abstraction 1910-1925*
G. Braziller, New York 1978

Lewis, P.E.
*La Rochefoucauld:
The Art of Abstraction*
Cornell UP, Ithaca, 1977

Liu, X.
*Abstr-
Action:
A Notion For
Reverse Engineering*
De Montfort Un. Leicester 1999

Livingston, K.
Rationality & The Pschology Of Abstraction
The Atlas Society, Kindle 2015

Lomas, D.
Hilma Af Klint: A Pioneer Of Abstraction
Hatje Cantz, Ostfilden 2013

London, R.L.
Abstraction & Verification in Alpha Rd: Introduction To Language & Methodology
Carnegie-Mellon U. Pitts. 1976

Lotz, C.
The Capitalist Schema: Time, Money & The Culture of Abstraction
Lexington Books, Lanham 2014

Lowry, J.
Painting & Understanding Abstract Art
Crowood, Ramsbury, Wiltshire 2010

Lucie-Smith, E.
Art Now: From Abstract Expressionism To Superrealism
Morrow, New York 1977

Lunn, F. & Godfrey, T.
Alf
Lohr
:Abstr
Action
Firstsite,
Colchester
Essex 1999

Luo, Z.
Temporal
Abstraction in
Reinforcement Learning
Based On Environmental Feature
Queen's University, Belfast 2010

Lush, R.
Hydrogen Atom
Abstraction Pathways
To Functionalised Free Radicals
University of Oxford Press 2001

Mandarini, M.
Efficient Ma
Terial Abs-
Traction:
Towards
A Crit
-Ical
Mat
-Eri
-Al
-Is
-T
P
-Ra
-Gm
-Atics
Univer
Sity Of W
-Arwick 1998

Martin, J.N.
Themes In
Neo-Pla
-Tonic
& Ar
-Isto
-Tel
-Ia
-N
Lo
-Gic:
Order,
Negation
& Abstraction
Ashgate, Aldershot 2004

Mathieu, G.
L'Abstr-
Act-
Io-
N
P-
Ro-
Phé-
Tique
Gallim-
Ard Pubns, Paris1984

MBZ
Hermann Obrist:
Sculpture, Space,
Abstraction Around 1900
University of Chicago Press 2015

McCusker, G.
Games & Full Abstraction For
A Function Meta-Language
With Recursive Types
Springer Pubns.
London
1998

McClintic, M.
Modernism &
Abstraction:
Treasure-
S From-
The S-
Mith-
Son-
Ian
Am
E-
Ri-
Can
Art M-
Uuseum,
New York 2001

McEwen, R.
Portraits
In Abs-
Traction
Create Space 2015

McIver, A. &
Morgan, C.
Abstr-
Action,
Refineme-
Nt & Proof For
Probabilistic Systems
Springer-Verlag, Berlin 2005

McIvor, J.M.
Karl Marx's Political Epistemology: Subjectivity & The State In The Writings Of The Early 1840's
LSE, University Of London
2004

Mecklenburg, V.M.
Modern Masters: American Art At Mid-Century
Smithsonian Art Museum, Washington DC 2008

Meehan, A.
Garbage Collection & Data Abstraction Based Modular Programming
Ulster University, Coleraine 1999

Mehring, C.
Blinky Palermo: Abstract-Ion Of An Era
Yale University Press
New Haven, Connecicut. 2008

Meldal, S.
Langu-Age Ele-M-E-N-Ts For Hier-Archi-Cal Ab-Straction In Concur-Rent Structures
Institute Of Informatics, University of Oslo, 1986

Melham. T.F.
*Formalizing
Abstraction
Mechanisms
For Hardware
Verification In
Higher Order Logic*
Computer Laboratory,
University of Cambridge 1990

Menaa,
M.N.
*On
The
Compo-
Sitionality of
Round Abstraction*
University of Birmingham 2012

Mercer, K.
Discrepant Abstraction
The MIT Press,
Cam. Mass,
London
2006

Miguel, I. &
Rumi, W.
*Absraction,
Reformulation
& Approximation
Proceedings: The 7th
International Symposium
Whistler, Canada July 2007*
Springer-Verlag, Berlin 2007

Miracco, R.
*Ita-
Lian
Abstr-
Raction
1910 -1960*
Mazzotta, Milan 2006

Mitnick, K.
*Artificial
Light: A
Narrative
Enquiry
Into The
Nature Of
Abstraction,
Immediacy & Other
Architectural Fictions*
Princeton Architectural Press 2008

Mondrian, P.
*Mondrian:
From
Figuration
To Abstraction*
Thames & Hudson, London 1988

*Natural
Reality &
Abstract Reality:
An Essay in Trialogue Form*
George Braziller, New York 1995

Moore,
T.V.
*The
Process
Of Abstraction:
An Experimental Study*
Berkeley - University Press 1910

Mozur, G.E.
*Argument &
Abstraction:
An Introduction
To Formal Logic*
Primis, NewJersey 1999

Müller-Westermann, I. (Ed)
*Hilma af
Klint:
A
Pio-
Neer of
Abstraction*
Hatje Cantz, Ostfildern 2013

Mullin, A.
*Working At
The Margins
Of Abstraction:
Understanding Child
Neglect In General
Practice: A Mixed
Methods Study*
University of Strathclyde 2012

Mulmuley, K.
Full Abstra-
Ction &
Seman-
Tic-
E-
Qu-
Iva-
Lence
MIT Press,
 Cam. Mass. 1987

Nardi, E.
The
Novice
Mathematician's
Encounter With Mathematical
Abstraction: Tension in Concept-
Image Construction &
Formalization
Oxford Un.
1996

Natkin, R.
Subject
Matter
& A-
Bst-
Ra-
C-
Ti-
On –
In Exile
Claridge Press, St Alban's 1993

Newall, M.
What is A
Picture?
Depiction,
Realism, Abstraction
Palgrave Macmillan, Bas. 2011

Nickas, R.
Painting
Abstraction:
New Elements
In Abstract Painting
Phaidon, London 2009

Nikolaidis, K.
Techniques
For Data Pattern
Selection & Abstraction
University of Liverpool 2012

O'Keefe, G.
*Georgia
O'Keefe:
Circling Ar-
Ound Abstraction*
Norton Museum of Art,
West Palm Beach, Florida 2007

Osbourne, H.
*Abstraction
& Artifi-
Ce In
Twe
-Nti
-Et
-H
C
-En
-Tur
-Y Art*
-Clare
-Ndon P
Rress, Oxford 1979

O'Loughlin, J.
*Supercontemplations:
Experiments In
Abstraction*
Create
Space
2014

*Ultracontemplations:
Experiments in
Poetic
Abstraction*
Create Space 2014

Palmer,
C.
*The
Sport-
Ing Image:
The Abstracti-
On Of Form In Sp-
Ort A Collection of Art
With Supporting Narratives*
SSTO Publications, Preston 2011

83

Parlour, S.
*Depicting
Limits: Syntax,
Abstraction & Space
In Contemporary Painting*
Goldsmiths College,
University of
London
2005

Payne, J.
Expansionist Abstraction
University of Sheffield 2013

Paulson, R.
*Figure
&
Abs-
Traction in
Contemporary Painting*
Rutgers University Press
New Brunswick NJ 1990

Maloon, T. (Ed)
*Abstraction:
Paths To
Abstr-
Action,
1867-1917*
Art Gallery Of
NSW, Sydney 2010

Marcoci, R.
*Comic Abs-
Traction:
Image
Breaking,
Image Making*
MOMA, New York
Thames & Hudson, London 2007

Pauluci, P.
*Marx
&
The
Politics
Of Abstraction*
Brill, Leiden 2011

Oeser, O.A.
*Some Experiments On
The Abstraction of Form &
Colour: A Contribution To The
Psychology of Types*
University Of
Camb-
Ridge
1931

Marin, J.
*John
Marin:
Between
Realism &
Abstraction*
Kennedy Galleries, N. York 1997

O'Hare, M.K.
*Constructive Spirit:
Abstract Art in South &
North America 1920's -1950's*
Pomegranete, San Francisco 2010

Melham, T.F.
*Formalizing
Abstracti-
On Me-
Chan-
Isms
For
H-
Ar-
Dware
Verification In
Higher Order Logic*
The Computer Laboratory,
University of Cambridge 1990

Ormell,
C.
*The
Value
Of Low-
Abstracti-
On Mathematics*
Ingle-Ashby Pbns, London 2009

Osborne, H.
*Abstaction
& Artif-
Ice In
20th
Cen-t
Ury Art*
Clarendon
Press, Oxford 1979

Ottley, D.
*Grace
Crowley's
Contribution
To Australian
Modernism A-
Nd Geometric
Abstraction*
Cambridge
Scholars
Newcastle 2010

Pavlovic, D.
*Categori-
Cal Logic
Of Names
& Abstraction
In Action Calculi*
School of Cognitive
& Computing Science,
University of Sussex, Falmer 1996

Pérez-Barreiro, G. (Ed)
*The Geometry of Hope:
Latin American
Abstract Art From
The Patricia Phelps
De Cisneros Collection*
Blanton Museum of Art,
University of Texas, Austin 2007

Park, R.
*Hazlitt
&
The
Spirit
Of The
Age: Abs-
Traction &
Critical Theory*
Clarendon Press, Oxford 1971

Porter, F.
*Fairfield
Porter:
Realist
Painter
In An Age
Of Abstraction*
Museum of Fine Arts,
Boston, Massachusetts 1982

Petrova, Y.
*Abstraction
In Russia:
The Twentieth Century*
Palace Editions, Bad Breisig 1999

Pikas, A.
*Abstraction
& Concept Formation*
Harvard UP, Cam. Mass. 1966

Pousette-Dart, R.
*Transcending
Abstra
-Acti
-On
:P
A
-I
-N
-Ti
-Ngs
1939*
1985 Mus
-Eum Of Art
Fort Lauderdale, Florida1986

Pratt, D.C.
Mean-
Ings
In
&
M-
Ea-
Nin -
Gs F-
Or A
Domain
Of Stochas-
Tic Abstraction
University of London 1998

Pugh, K.
Pre-
Factoring:
Extreme
Abstraction,
Extreme
Separation,
Extreme
Readability
O'Reilly Media
Farnham & Beijing 2005

Purdom, J.
Thinking
In Painting:
Gilles Deleuze
& The Revolution From
Representation To Abstraction
The University of Warwick 2000

Ragg, E.
Wallace
Steph
-En
-S
&
The
Aesthetics
Of Abstraction
Cambridge University Press 2010

M.N.
The
Abs-
Tract
Impulse:
Fifty Years
Of Abstraction
At The National
Academy 1956-2006
NAMSFA –Hudson Hills 2007

Rawlinson, M.
Charles Sheeler: Modernism, Precisionism & The Borders of Abstraction
Tauris Publications London 2007

Railing, P. (Ed)
From Science To Systems Of Art: On Russian Abstract Art & Language 1910-20 & Ot-Her Essays
Artists Bookworks
Forest Row, East Sussex 1989

Ramirez, M.C. & Rowell, M.
Joaquin Torres-Garcia: Constructing Abstraction With Wood
Yale UP, New Haven 2009

Reth, A.
Alf-Red Reth 1884-1966: From Cubism To Abstraction
Maklary Artworks, Budapest 2003

Rexer, L.
The Edge Of Vision: The Rise of Abstraction In Photography
Aperture Pubs, New York 2009

Riley, B. & Rainbird, S.
Mondrian: Nature to Abstraction
Tate Publishing, London 1997

Rizvi, S.
Hai Shuet Yeung : Innovation In Abstraction
Saffron, London 1997

Roberts, J.C.
Aspects Of A- Bs- Tra- Ction In Science Visualization
University of Kent
Canterbury, Sussex 1995

Reynolds, D.
Symbolist Aesthetics & Early Abstract Art: Sites of Imaginary Space
Cambridge University Press, 1995

Rogers, W.E.
Image & A-Bstr-Action: 6 Middle English Re-Ligious Lyrics
Rosenkilde & Bagger Pubns, Copenhagen 1972

Robinson, E.P.
Logical Rel-Ations & Data Abs -Tr -A -Ct -Ion Dept Of Co -Mputer Science, Queen Mary &
Westfield College, London 1996

Robinson, J.
Glorification: Religious Abstraction in The Renaissance & 20th Century Painting
Crescent Moon, Kidderminster 1990

Rollinger, R.D.
Meinong & Husserl on Abstraction & Universals: From "Hume Studies 1" To "Logical Investigations II"
Rodopi Pubs, Amsterdam 1993

Roque, G.
Art Et Scie-
Nce de La
Couleur:
Chevre
Ut Et
Les
Pe-
In-
T-
Re-
S De
Lacro-
Ix À L'
Absraction
J.Chambon Nîmes 1997

Rosenthal, M.
Abstract-
Ion In
20th
Cen
-Tury:
Total Risk,
Freedom, Discipline
H. Abrams, New York 1996

Rosenblum, R.
The Intern-
Ational
Style
Of
1800:
A Study
In Linear
Abstraction
Garland Pub, New York 1976

Rosenthal, M.
& Artsch-
Wager, R.
Critiques of
Pure Abstraction
Independent Curators 1995

Ross,
C. (Ed)
Abstract-
Expressionism:
Creators & Critics
Abrams, New York 1990

Roverso, D.
Analogy By
Mapping
Spread-
Ing &
Abst-
Rac
-Ti
-O
N
In
La
-Rge
Multi
-Funct
-Ional K
Knowledge Bases
University of Aberdeen 1997

Rubinstein, R.
Reinventing
Abstr
-Act
-Io
N:
New
York P
-Ainting In
The 1980's
Cheim & Reid, New York 2014

Ruhrburg, P.
Simulta-
Neous
Abstr
Act-
Io-
N
&
Se-
Man-
Tic Theories
University of Edinburgh 1996

Russo,
C.
In
Plane View:
Abstraction of Flight
Powerhouse Books 2008

Saad-Filho, A.
Levels of
Abstraction
& The Roles Of
The Organic & Value
Composition of Capital in
The Transportation Problem
School of Business & Economic Studies, University of Leeds 1996

Saitta, L. & Zucker, J-D.
Abstr
-Act
-Io
-N
In
Art
-Ificial
Intelligence
& Complex Systems
Springer, New York 2013

Sayer,
D.
The
Viole-
Nce Of Ab-
Straction: The
Analytic Foundations
Of Historical Materialism
Basil Blackwell, Oxford 1987

Schlemmer, O.
*Théâtre et
Abstraction:
(L' Espace du Bauhaus)*
L'Âge d'Homme, Lausanne 1978

Sers, P.
*Kandinsky,
Philosophie
Et L'Art
Abstr
-Ai
-T
:P
Ai
-Nt
Ure,
Poésie,
Scénographie*
Skira, Milano 2003

Scott, J.
*Terminal
Abstraction*
iUniverse 2005

Selz, G.
*Unstill
Life: A
Daughter's
Memoir Of A-
Rt & Love In The
Age of Abstraction*
Norton, New York 2014

Shepard, P.
*Where We
Belong:
Beyond
Abstraction
In Perceiving Nature*
University of Georgia Press, 2003

Sherwood, M.J.
*Medical Record
Abstraction
Form
Guidelines
For Assessing
The Appropriate
ness Of Hysterectomy*
RAND Corporation 1940

Shield, P.J.
*Spontaneous
Abstraction
In Denmark
& Its Aftermath
In Cobra, 1931-1951*
The Open University, MK 1984

Smith, M.J.A.
*Stochastic Abstraction
Programs: Towards
Performance-
Driven
Development*
University of Edinburgh 2010

Solomon, A.R.
Towards A New Abstraction
The Jewish Museum
Berlin 1963

Slobodkina, E.
*Rediscovering
Slobodkina:
A Pioneer
Of American Abstraction*
Hudson Hills, New York 2009

Sovran, T.
*Relational
Semantics & The
Anatomy of Abstraction*
Routledge, New York 2014

Spender, M.
*Ashile
Gorky
& The
Genesis of
Abstraction:
Drawings From
The Early 1930's*
Stephen Mazoh,
New York,
Seattle
1994

Stevenson, M.
*Moving in
Time &
Space
:Shifts
Between
Abstraction &
Representation In
Post-war South African Art*
M.S. Cont., Cape Town 2003

Steiner, R.
*Towards A
Grammar
Of Abst-
Raction:
Modernity,
Wittgenstein
& The Paintings
Of Jackson Pollock*
Penn State University Press 1992

Stewart, N.
*Abstr
-Act
-Io
-N
&
Co
-Medy*
Goldsmi
-Ths College
University of London 2013

Stinchcombe, A.L.
When Formality
Works:
Authority
& Abstraction
In Law & Organisations
University of Chicago Press, 2001

St John, S.
Journey To
Abstraction,
Vol. 1. :100 Paintings
& Their Secrets Revealed
North Light Books, US 2012

Stoops, S.L.
More Than
Minimal:
Feminism &
Abstraction
In The 1970's:
Lynda Benglis
Rose Art Museum,
Brandeis University
Waltham, Mass. 1996

Journey To
 Abstraction,
Vol.2. :100 Paintings
& Their Secrets Revealed
North Light Books, US 2015

Strayer, J.
*Subjects
& Ob-
Jects:
Art,
Es-
s-
E-
Nt-
Ial
Ism &
Abstraction*
Brill, Leiden 2007

Sturgis, D.
*Critical
Appraisal
:Abstraction
After Modernism
Re-Examining The
Case For The Baroque*
Oxford Brookes University 2008

Streader, D.
*Abstraction
& Refinement
Of Process Actions*
University of London 2000

Strickler, S.E.
*The Second Wave:
American Abstraction
Of the 1930's & 1940's*
Worcester Art Museum, MA 1991

Suarez, O. & Paternosto, C.
*Cold America:
Geometric
Abstraction
In Latin America*
Fndn Juan March, Madrid 2011

Suman, A.
From Knowledge Abstraction
To Management: Using
Ranganathan's
Faceted
Sche-
Ma
To
Dev-
Elop
Conc-
Eptual F-
Rameworks
For Digital Libraries
Elsevier, Amsterdam 2014

Thompson, P.J.
Fatal Abstractions:
Book 3 –
The
Parallogics
Of Everyday Life
Peter Lang, Bern 2004

Tansaekhwa
& J.Kee
From
All Sides:
Tansaekhwa
On Abstraction
Blum & Poe, New York 2015

Thorp, D.
Abstraction:
Extracting
From The World
Millenium, Sheffield 2007

Teiser, J. &
Gerrit, G.
Public-
Abstr-
Act-
Io-
N
W-
Al-
Ther
Konig,
Cologne 2015

Tirr, W.
*A Study
Of
The
Cau-
Sative
Factors In
The Development
Of Expression Towards
Abstraction In Germany*
Lancaster University 1979

Tonning, E.
*Abstraction
In Samuel
Beckett's
Dra-
Ma
For
Stage
& Screen,
1962 -1985*
University of Oxford 2006

Tomsic, T.
*Arrog-
Ance
Of
A-
Bs-
Tra-
Ction*
Kindle Edition 2013

Töpfner, C
*Subjects
Of Cr
-Ea
-Ti
On
:Mat
-Erial
Abstrac
-Ttion &
The Enact
-Ment Of Ideas*
Goldsmiths College, London 2015

Turim, M.C.
*Abstraction In
Avant-garde Films*
UMI Research Press,
Ann Arbor, Michigan 1985

Ustvedt, O.
& Osborne, P.
*Mathias Faldbakken:
Shocked Into Abstraction*
Ikon Gallery, Birmingham 2009

Van Overveld, K. & Strothotte, T.
*Computational Visualisation:
Graphics, Abstraction
& Interactivity*
Springer,
Berlin
1998

Van Vliet, R.
*The Art of
Abstract
Painting:
A Guide To
Creativity & Free Expression*
Search Press, Tunb/Wells 2010

Uidhir, C.M.
*Art &
Abstract Objects*
Oxford University Press 2012

Varnedoe, K.T.
*Pictures of
Nothing:
Abstr-
Act
Ar-
T
S-
I-
Nce
Pollock*
Princeton University Press,
New Jersey & Oxford 2006

Venlet, R. & Bernstein, T.
Abstraction & Empathy:
Victoria Miro
Gallery,
London
1989

Vernay-Nouri, A.
*Enluminures
En Terre
D'Islam:
Entre
Abs-
Traction
& Figuration*
Bibliothèque
Nationale
de France
Paris
2011

Veneciano, J.D.
*The Geometric
Unconscious: A
Century of Abstraction*
Nebraska UP, Lincoln 2012

Veronesi-Wolbert, K.
*Luigi Veronesi:
Rationalistic
Abstraction, 1927-1996*
IMD Mazzotta, Milan 1997

Waldrop, R.
Driven
To A-
Bst-
Ra-
C-
Ti-
On-
New
Directions,
New York City 2011

Walton, M.
First
-Order
Tax Logic
:A Framework
For Abstraction,
Constraints & Refinement
University of Sheffield 1998

Warren, A.
Noble
Abstraction:
American Liberal
Intellectuals & World War II
Ohio State UP, Columbus 1999

Watt, D.C.
What About The People?:
Abstraction & Reality
In History & The
Social Sciences
- Inaugural
Lecture
The LSE, London 1983

Walsh, T.
A The-
Ory
Of
Abs-
Traction
University of
Edinburgh 1990

Weinberg, J.R.
Abstraction,
Relation
& In-
Duct
Ion:3
Essays
In The Hist-
Ory Of Thought
University of Wisconsin,
Madison, Milwaukee US 1965

Wechsler, J.
Abstract
Expressionism
– Other Dimensions:
An Introduction
To Small-Scale
Abstraction
In America
1940-1965
Rutgers University, NJ. 1989

Weis, S.
Abstr-
Act-
Ion -
A Novel
Create Space 2015

Asian
Traditions/
Modern Expressions:
Asian American Artists
& Abstraction, 1945-1970
H.N. Abrams/Jane Voorheen
Zimmerli Art Museum - 1997

Wick, O. Et al
Alexander
Calder
Tree
-S:
N
-Am
-Ing A
-Bstraction
Hatje Cantz 2013

Wierzchowska, J.
The Absolute &
The Cold War
Discourse of
Abstract-Expressionism
Peter Lang, New York 2011

Williams, L.
Model Abstraction
& Reusability In
A Hierarchical
Architecture
Simulation
Environment
University Of
Edinburgh 1999

Wood, J.
Thoughts
On The Effects
Of The Application
& Abstraction of Stimuli
On The Human Body: With
A Particular View To Explain
The Nature & Cure of Typhus
J. Murray, etc, London 1793

Wilson, D.N.
Primordial:
An Abstraction
Anti-Oedipus Press,
Grand Rapids, Michigan 2014

Yallop, J.
*Abstract
Ion For
Web P-
Rogr-
Amming*
University of
Edinburgh 2010

Worringer, W.
*Abstraction
& Empathy: A
Contribution To
The Psychology of Style*
RKP, Bloomsbury, London 1963

Yardley, S.
*All Abstractions
Point In The Same
Direction: There
Is No Horizon*
Create Space 2014

Wright, L.
*Better
Reasoning:
Techniques For
Handling Evidence & Abstraction*
Rinehart & Winston, N. York 1982

Zak, M.
*Particles of
Life: Mathematical
Abstraction or Reality?*
Nova Science, New York 2014

Zarringhalam, M.
*The Nature Of
Islamic Art
& Its Re-
Lation-
Ship
Wi-
Th
A-
Bs-
Tra-
Ction*
RCA 1979

Zimmermann, T.
*Abstraktion und
Realismus im
Literatur -
Und Kunstdiskurs
Der Russischen Avantgarde*
Sagner Publications, Munich 2007

Zepke, S.
*Art As
Abstrac-
T Mac-
Hine:
Ont-
Ol-
Og-
Y &
Aes-
Thet-
Ics In
Deleuze
& Guattari*
Routledge, London 2014

Zucker, J-D. &
Saitta, L.
(Eds)
*Abstraction,
Reformulation
& Approximation,
Proceedings of The 6th
International Symposium*
July, Airth Castle, Scotland
Springer, Berlin & London 2005

Abadie, D.
Alberto
Magnelli:
Pionnier de
L' Abstraction
Aubier, Paris 1999

Abe, S.K. & Cheetham, M.A.
Discrepant Abstraction
Vol.2: Annotating
Art's Histories
Institute
Of International
Visual Arts, London 2006

Abramsky, S.
Full Abstract-
Ion In Th-
E Lazy
Lam
-Ba
-D
-A
C
-Al
-Cu
-Lus
Com
-Puter
Laboratory,
University of Cambridge 1992

Abrams, H.N.
Abstraction
Geometry Painting:
Selected Geometric Abstract
Painting in America Since 1945
Albright-Knox Art Gallery,
Buffalo, New York 1989

Adams, S.E.
Abstraction Discovery
& Refinement
For Model
Checki-
Ng By
Sym
-Bo
-L
-Ic
Traj
-Ectory
Evaluation
University of Oxford 2014

Altieri, C.
Painterly
Abstraction
In Modernist
American
Poetry
:The
Cont-
Empor-
Aneity Of
Modernism
Penn State UP,
Pennsylvania 1995

Ames, L.J.
The Dot,
Line & Shape
Connections, Or How
To Be Driven To Abstraction
Doubleday Pubs, New York 1982

Anderson, S.M.
Roger Kuntz:
The Shadow Between
Representation & Abstraction
Laguna Museum of Art, Cal. 2009

Andel, J.
Paint-
Ing
The
Un-
Ive-
Rse,
Franz
Kupka:
Pioneer
In Abstraction
Verlag Gerd Hatje
Ostfildern-Ruit 1997

Anon
Abstraction:
Towards A New
Art – Painting 1910-20
Tate Gallery Pubs, London 1980

Anon
Economic
Instruments
In Relation To
Water Abstraction:
A Consultation Paper
Dept of The Environment,
Gov. Printing Office, London 2000

Anon
Fore-
Runners Of
American Abstraction
Cambridge Inst. Art Museum 1972

Anon
Landfill Gas
Abstraction From
Mounded Landfill Site
GB Energy Efficiency Office
Gov. Printing Office, London 1988

Anon
Lyrical
Abstr
-Act
-Io
N
W
-Hit
-Ney
-Mus
-Eum Of
American Art,
New York 1971

Anon
Monet et
L'Abstraction
Musée Marmottan
Hazan Pubs, Paris 2010

Anon
Mondrian:
Nature
To Ab
-Str
-Ac
-T
-Ion
Tate
Gallery,
London 1993

Anon
New York Abstraction: A Symposium
Macdonald Stewart Art Centre-Gue-Lp-H, O-Nt-Ario, Canada 1997

Anon
Reduction – Abstraction – Analysis Proceedings of The 31st International Ludwig Wittgenstein Symposium In Kirchberg 2008
De Gruyter, Warsaw 2009

Anon
The Patricia & Phillip Frost Collection: American Abstract Art, 1930-1945
Smithsonian Institution, NY 1989

Anon
Post-Pai-Nte - Rl-L-Y A-Bs-Tra-Ction
San F-Rancisco Museum of Art, San Francisco 1964

Anon
The Presence Of Painting: Aspects of British Abstraction, 1957-1988
South Bank Centre, London 1988

Attieri, C.
*Painterly
Abstraction in
Modernist Poetry: The
Contemporaneity of Modernism*
Cambridge University Press 1989

Auping, M.
*Abstraction
Geometry Painting:
Selected Geometric Abstract
Painting In America Since 1945*
Albright-Knox Gallery, NY 1989

Ausby, E.
Et al
*Afro-
Americ-
An Abstraction*
Art Museum Assn,
San Francisco, Cal. 1982

Austin, E. & Harford, L.
*Abstraction-Creation:
Post-war Geometric
Abstract Art
From Europe
& South America*
Austin- Desmond Fine Art,
Great Russell St, London 2010

Autexier, S.
*An Abstract
Ion For
Proof
Pla
-Nn
-In
-G
U
-Ni
-Ver
Sitatis
Des Sa
-Arlandes,
Fachbereich In-
Formatik Saarbrücken 1997*

Back, A.
*Aristotle's
Theory of Abstraction*
Springer-Verlag, Cham 2014

Bal, M.
*Endless
Andness:
The Politics
Of Abstraction
According To A.V. Janssens*
Bloomsbury Academic 2013

113

Ballard, D.H.
*Brain Com-
Putation
As Hier-
Archical
Abstraction*
The MIT Press
Cambridge, Mass. 2015

Bann, S.
*Experi-
Mental
Painting:
Construct-
Ion, Abstraction,
Destruction, Reduction*
Studio Vista, London 1970

Baofu, P.
*The Future Of
Post-Human
Formal S-
Cience:
Prefac
-E To
A N
-Ew T
-Hory Of
Abstraction
& Application*
Cambridge Scholars,
Newcastle Upon Tyne 2010

Ballen, R.
*Animal
Abst-
Rac-
Ti-
On*
Re-
Flex
Gallery,
Amsterdam 2011

Barr Jnr, A.H.
*Cubism &
Abstract Art*
Arno Press, New York 1966

Belisle, J.
Et al
*The
Qu
-Est
-Ion Of
Abstraction*
MAC, Montreal 2013

Barron, S. & Fort, L.S.
*Calder & Abstraction:
From Avant-garde
To Iconic*
Prestel, London 2013

Bellman, R. Et al
*Abstr-
Action
& Pattern
Classification*
Academic Press,
Salt Lake City, UT 1966

Bashkoff, T. &
Fontanella, M.M.
*Art of Another Kind:
International Abstraction
& The Guggenheim, 1949-1960*
Guggenheim Museum Pubs. 2012

Becks-Maloray, U.
*Wassily Kandinsky
1866-1944:
The Journey
To Abstraction*
Taschen Publishers, London 1999

Belshaw, A.
*The A
-Bstr
-Act
-Io
N
Of
Verse*
Tyne Press,
North Shields 2012

PART 3:

ARTICLES

MELLERS, W.
*The Silence of
Nothingness
& American
Abstraction:
On John Cage*
<u>Modern Painters,</u>
Vol. 11, No.1, 88-92
Fine Art Journals Ltd 1998

MENEGATTI, M.
& RUBINI, M.
*Convincing
Similar &
Dissim-
Ilar O
Thers:
The Pow-
Er Of Langu-
Age Abstraction In
Political Communication*
<u>Personality & Social Psychology
Bulletin,</u> Vol.39, No.5, 596-607
Sage, Thousand Oaks, Cal. 2013

*Initiating,
Maintaining
Or Breaking Up?
The Motivated Use Of
Language Abstraction
In Romantic Relationships*
<u>Social Psychology- Journal,</u>
Vol. 45, Number 5, 408-420
Hogrefe & Huber, Cam. Mass 2014

MERGENTHALER, E.
*Emotion Abstrac-
Tion Patterns
In Verbatim
Protocols:
A New Way
Of Describing
Psychotherapeutic Processes*
<u>Journal of Consulting & Clinical
Psychology,</u> Vol.64, No.6, 1306-15
American Psychological Assn1996

MENDES, N.D. Et al
*Composition &
Abstraction
Of Logical
Regulatory
Modules:
Applic'n
To Multi-Cellular Systems*
<u>Bioinformatics,</u> 29, 6, 749-57
Oxford University Press 2013

MEROD, J.
The Sublime Lyrical
Abstract-
Ion Of
Edw-
Ard
W. Said
Boundary 2,
Vol.25, No.2, 117-144
Duke University Press 1998

METZER, D.
"Spurned Love":
Eroticism & A-
Bsrtaction In
The Early
Works
Of
Aaron
Copland
The Journal
Of Musicology,
Vol.15, No.4, 417-443
University of California Pr. 1997

MERRETT, S.
The Po-
-Litical Eco-
Nomy Of Water
Abstraction Charges
Review of Political Economy,
Vol.11, No.4, 431-442
Edward Arnold
London
1999

MESEGNER, J. Et al
Equati-
Onal
Abstr-
Action s
Theoretical
Computer Science,
Vol.403, No.2-3, 239-264
Elsevier, Amsterdam 2008

MEYERTHOLEN, A.
Apocalypse
Now: Heinrich
Von Kleist, Caspar
David Friedrich & The
Emergence of Abstract Art
The German Quarterly, 86, 4, 404
J. Wiley & Sons, Hoboken NJ 2013

MICHAEL, M.C.
*Materiality vs
Abstraction in
DM Thomas's,*
The White Hotel
Critique, Vol.43, No.1, 63-83
Heldref Pubrs, Philadelphia 2001

MIODUSER, D. Et al
*Episodes To Scripts To Rules:
Concrete – Abstractions
In Kindergarten
Children's
Explana-
Tions
Of
A
R-
Ob-
Ot's
Beha-
Viour*
Inter -
National
Journal Of
Technology &
Design Education,
Vol.19, Number 1, 15-36
Springer-Verlag, Berlin 2009

MIKSCH, S. Et al
*Utilizing Temporal
Data Abstraction
For Data Val-
Idation &
Therapy
Plann
-Ing
For
Artific-
Ally Ventilat
-Ed Newborn Infants*
AI In Medicine, 8, 6, 543-576
Elsevier Pubs, Amsterdam 1995

MILLER, G. Et al
*Towards
A General
Abstraction
Through Sequences
Of Conceptual Operations*
Journal of Data Semantics 6962
183-192 , Springer Berlin 2011

MITCHELL, C.D.
*The Utopian Angle:
Latin American
Abstraction Is
The Focus Of
A Show Titled
"The Geography of Hope"*
Art In America, 95, 11, 112-15
Brant Publications, N. York 2007

MITCHELL, D.G. &
TERNOVSKA, E.
*Expressive Power
& Abstraction
In Essence*
Constraints,
Vol.13, No.3, 343-84
Springer-Verlag, Berlin 2008

MITTERER, H. Et al
*Phonological
Abstract-
Ion
Without
Phonemes
In Speech Perception*
Cognition, 129, 2, 356-61
Elsevier Pubs, Amsterdam 2013

MIX, K.S. Et al
*Numerical
Abstr-
Act-
Ion
In
Infants:
Another Look*
Developmental
Psychology Journal,
Vol.33, No.3, 423-428
American Psychological Assn 1997

MLINKO, A.
*Corporate
Abstraction*
The Critical Quarterly,
Vol.51, 3, 117
Blackwell
Oxford
2009

MOK, A.K. Et al
*Real-Time Virtu-
Al Resource:
A Timely
Abstraction For
Embedded Systems*
Journal on Data Semantics,
No.2491, 182-196
Springer,
Berlin
2002

MONAGHEN, J.
& OZMANTAR, M.F.
Abstraction & Consolidation
Educational Studies in
Mathematics, 62,
No.3, 233-58
Springer,
Berlin
2006

MOORE, J.B.
*On Avoiding
An Abstraction Of
The Abstract: Preparing
Abstracts For Submissions*
**Journal Of Public Health
Management & Practice**
Journal Of Public Health
Management & Practice
Vol.15, No.5, 373-4
Aspen, NY 2009

MOORE, T.L. Et al
*A Non-Human Primate
Test Of Abstraction
& Set Shifting:
An Automa-
Ted Ad-
Aptat-
Ion
Of
The
Wisconsin
Card Sorting Test*
Journal of Neuroscience
Methods, 146, No.2, 165-173
Elsevier Pubs, Amsterdam 2005

*Impairment
In Abstraction
& Set Shifting in
Aged RhesusMonkeys*
Neurobiology of Aging,
Volume 24, No.1, 125--134
Elsevier Pubs, Amsterdam 2003

MORGADO, L. Et al
*Abstraction Level
Regulation Of
Cognitive
Processing
Through
Emotion
-Based
Attention
Mechanisms*
Journal On Data
Semantics, No.4840, 59-74
Springer-Verlag, Berlin 2007

MORGAN, D.
*The Enchant-
Ment Of Art:*
**Abstraction &
Empathy From
German Romantic
-Ism To Expressionism**
Journal of The History of Ideas,
Volume 57, No.2, 317-42
John Hopkins UP
Baltimore
1996

MORRISON, M.C.
*Scientific Understanding
& Mathematical
Abstraction*
Philosophia,
Vol.34, No.3, 337-353
Springer-Verlag, Berlin 2006

MUHAMMED, S. Et al
Quantum Chemical Study
Of Benzimidazole
Derivates To
Tune The
Second-
Order
Non-
Linear
Optical
Molelcular
Switching By
Proton Abstraction
Physical Chemistry: Chemical Physics, V.12, No.18, 4791-99
Royal Society of Chemistry 2010

MUNSON, B.
Nonword
Repetition
& Levels Of
Abstraction In
Phonological Knowledge
Applied Psycholinguistics,
Volume 27, Number 4, 577-80
Cambridge University Press 2006

MURAWSKI, A.S.
Full Abstraction Without
Synchronization
Primitives
Electr-
onic
Notes In
Theoretical
Computer Science,
Volume 265, 423-36
Elsevier, Amsterdam 2010

MURAWSKI, A.S. &
TZEVELEKOS, N.
Full Abstraction
For Reduced ML
Annals Of Pure
 & Applied Logic,
Vol.164, 11, 1118-1143
Elsevier Pubs, Amsterdam 2013

MURMANN, J.P.
Reflections On Choosing
The Appropriate Level
Of Abstraction
In Social
Science
Research
Management
& Organization
Review, Vol.10, No.3, 381
Wiley & Sons, Hoboken NJ 2014

NAMDEO, V. & THAKUR, R.S.
*Classification of
Data At
Multilevel
Abstraction*
International Journal of
Information & Communication
Technology, Vol.6, No.2, 142-155
Interscience Pubs, New York 2014

NANARD, J. Et al
*Media Construction Patterns:
Abstraction & Reuse In
Multimedia Appl-
Ication Spe-
Ciflcat-
Ions
Pro-
Ce -
Ed-
Ings
Of The*
International
Society For Optical
Engineering, 4312, 123-34
SPIE Bellingham, Washington 2001

NARUMI, T. Et al
*Switching The Level
Of Abstraction
In Digital
Exhibit
Ions
To
P
-Ro
Vide
An Und
-Erstanding
Of Mechanisms*
Journal On Data
Semantics, 8522, 567-78
Springer-Verlag, Berlin 2014

NAVARRO-LOPEZ, E.
& CARTER, R.
*Hybrid
Automata:
An Insight Into
The Discrete Abstract-
Ion Of Discontinuous Systems*
International Journal of Systems
Science, Vol.42, No.11, 1883-98
Taylor & Francis, Phil. USA 2011

NEBEL, M.E.
*On Quant-
Itative
Effe-
Cts
Of
RNA
Shape
Abstraction*
Theory in Biosciences,
Volume 128, No.4, 211-25
Springer-Verlag, Berlin 2009

NEE, D. Et al
*Prefrontal Cortex Organisation:
Dissociating Effects of Temporal
Abstraction, Relational
Abstraction &
Integr-
Ation
With IMRI*
Cerebral Cortex,
Vol.23, No.9, 2377-87
Oxford University Press 2014

NERESSIAN, N.J. Et al
*Abstraction Via Genetic
Modelling In Con-
cept Format
Ion In
Sci-
Ence*
Poznan
Studies In
The Philosophy
Of Science & The
Humanities, 86, 117-144
Rodopi Pubns, Amsterdam 2005

NESBITT, K.
*The Sublime & Modern
Architecture: Unmasking
(An Aesthetics of) Abstraction*
New Literary History V.26, 1, 95
John Hopkins UP, Baltimore 1995

NEUHAUSER, C.
*The Role of
Integration
& Abstraction
In Complex Systems
Thinking Across Multiple Contexts*
Special Papers - Geological
Society Of America,
Vol.486, 121-22
GSA Boulder
Col. 2012

NEUMAN, Y. Et al
*How Language
Enables Abs-
Traction:
A Study
In Com
-Putat
-Ational
-Cultural
Psychology*
Jnl-Integrative
Psychological &
Behavioural Science,
Volume 46, No.2, 129-45
Springer-Verlag, Berlin 2012

NIELSEN, C.M. Et al
Exploring Interaction
Space As Abstr-
Acton Me-
Chan-
Ism
For
Task-
Based
User Inter-
Face Design
Journal On Data
Semantics, 4385, 202-216
Springer-Verlag, Berlin 2007

NIKANDER, J. Et al
Visualisation Of Spatial
Data Structures
On Different
Levels Of
Abstraction
Electronic Notes
In Theoretical Computer
Science, Volume 178, 89-99
Elsevier Pubs, Amsterdam 2007

NITTA, N.
Automatic
Persona-
Lized V-
Ideo A-
Bstra-
Acti-
On For
Sports Video
Using Metadata
Multimedia Tools &
Applications, Vol.41, No.1, 1-25
Springer-Verlag Pub, Berlin 2009

NOVACK, M.A. Et al
From
Act-
Ion
To
Abs-
Traction
Psychological
Science, Vol.25, 4, 903
Sage, Thousand Oaks CA 2014

NUNEZ, R.E.
Numbers And
Numerosities:
Absence Of
Abstract Neural
Realization Doesn't
Mean Non-Abstraction
The Behavioural & Brain
Sciences, Vol.32, No.3/4, 344
Cambridge University Press 2009

OBLESER, J. &
EISNER, F.
Pre-Lexical
Abstract-
Ion Of
Spe-
Ech
In The
Auditory Cortex
Trends In Cognitive
Sciences, Vol.13, No.1, 14-19
Elsevier Pubs, Amsterdam 2009

OFTE, S.H. & HUGDAHL, K.
Right-Left Discrimination
In Younger & Older
Children Measured
With 2 Tests
Conta
-In
-Ing
Stimuli
On Different
Abstraction Levels
Perceptual & Motor
Skills, Vol.94, 3, 707-719
Ammons, Missoula MT 2002

O'CONNELL, J.P.
John M.
Pausnitz: Bridging
Abstraction & Realities
AICHE Journal, V.61, No.9, 2675
Wiley & Sons, Hoboken NJ 2015

O'CONNOR, P.B. Et al
Long-Lived Electron Capture
Dissociation Product Ions
Experience Radical
Migration Via
Hydrogen
Abstraction
Journal of The
American Society
For Mass Spectrometry,
Volume17, No.4, 576 - 585
Elsevier Pubn, Amsterdam 2006

O'KANE, R.H.T.
The Ladder Of
Abstraction:
The Purp
-Ose of
-Com
-Par
-Iso
N
&
The
Practice
Of Comparing
African Coups D'État
Journal Of Theoretical P-
Olitics, V. 5, N. 2, 169, Sage
Pubn. Thousand Oaks CA 1993

OLDEVIK, J. Et al
Model Abstract-
Ion Versus
Model
To Text
Transformation
Technical Report, N.17, 188-93
Kent University, Canterbury 2004

OLIVER, T.
Techniques
Of
Abs-
Traction
Millenium,
Volume 30, Number 3, 555-570
London School of Economics 2001

OLVECZKY, P.C.
& MESEGUER, J.
Abstraction &
Complete-
Ness
For
Re-
Al-
Time
Maude
Electronic
Notes in Theoretical
Computer Science, 176, 4, 5--27
Elsevier Pubns, Amsterdam 2007

OPHIR, E.
Towards A
Pitiless Fiction:
Abstraction, Comedy &
Modernist Anti-Humanism
Modern Fiction Studies,
Vol.52, No.1, 92-120
John Hopkins UP
Baltimore
2006

OR-BACH, R. & LAVY, I.
Cognitive Activities of Abstraction
In Object Orientation:
An Empirical
Study
SIGCSE Bulletin,Vol 36, 2, 82-6
Assn Computing Machinery 2004

ORPHANOU, K. Et al
Integration of Temporal
Abstraction &
Dynamic
Bayesian
Networks For
Coronary Heart Diagnosis
Frontiers in Artificial Intelligence
& Applications, Vol. 264, 201--10
IOS Press, Amsterdam, NLS 2014

OTERO, A. Et al
A Fuzzy Constr-
Aint Satisfact-
Ion Appro-
Ach For
Signal
Abstr-
Act-
Ion
Inter-
National
Journal Of
Approximate Reasoning,
Volume 50, Number 2, 324-340
Elsevier Pubs, Amsterdam 2009

OTT, W.R.
The Cartesian
Context Of
Berkeley's
Attack On
Abstraction
Pacific Philosophical
Quarterly, Vol.85, No.4, 407-24
Basil Blackwell Pubs, Oxford 2004

OU, C.M.
Multiagent-Based Computer
Virus Detection Systems:
Abstraction From
Dendritic Cell
Algorithm
With D
-Ang
-Er
Th
-Eory
Telecom
Munications
Systems, 52, 2, 681-91
Springer-Verlag Pub. Berlin 2013

OVERBEEK, R.
Moving To A
Higher
Level Of
Abstraction
Environmental
Microbiology, Vol.9, 1, 7-8
Basil Blackwell, Oxford 2007

PACKER, G.
Over Here:
Iraq The
Place
Versus
Iraq The
Abstraction
World Affairs,
Vol.170, No.3, 14-23
WA Institute, Pittsburgh 2008

PALOPOLI, L. Et al
*Automatic & Semantic
Techniques For
Scheme In-
Tegra-
Tion
& S-
Ch-
Eme
Abstr-
Action*
Journal
On Data
Semantics,
No.1677, 511-20
Springer,Berlin1999

PAPPAS, A.
*Haunted
Abstraction*,
Journal of Modern Jewish Studies, Vol.6, No.2, 167-183
Taylor & Francis Pubs,
Philadelphia
2007

PARIS, S.
*Environmental
Abstraction &
Path Planning
Techniques For
Realistic Crowd Simulation*
Computer Animation & Visual Worlds, Vol.17, No.3-4, 325-35
John Wiley & Sons, Hoboken 2006

PARULEK, J. Et al
*Continuous Levels-of-Detail
& Visual Abstraction
For Seamless
Molecular
Visualization*
Computer Graphics Forum, Vol.33, No.6, 276
John Wiley & Sons, Hoboken 2014

PARA, J-B.
*Genese de
L'Abstraction*
Europe: Revue Littéraire Mensuelle,
Vol.82, No.897/8, 310-14
Centre National
Du Livre
Paris
2004

PASNAK, R. Et al
Promoting Early
Abstraction
To Pro-
Mote
Early
Literacy
& Numeracy
Journal of Applied
Developmental Psychology,
Volume.30, Number 3, 239-49
Elsevier Pubs, Amsterdam 2009

PATTILLO, M.
The Tension Between
Abstraction &
Specific-
Ity
In
En-
Acting
Reflexivity In
Race Scholarship
Ethnic & Racial Studies,
Volume 35, No.4, 620-625
Routledge Pubs, London 2012

PAVLOVIC, D. Et al
Geometry of
Abstraction in
Quantum Computation
Proceedings of Symposia in
Applied Mathematics,
Vol.71, 233-267
AMS 2012

PAYNE, J.
Abstraction
Relations
Need
Not
Be
R
-E
-Fle
-Xive
Thou-
Ght: A
Journal Of
Philosophy,
Vol.2, No.2, 137
J.Wiley & Sons, Hoboken 2013

PEI, H. Et al
Snow
Information
Abstraction Based on
Remote Sensing Data: Taking
The North Of Xinjing For Example
Geo-Spatial Information Science,
Vol.12, No.1, 56-60
Springer,
Berlin
2009

PERCIVAL, P.
Predicate
Abstraction, The
Limits Of Quantification &
The Modality of Existence
Philosophical Studies,
156, 3, 389-416
Springer,
Berlin
2011

PERL, J.
Art The Abstract Imperfect: MOMA's Retrospective Of Willem De Kooning May Be More Certain About Him Than He Ever Was
The New Republic, 242, 4911, 25-27
Chris Hughes
Washington
DC 2011

Matisse's Uncertainty: Henri Matisse Led A Life Of Contradictions. His Art Is Both Emotionally Overwhelming & Emotionally Elusive: His Creative Impulse Swerved Between Nature & Abstraction; His Family Was Both His Bulwark & His Ball & Chain
The New Republic, No.4740, 27-31
Chris Hughes
Washington,
DC 2005

The Story Of How Art Became Abstract
Modern Painters, Vol.15, No.2, 84-85
Fine Art Journals Ltd 2002

On Art: Reckless Beauty: Giacometti's Greatness Is Beyond Dispute But A New Retrospective Raises Some Old Questions About Abstraction, Representation & The Nature of Art Itself
The New Republic, No. 4350, 32-37
Chris Hughes
Washington
DC 2001

On Art: Solitary In The City of Art - Kitaj & Balthus, Two Nonconformist Rebels Against An Age of Abstraction
The New Republic, Isssue 4182, 35
Chris Hughes
Washington,
DC 1995

PERRENET, J. &
KAASENBROOD, E.
*Levels of Abstraction
In Students'
Understa-
Nding Of
The Concept
Of Algorithm The
Qualitative Perspective*
SIGCSE Bulletin, 38, 3, 270-74
ACM, New York City, US 2006

PETERS, J.
*Abstraction
& Intimacy
In Flannery
O'Connor's*
**The Violent
Bear It Away**
Shenandoah, 60
Number 1-2, 212-23
Washington & Lee University
Lexington, Virginia USA 2010

PERRUCHET, P. Et al
*Absence Of Covariations
In Incidental
Learning &
Covariation Bias*
British Journal Of Psychology,
Volume 88, Number 3, 441-458
Wiley-Blackwell, Hoboken 1997

PERSSON, P-A.
*Technology:
From Sub-
Stance To
Abstraction
& What This
Means For Our
Understanding Of It*
International Journal of
Sociotechnology & Knowledge
Development, Vol.4, No.2, 14-20
IGI Global, Pennsylvania US. 2012

PETERS, J.D.
*Publicity & Pain: Self-
Abstraction
In Adam
Smith's
Theory
Of Moral
Sentiments*
Public Culture,
Volume.7, No.3, 657
University of Chicago Press 1995

PETTITT, J.
*On
Blends
& Abstraction:
Children's Literature
& The Mechanisms Of
Holocaust Representation*
International Research in
Children's Literature,
Vol.7, No.2, 152
Edinburgh UP
2014

PHILEMOTTE, C. &
BERSINI, H.
*The Gestalt-
Heuristic:
Emerging
Abstraction To
Improve Combinatorial Search*
Natural Computing,
11, 3, 499-517
Springer,
Berlin
2012

PHILLIPS, E.D. Et al
*Free Radical
Rearrangement of
Unsaturated Sulphones
Involving An Intramolecular
Hydrogen Abstraction*
Tetrahedron Letters,
V 34, 15, 2541
Pergamon,
Oxford
1993

PICKSTONE, C.
*A Theology of Abstraction:
Wassily Kandinsky's,
'Concerning The
Spiritual
In Art'*
Theology,
Vol.114, No.1, 32-44
Sage Thousand Oaks CA 2011

PIKE, B.
Donahue, Neil H.
***Forms of Disrupti-
On: Abstraction
In Modern
German
Pro-
Se***
S
-Tu
Dies
In 20th
Century
Literature,
Vol.19, No.2, 296
P-Macmillan, Basingstoke 1995

PILLATT, T.
*Resilience
Theory
& Social Memory:
Avoiding Abstraction*
Archaeological Dialogues,
Volume 19, Number 1, 62-74
Cambridge University Press 2012

PIPPIN, R.B.
*What Was
Abstract Art?
(From The Point
Of View of Hegel)*
Critical Enquiry,
Vol.29,.1, 1-24
University of
Chicago
Press
2002

PING, L. Et al
*Real Time & Multi-
Channels
Signal
Abstraction
For Piezoelectric
Resonant Sensor Array*
Proceedings of The International
Society For Optical
Engineering,
No. 3242,
192-201
SPIE,
Bellingham,
Washington 1997

PNUELI, A. Et al
*Liveness With
(0, 1 & Unknown)
Counter-Abstraction*
Journal on Data Semantics,
No.2404, 107-122
Springer,
Berlin
2002

POIRIER, C.
*Abs-
Traction
Of Central
Representation
In 3-Month-Old Infants*
L'Année Psychologique,
Vol.95, No.3, 377-400
Centre Henri
Piéron
Paris
1995

POLLOCK, G,
*Pure Abstraction: Sir
George Pollock
Recounts His
Explorati-
On Over
Forty
Years
Of
Light
Itself As
Subject Matter*
RPS Journal,147, 9, 418-421
Royal Photographic Society 2007

PORTIDES, D.P.
*A Theory
Of Scientific
Model Construction:
The Conceptual Process of
Abstraction & Concretization*
Foundations of Science,
Vol.10, 1, 67-88
Springer,
Berlin
2005

POSTPONE, M. Et al
*Labor &
The Logic of
Abstraction: An Interview*
The South Atlantic Quarterly,
Volume108, Number.2, 305-30
Duke Un. Press, Durham NC 2009

POTTS, C. & HSI, I.
*Abstraction & Context
In Requirements
Engineering:
Towards A
Synthesis*
Annals
Of S
-Oft
-W
-Ar
E
- En
-Gin
-Eering
Vol.3, 26-32
Baltzer Science,
Basel, Switz. 1997

PRATT, D. & NOSS, R.
*Designing For
Mathema-
Tical A-
Bstr-
Act-
Ion*
Inter-
National
Journal Of
Computers For
Mathematical Learning
Volume 15, Number 2, 81-97
Springer-Verlag, Berlin 2010

PRATTEN, S.
*Realism, Closed
Systems &
Abstr-
Act-
Ion*
Journal
Of Economic
Methodology, 14, 4, 473--97
Taylor & Francis, Phil. 2007

PRICE, L.S.
*Points Of Perspective: On A Tour
Of The Metropolitan Museum
Of Art, Renowned Artist
Will Barnet Discusses
The Relationship of
Form, Space &
Perspective,
From The
Old M-
Ast-
Er-
S
To
M-
Od-
Ern
Abstr-
Action*
Journal of
Business &
Economic Statistics,
Volume 15, No.4, 26-35
ASA, Alexandria, Vancouver 1997

PRIMIERO, G.
*Proceeding In
Abstraction:
From Con
-Cept To
Types
& The
Recent
Perspective
On Information*
History & Philosophy Of Logic,
Volume 30, Number 3, 257-82
Taylor & Francis Pubn, UK 2009

PRINCE, D.
*Founding
Faces:
Death &
Abstraction
In Wyschogrod's*
Aesthetics & Ethics
Philosophy Today/Michigan
Then Chicago, V.55, 4, 392-400
De Paul University, Chicago 2011

QIWEI, L.
*Comm-
Ents On
Reflecting
Abstraction In
Piaget's Epistemology*
Psychological Science - Shanghai
Volume 27, Number 3, I/149, 514
King's Coll. Strand, London 2004

QU, W-X. Et al
*A Generic
Framework of Two-
Dimensional Abstraction
For Paramaterized Systems*
Journal of National University
Of Defence Technology,
Vol.32, 1, 95-100
NUDT 2010

RACO, M. & GILIAM, K.
*Geographies of Abstraction,
Urban Entrepreneur-
Ialism & The
Production
Of New
Cultu-
Ral
Spa-
Ces:
The
West
Kowlo-
On Cultural
District, Hong Kong*
Environment & Planning, Volu-
Me 44, Number 6, 1425-1442
Pion Ltd, Brons. London 2012

QUOI, A.
*Regards Sur
L'Abstraction,
Entretien Avec
Serge Lemoine
& Pascal
Rous-
Seau*
L'Oeil,
552, 74-7
OMI, Paris 2003

RAFIN, A. Et al
*L'Abstraction
Narrative Dans
L'Imagerie Des Celtes*
Collection De L'École Francaises
De Rome, No.371, 185-207
EFDR Paris1999 – 2006

RAGG, E. & EECKHOUT, B.
Pragmatic Abstraction Vs Metaphor: Stevens', "The Pure Good of Theory"
& ***Macbeth***
The Wallace Stevens Journal,
Volume 30, No.1, 5-29
The WS. Society, John Hopkins University Press Baltimore 2006

RAILING, P.
Review: P
-Etrova Et al,
Origins Of The Russian Avant-garde;
Y.Petrova Et al, ***Abstraction in Russia XX Vol.1.;*** *A.Brovsky Et al,* ***Abstraction in Russia XX Vol.2***
The Art Book, V.11, 2, 42-3
Blackwell, Oxford 2004

The Path To Abstraction, *By H. Fischer & S. Rainbird* & ***Concerning The Spiritual In Art***, *By W. Kandinsky, Introduction by Adrian Glear*
The Art Book,
Vol.14, No.1, 18-19
Basil Blackwell, Oxford 2007

RAILLARD, G.
Aux Origines De L'A
-Bstr
-Act
-Io
-N
La Quinzaine Littéraire,
Issue 868, 17 Paris 2004

RAJAN, S. Et al
From Abstraction Data Types To Shift Registers: A Case-Study In Formal Specificaton & Verification At Differin
-G Levels Of Abs
-Traction Using Theo
-Rem Proving & Symbolic Simulation
Journal On Data Semantics, No. 780, 490, Springer Berlin 1994

RAMACHANDRAN, U. Et al
Space-Time Memory: A Parallel Program-
Ming Abstract
Ion For
Inter-
Act-
Ive
Multi
-Media
Applications
ACM Sigplan Notices, Vol.34, No.8, 183-92
ACM Special 1999

REITSMA-VAN ROOIJEN, M. Et al
The Effect Of Linguistic Abstraction On Interpersonal Distance
European Journal of Social Psychology, Vol.37, .5, 817-825
John Wiley & Sons, Hoboken 2007

RENIERS, M.A. Et al
Action Abstraction in Timed Process Algebra: The Case For An Untimed Silent Step
Journal on Data Semantics, No.4767, 287-301
Springer-Verlag, Berlin 2007

REVELLE, W. & CONDON, D.
Personality At Three Levels Of Abstr-
Act-
Io -
N
P-
Er-
So-
Nal-
Ity &
Individ-
Ual Differences,
Volume 60, Supp. S18
Elsevier Pubn, Amsterdam 2014

RASSKIN-GUTMIN, D.
The Power of Formalization & Abstraction in Evolutionary Biology: **The Geometry Of Evolution - Adaptive Landscapes & Theoretical Morphespaces** *(2006)*
Bio Essays, 29, 10, 1068-9
John Wiley & Sons, Hoboken 2007

REYBROUCK, M.
Music Cognition & Real-Time Listening: Denotation, Cue Abstraction, Route Description & Cognit-Ive Maps
Musiciae Scientiae,
Vol.14,187-202, European Society For The Cognitive Sciences of Music & Music Education Jyvaskyla Univ, Finland 2010

RIEKE, R.
Abstraction-Based Analysis Of Known & Unknown Vulnerabilities of Critical Information Infrastructures
International Journal Of Systems Engineering,
Vol.1, N.1-2, 59-77
Interscience Enterprises
Geneva
2008

RIGHELATO, P.
Elizabeth W. Joyce, **Cultural Critique & Abstraction: Marianne Moore & The Avant-Garde Year-Book Of English Studies,**
Vol.31, 322
Modern Humanities Research Assn Cambridge 2001

RISING, L.
Understanding The Power of Abstraction In Patterns
IEEE Software,
Vol.24, No.4, 46-51
IEEE, New York 2007

RIVAL, X. Et al
Calling Context Abstraction Without Shapes
ACM Sigplan Notices,
Vol.46, No.1, 173-186
ACM, New York 2011

RIZZA, D.
Abstraction &
Intuition in Peano's
Axiomatizations Of Geometry
History & Philosophy of Logic,
Volume 30, Number 4, 349-368
Taylor & Francis, Philadia. 2009

ROL, M.
Idealization, Abstraction
& The Policy of
Relevance
Econo-
Mic
Th-
E-
O-
Ri-
Es-
Jou-
Rnal of
Economic
Methodology,
Vol.15, No.1, 69-97
Taylor & Francis UK 2008

ROBETANAGEL, C.S.
Revealing Hidden Covariation
Detection: Evidence For
Implicit Abstraction
At Study
Journal Of
Experimental Psychology,
Vol.27, No.5, 1276--1288
APA, Washington, DC 2001

ROMEY, W.D.
Using Patterns,
Abstractions
& Metaphors
From Art In
Geoscience Classes
Journal of Geoscience
Education, Vol.48, No.3, 295
National Association of
Geoscience
Teachers
2000

ROBERTS, J.M.
Realistic Spatial
Abstraction? Marxist
Observations of A Claim
Within Critical Realist Geography
Progress In Human Geography,
Volume 25, Number 4, 545-568
Edward Arnold Pr, London 2001

ROUPP, A.
Exploring
Comp-
Osition
Through
Abstraction
School Arts,
V. 98, 3, 18--19
Davis Publications
Worcester MA 1998

ROZOY, J.G. & ROZOY, C.
Gravures Et Abstraction: Les
Gravures Non-Figurative
De Roc-La-Tous I, Le
Schiste Grave Des
Beaux-Arts
Et Les Pr
-Ogres
De L
'Ab
-Stra
-Ction
Durant
La Prehisto-
Ire Et L'Histoire
L'Anthropologie, Vol.
111, Number 4, 655-686
Elsevier Pbns, Amsterdam 2007

RUBINI,
M. Et al
The Strategic
Role of Language
Abstraction in Achieving
Symbolic& Practical Goals
European Review Of Social
Psychology, Vol. 25, 1, 263-313
Taylor & Francis, London 2014

RUECKER, S. Et al
Abstraction & Realism
In The Design
Of Avatars
For The
Simul-
Ated
Envir-
Onment
For Theatre
Visual Communication,
Volume 12, Number 4, 459-472
Sage, Thousand Oaks, CA 2013

RUHRBERG, P. Et al
A Simultaneous
Abstraction
Calculus
& Theories
Of Semantics
Lecture Notes,
CSI, Volume 1, 495-510
CLSI, Stanford CA 1996

RUI, C. & XIANGPING, G.
*The
More
Fluent, The
More Beautiful? An
Exploration of Abstract
Art Aesthetic Processing*
Psychological Science –
Shanghai, V.34, No.3,
Issue 191, 565-70
PS Editorial
Board
2011

RUNGTA, N. Et al
*Efficient
Testing of
Concurrent
Programs With
Abstraction-Guided
Symbolic Execution*
Journal On Data
Semantics, No.
5578, 174-79
Springer-
Berlin
2009

SABINE, G.H.
Moore, T.V.,
**The Pro-
Cess
Of
Abs-
Tract-
Ion: An Exp
Erimental Study**
Philosophical Review,
Volume 21, No.5, 611-612
Duke Uni. Press, Durham 1912

SACHENBACHER, M.
& STRAUSS, P.
Task-Dependent
Qualitative
Domain
Abstraction
Artificial Intelligence,
Vol.162, No.1-2, 121-43
Elsevier, Amsterdam 2005

RUSSOMANNO, D.J.
*A Function-Centred Framework
For Reasoning About
System Failure
At Multiple
Levels Of
Abstraction*
Expert Systems :
The International Jrnl.
Of Knowledge Engineering
Volume.16, Number 3, 148-169
Learned Information, ALPSP 1999

SAGIV, M.
Et al
*On The
Expressive
Power Of Can
-Onical Abstraction*
Jrnl. on Data Semantics,
Number 2937, 58
Springer,
Berlin
1999

SAMOYAULT, T.
Fiction et Abstraction
Littérature,
123, 56-66
Revue Publiée
Avec Le Concours
Du Centre National Paris 2001

SANDER, E. & RICHARD, J-F,
*Analogical Transfer
As Guided By
An Abstr-
Action
Proc-
Ess:
The
Case of
Learning By
Doing In Text Editing*
Journal of Experimental
Psychology, 23, 6, 1459-83
APA, Washington DC. 1997

SARLIN, P.
*Self-organizing
Time Map:
An A-
-Bstr
-Act
-Io
-N
Of
Tem
-Poral
Multivar
-Iate Patterns*
Neurocomputing, V. 99, 496-508
Elsevier Pubn, Amsterdam 2013

SCANLAN, M.
J.N. Martin,
**Themes in
Neoplatonic &
Aristotelian Logic:
Order, Negation & Abstraction**
History & Philosophy Of Logic,
Volume 26, Number 4, 359-360
Taylor & Francis, Philadia 2005

SCHAECKELER, S. Et al
Visualization &
Procedural
Abstraction
Electronic
Notes In
Theoretical
Computer Science,
Number 224, 27--39
Elsevier, Amsterdam 2009

SCHIRN, M.
Fregean Abstra-
Ction, Refe-
Rential
Indet-
Erm-
Ina-
Cy-
&
The
Log
Ical Fo-
Undations
Of Arithmetic
Erkenntnis, Vol.
59, Number 2, 203-32
Kluwer Academic, Berlin 2003

Hume's Principle
& Axiom V
Recon
Side
Red:
Cr-
Iti-
Cal
Refl-
Ection
On Fre-
Ge & His
Interpreters
Synthese, 148,
Issue 1, 171-227
Springer, Berlin 2006

SCHAMANN, V.
The Material-
Ity Of The
Abstr-
Act-
Ion
Voice
Integrative
Psychological &
Behavioural Science,
Volume.42, No.1, 114-20
Springer-Verlag, Berlin 2008

SCHMERTZ, M.F.
Driven To Abstraction:
Pre-War Lines Inform A
Post-War Apartment in
Manhattan: Interior
Architecture &
Design by
Skelton,
Mandel
& Associates
Architectural Digest,
Vol.60, No.11, 280-289
KNAPP Communications US 2003

*Midwestern Abstraction:
Distilling The
Essence Of*
The Barn
*On Lake
Michigan*
Architecture
Digest, Vol. 62,
Number 5, 332-337,
KNAPP Communications US 2005

SCHMIDT, K.
*Abstraction-
Based
Failure
Diagnosis For
Discrete Event Systems*
Systems & Control Letters,
Volume 59, Number.1, 42--7
Elsevier Pubs, Amsterdam 2010

SCHMIDT, R. Et al
*Abstraction Of Data &
Time For Prognoses
Of The Kidney
Function In
A Case-
Based
Reas-
On -
In-
G
Sy-
Stem*
Studies
In Health
Technology
& Informatics, 34, 570-74
IOS Press, Amsterdam 1996

SCHMIDT, R. & GIERL, L.
*A Prognostic Model For
Temporal Courses
That Combines
Temporal
Abstr-
Action
& Case-
Based Reasoning*
International Journal of Medical
Informatics, Vol 74, 2-4, 307-15
Elsevier Pubns, Amsterdam 2005

SCHOR, M.
*Notes On
Women &
Abstraction &
A Curious Case
History: Alice Neel As
A Great Abstract Painter*
Differences, 17, 2, 132-160
Indiana UP, Bloomington 2006

SCHRODER, J.
*Computation,
Levels of
Abstraction,
& The Intrinsic
Character of Experience*
The Behavioural & Brain Sciences, Vol. 22, No. 6, 970
Cambridge University Press 1999

SCHREIBER, S.S.
*Art & The Heart:
A Scientist Explores
His Research & His
Art. The Abstract
Art of Cardiac
Imaging As
A Prelu-
De To
A D-
Efin
Ing
E
Nc
O
Un
Ter
With
Colour*
Dialogues
In Cardiovascular
Medicine, 15, 3, 217-22
Servier Int. Med., Slough 2010

SCHWARTZMAN, L.H.
*Abstraction,
Idealization
& Oppression*
Metaphilosophy,
Vol.37, No.5, 565-588
Basil Blackwell, Oxford 2006

SCHWARZ,
B. Et al
*Abstr
-Act
-Io
-N
In
Context:
Construction &
Consolidation Of Knowledge*
PME Conference 26, V. 1, 1-12
PMEC Publication Norwich 2002

SCHWERING, A.
KUHNBERGER, K-U.
Child Versus Adult
Analogy: The
Role of Sy-
Stematicity
& Abstraction
In Analogy Models
The Behavioural And
Brain Sciences, 31, 4, 395
Cambridge University Press 2008

SCIAMA, S.
Abstraction & Perceptual
Individuation In Primed
Word Identification Are
Modulated By Distortion
& Repetition: A Dissociation
Memory, Vol.15, No.8, 899-911
Taylor & Francis, London 2007

SCOTT, W.R.
When Form-
Ality Wor-
Ks: Autho-
Rity & Abstr-
Action In Law
& Organisations,
By A. L. Stinchcombe
Contemporary Sociology,
Volume 31, No. 6, 635-637
American Sociological Assn 2002

SEDIVY, S.
Hume,
Images :
Abstraction
Hume Studies
Vol.21, N.1, 117
The Hume Society
Department. of Philosophy
Azusa Pacific Uni, Calif. 1995

SEWAL, R. & STUMP, H.
Gain Abstraction & Accuracy
From RTL Power
Estimation
Electronic Design,
Volume 55, No.2, 49-50
Penton Publications, Belfast 2007

SHABTAI, A. Et al
Intrusion Detection For
Mobile Devices Using
The Knowledge-Ba
-Sed, Tempor
Al Abstr-
Actio-
N M-
Eth-
Od
The
Journal
Of Systems
& Software, Vol.
83, Number 8, 1524-37
Elsevier Pubn, Amsterdam 2010

SHAH, R. Et al
*How Well Does Record
Abstraction Quantify
The Content Of
Optometric
Eye Exa-
Minat-
Ions
In
The
UK?*
-Optha
-Lmic & Ph
-Ysiological Optics,
Volume 29, No.4, 383-96
Basil Blackwell, Oxford 2009

SHAHAR, Y. Et al.
*Knowledge-Based
Temporal
Abstrac-
Tion I-
N C-
Li-
Ni-
Cal
Dom-
Aains
Artificial
Intelligence
In Medicine,*
Vol.8, No.3, 267-298
Elsevier Pubs, Amsterdam 1996

SHANK, B.
*Abstraction & Embodi-
Ment:Yoko Ono &
The Weaving
Of Global
Musica-
L Net-
Works*
Journal
Of Popular
Music Studies,
Volume18, No.3, 282-300
Basil Blackwell, Oxford 2006

SHAHAR, Y.
*A Frame-
Work
For
Kn-
Ow-
Ledge
Based
Temporal
Abstraction*
Artificial Intelligence,
Vol.90, No.1-2, 79-134
Elsevier, Amsterdam 1998

SHAPIRO, S.
*From Capitalist
To Communist
Abstraction:*
**The Pale
King's**
Cultural Fix
Textual Practice,
Vol.28, No.7, 1249-71
Taylor & Francis, London 2014

SHARYGINA, N.
*An Abstraction Re-
Finement Approach
Combining Precise &
Approximated Techniques*
International Journal on Software
Tools For Technology Transfer
14, 1, 1-14 Springer, Berlin 2012

SHAW, J.L.
*Frenchness,
Memory
& Abs-
Tract-
Ion:
Th-
E
C-
As-
E Of
Pierre
Puvis De
Chavannes*
Studies in The
History of Art, 68, 153-72
National Gallery of Art 2005

SHEETS, H.M.
*The Writing On
The Wall: Using Borr-
Owed Texts By Figures
Ranging From Gertrude
Stein To Richard Pryor,
Gleen Ligon
Transfo
-Rms
-Wo
R-
Ds
Into
Abstr
Actions
That Spe-
Ak Volumes*
Art News, 110,
Number 4, 86-91
ANSS, New York 10010, 2011

SHEN, K. Et al
*Visual Analysis
Of Large
Heter
-Oge
-Ne
-Ous
Social
Networks
By Semantic &
Structural Abstraction*
IEEE Transactions on Visualiza
Tion & Computer Graphics, V.
12, No. 6, 1427-1439 IEEE 2006

SHEPARD, S.S.
Exploiting Mid-Range DNA Patterns For Sequence Classification: Binary Abstraction Markov Models
Nucleic Acids Research, Vol.40, No.11, 4765-4773 Oxford University Press 2012

SHIH, T. Et al
A Knowledge Abstraction Approach For Multi-Media Presentation
Proceedings /Southeastern Symposium On Systems Theory, 29, 528-32 IEEE Computer Soc. Press 1997

SHESTAKOV, A.F. & DENISOV, E.T.
Transition State Geometry In Radical Abstraction Reactions: Comparison Of Interatomic Distances In The Intersecting Parabolas & Morse Curves Models With Quantum-Chemical Calculations
Russian Chemical Bulletin, Vol. 52, 2, 320-9 Springer Berlin 2003

SIEGLING, A.B. Et al
A Preliminary Investigation Into The Effects Of Linguistic Abstraction On The Perception Of Gender in Spoken Language
Current Psychology, 33, 4, 479-500 Springer, Berlin - Heidelberg 2014

SILVER, H. Et al
'Executive'
Funct-
Ions
&
No-
Rmal
Ageing:
Selective
Impairment
In Conditional
Exclusion Compared
To Abstraction Inhibition
Dementia & Geriatric
Cognitive Disorders,
Vol.31, 1, 3-62
Karger, Basel
2011

Suboptimal Processing Strategy &
Working-Memory Impairments
Predict Abstraction
Deficit In Schizophrenia
Journal Of Clinical &
Experimental Neuropsychology,
Volume 29, Number 8, 823-830
Taylor & Francis, London 2007

SILVERMAN, D.
Painting, Self
& Society At
The Cusp
Of Abs-
Tract-
Ion:
Com-
Ments
On Art &
Comparative
Cultural History
French Politics, Culture &
Society, Vol.24, No.2, 91-101
Berghahn Books, N. York 2006

SIMON, A.
& CATTAPAN
-LUDEWIG, K.
Challenging
The Wor
-King
Me
-M
-Ory
Model
Of Thoug
-Ht Abstraction
Schizophrenia Research,
Vol.102, No.1-3, Supp.2, 128
Elsevier Pubs, Amsterdam 2008

SIMPSON, C.
John Gage, Colour & Culture:
Practice & Meaning
From Antiquity
To Abstr-
Acti-
On
The
Journal
Of Aesthetics
& Art Criticism,
Volume 56, No.1, 80-81
UWP, Madison Wisconsin 1998

SMART, A.
Abstraction & Reality,
By Jonathan Black
& Sara Ayres
The Spectator,
Number 9703, 34-35
The Spectator Ltd, London 2014

SIPLE, M.
Finding
Realism
Through
Abstraction
American Artist
Number 761, 26-31
AA Digital Journal 2006

SMIRNOV, S. Et al
Business Process
Model Abstr-
Action :
A Def-
Init-
Ion,
Cata-
Logue
& Survey
Distributed &
Parallel Databases,
Volume.30, No.1, 63-99
Springer-Verlag, Berlin 2012

SKORDOULIS, R.T.
Strategic Flexibility
& Change:
An Aid To
Strategic
Thinking
Or Another
Managerial
Abstraction?
Strategic Change,
Vol.13, No.5, 253-258
John Wiley & Sons Online 2004

SMITH, R.
Abstraction & Finitude:
Education, Chance
& Democracy
Studies In
Philosophy
& Education,
Vol.25, No.1-2, 19-35
Springer-Verlag, Berlin 2006

SNAPPER, L. Et al
Your Kid Could
Not Have Done
That: Even
Untutore-
D Obse-
Rvers
Ca-
N
D-
Isc-
Ern
Inte-
Ntion-
Ality &
Structure
In Abstract
Expressionist Art
Cognition, Vol.137, 154-165
Elsevier Pubs, Amsterdam 2015

SOLOMON-GODEAU, A.
On Briony Fer's,
On Abs-
Tract
Art
Art In America,
Vol.86, No.5, 37-45
Brant Publications US 1998

SOLOMOS, M. & HARLEY, J.
Xenakis' Early Works: From
"Bartokian Project"
To "Abstr-
Acti-
On"
Con-
Temporary
Music Review,
Volume 21, No.2-3, 21-34
Harwood Pubs, Amsterdam 2002

SON, J-Y. Et al
Simplicity & Generalization:
Short-Cutting Abstraction In
Children's Object Categorizations
Cognition, Vol.108, 3, 626-38
Elsevier Pubs, Amsterdam 2008

SONNENFELD, D.A.
The Violence
Of Abstraction:
Globalisation &
The Politics Of Place
Global Environment Politics,
Volume 6, Number 2, 112-117
The MIT Press, Cam.Mass. 2006

SPAID, S.
Brid
Get -
Riley:
Action,
Fraction
Attraction
Abstraction
Art & Text Jrnl,
Volume 73, 56-65
A & T PTY Ltd 2001

SPECHT, S.M.
*Successive Contrast Effects
For Judgements
Of Abstr-
Act -
Ion
In
Art
Work
Following
Minimal Pre-Exposure*
Empirical Studies of The Arts,
Volume 25, Number 1, 63--70
Baywood Amityville NY 2007

STANLEY, K.O.
*Compositional Pattern Produci-
Ng Networks: A Novel
Abstraction Of Development*
Genetic Programming & Evolv-
Able Machines, Volume.8, No.
2, 131-62 Springer, Berlin 2007

STANOJEVIC, M. Et al
*NIMFA – Natural Language
Implicit Meaning
Formalization
& Abstraction*
Expert Systems
With Applications,
Vol.37, No.12, 8172-87
Elsevier, Amsterdam 2010

STANTON, N.A. Et al
*Levels of Abstraction
In Human
Supervisory
Control Teams*
Journal of Enterprise
Information Management,
Vol. 19, No. 6, 679-694
MCB UP Bradford 2006

STARK, C.A.
*Abstraction &
Justification
In Moral
Theory*
Hypatia,
Volume 25,
Number 4, 825-833
Indiana UP, Bloomington 2010

SRIRAMAN, B.
*Reflective Abs-
Traction ,
Unifr-
Ames
& The
Formulation
Of Generalizations*
The Journal of Mathematical
Behaviour, Vol.23, 2, 205-22
Elsevier, Amsterdam 2004

ST-CYR, O. & BURNS, C.M.
Mental Models & The
Abstraction
Hierarchy:
Assessing
Ecological
Compatibility
The Proceedings Of The Human
Factors & Ergonomics Society
Annual Meeting, V.1, 297-301
HFES--Sage Online Pubs 2001

STEDMAN, J.M. Et al
Considerations of Maritain's
Three Degrees of
Abstraction As
A Solution
To Boundary
& Philosophical
Problems Within The
Psychology of Religion
Contemporary Philosophy,
Boulder, Vol. 17, N.3, 20-28
Realia Publications Ltd 1995

STEINHARDT, L.
Children
In Art
Therapy
As Abstract
Expressionist Painters
American Journal of Art
Therapy, Vol.31, No.4, 113
American Art therapy Assn 1993

STEWART, I. Et al
Generating Deriv-
Ed Relational
Networks
Via The
Abstra-
Ction
Of
Co-
Mmon
Physical
Properties: A
Possible Model Of
Analogical Reasoning
Psychological Record,
Volume51, No.3, 381-408
Springer-Verlag, Berlin 2001

STEWART, S.
Abstraction Set
Textual Practice,
Vol.28, No.7, 1245-48
Taylor & Francis, London 2014

STIMSON, B.
For The
Love
Of
Abst
-Raction
Third Text,
Vol.22, No.5, 639-650
Taylor & Francis, London 2008

STOTTS, D.B.
*The Usefulness Of
Icons On The
Computer
Inter-
Fa-
Ce:
Eff-
Ect Of
Graphical
Abstraction
& Functional
Representation On
Experienced & Novice Users*
<u>Proceedings Of The Human
Factors & Ergonomics Society
Annual Meeting</u>, Vol.1, 453-57
HFES Pubs, Santa Monica, 1998

STRATHEM, M.
*Virtual
Society?
Get Real!
Abstraction &
Decontextualization:
An Anthropological
Comment Or:
E For Ethn-
Ography*
<u>Cambridge
Anthropology</u>,
Volume 22, No. 1, 52-66
Berghahn, Oxford & N.York 2001

STUDER, T. & HUBNER, R.
*The Direction of Hemispheric
Asymmetries For Object
Categorization
At Differ-
Ent Le-
Vels
Of
Ab-
Str-
Action
Depends
On The Task*
<u>Brain & Cognition</u>,
Volume 67, No.2, 197-211
Elsevier Pubs, Amsterdam 2008

STURSBERG, O.
*Supervisory Control Of
Hybrid Systems
Based On
Model
Abstraction
& Guided Search*
<u>Nonlinear Analysis: An
International Multidisciplinary
Journal</u>, Vol.65, No.6, 1168-87
Elsevier Pubs, Amsterdam 2006

SUGINO, Y.
With Abstraction of Defect's Characters, Defect's Measurements & Class- Ificat- Ion- In- Tell- Igent Inspection System (PMAX)
Japan Tappi Journal,
Volume 55, No.9, 33-36
Kami Paupu Gijutsu Kyokai 2001

SUIT, V.
A Turn Towards Realism: Embroidery Artist B.J. Adams Reached A Turning Point In Her Work - From Bold Abstraction To Delicate Realism – When She Created A Memorial Quilt For The Children Killed In The Oklahoma City Bombing
Fiberarts,
Vol.27,
No.3,
34-38
Altamont
Press Publns
California US 2000

SULLIVAN, K.
Abstractio -N, Ani -Mat -Io -N ,M U -Sic Com -Puter G -Raphics, Volume 35, Number 3, 3-5
ACM, New York 2001

SUMPTER, H.
Catherine Yass Wrestles With Abstraction & Representation In Her Luminous Photo-Works
ArtReview, April Issue, 56-57
ArtReview Ltd, London 2002

SUNDER, S.
Economic Theory: Struct- Ural Abs- Tract -Ion Or Behaviour -Al Reduction?
History of Political Economy, 38, Supp, 322-42
The MIT Press, Cam. Mass 2006

SUTHERLAND, T.
*Clocks, Calendars
& Temporal
Abstraction*
Time & Society,
Vol.22, No.3, 410-414
Sage, Thousand Oaks, CA 2013

SYLVESTER, C.
*Art, Abstraction
& Intern-
Ational
Relations*
Millenium, 30, 3, 535-54
MPG/LSE London 2001

TABET, M.
*Minimalism
& Abstr-
Action
In Arc-
Hitecture*
Techniques Et
Architecture, 423, 66-69
Altedia Commns. Paris 1995

SUTHISUNG, N. Et al
*The Students' Process
Of Abstraction
Based On
Action
In Co-
Mpr-
Es-
S-
Io-
N
To
Thin-
Kable
Concept
Blending
Embodiment
& Symbolism
Under Context
Using Lesson Study
And Open Approach*
Psychology of Mathematics
Education Conference,
Volume 35, No. 1,
1-505, IGPMA
Ankara
2011

TABOR, W. Et al
*Birth of An Abstraction:
A Dynamical Systems
Account of The
Disco-
Very
Of
An
Else-
Where
Principle
In a Catego-
Ry Learning Task*
Cognitive Science,
Volume.37, No.7, 1993
John Wiley & Sons, Hoboken 2013

TAHINCI, A.F.
*Breaking The
Tradition:
Early
Paris
Avant
-Gardes
From Figure
To Abstraction*
Sculpture Review,
Volume.55, No.3, 16-23
National Sculpture Society
Varick St, New York City 2006

TAKEZAWA, N. Et al
*A Study on Abstraction
Of Music Char-
Acteris-
Tics
Using
Wavelet
Transforms*
The Journal of The
Visualization Society Of
Japan, Vol. 20, No.1, 301-02
Springer-Verlag, Berlin 2000

TAPLIN, R.
*Contemporary Climate
Change
Art
As
The
Abs-
Tract
Machine:
Ethico-Aesthetic
& Futures Orientation*
Leonardo, 47, 5, 509-10
MIT Press, Cam. Mass 2014

TARIS, T.
*Describing Behaviours of Self &
Others: Self-Enhancing
Beliefs &Language
Abstraction Level*
European Journal
Of Social Psychology,
Vol.29, No.2-3, 391-396
John Wiley & Sons, Hoboken 1999

TE'ENI, D.
& SANI-KUPERBERG, Z.
*Levels of Abstraction
In Designs Of
Human-
Comp
-Uter
Inter
-Action
:The Case
Of E-Mail*
Computers In
Human Behaviour,
Volume 21, Number 5, 817-30
Elsevier Pubn, Amsterdam 2005

TERRAILLON, J. & GALLE, J.
The HOORA Method:
The Bridge B-
Etween
UMC
Abs-
Tr-
A
Ct-
Ion
& Ha-
Rd Real
Time Reality
European Space
Agency, V. 447, 237-44
ESA Pubs, Harwell Herts1999

THEODORAKIS, M. Et al
Contextualization As
An Abstraction
Mechanism
For Con-
Cept-
Ual-
M-
Od-
Elling
Journal On
Data Semantics,
Number 1728, 475-489
Springer-Verlag, Berlin 1999

THOMAS, B.M.
Abstraction & The Real
Distinction Between
Mind & Body
Canadian
Journal
Of Phi
-Losophy,
Volume 25, No.1, 83
University of Calgary Press 1995

THAKUR, A.K. & OJHA, C.S.
Variation of Turbidity During
Subsurface Abstraction
Of River Water:
A Case
Study
Inter-
Nation-
Al Journal
Of Sediment
Research, Vol.25, No. 4, 355-65
Elsevier Pubs, Amsterdam 2010

THOMAS, M.
An Abstraction of Feeling:
Mark Rothko &
The Sub-
Ject
Of
Aes-
Thetic
Judgement
Australian & New
Zealand Journal of Art,
Volume 3, No.1, 97-116
ANZ Art Assn, Sydney 2002

TIAN, L. Et al
Chinese Word Segmentation
With Character
Abstraction
Journal on
Data Semantics,
Number 8202, 36-43
Springer-Verlag, Berlin 2013

TIERNEY, T.
Formulating A-
Bstraction:
Concep-
Tual
Art
&
The
Architectural Object
Leonardo: International
Journal Of Contemporary
Art, Vol.40, No.1, 51-58
MIT Press, Cambridge
Massachusetts 2007

TIPLEA, F.L. &
ENEA, C.
Abst-
-Act
-Io
N
Of
Dat
-A Types
Acta Info
Rmatica, Vol.
42, N. 8-9, 639-71
Springer, Berlin 2006

TOFTS, D.
Driven To
Abstr
-Act
-Io
-N
M
-Ea
-Njin,
Volume 58,
Number 2, 6-16
University of Melbourne 1999

TOKLEY, M. & KEMPS, E.
*Preoccupation With Detail
Contributes To Poor
Abstraction In
Women
With
An-
O-
Rex-
Ia Ne-
Rvosa*
Journal
Of Clinical
& Experimental
Neuropsychology,
Vol.29, No.7, 734-741
Taylor & Francis, London 2007

TORREANO, L.A. Et al
*When Dogs Can Fly? Level
Of Abstraction As A Cue
To Metaphorical
Use of Verbs*
Metaphor
 & Symbol,
Vol.20, 4, 259-74
Lawrence Erlbaum Pubs
Mahwah, New Jersey 2005

TOPPINO, T.C. Et al
*About Practice:
Repetition,
Spacing
& Ab-
Stra-
Cti-
On*
The Psychology Of Learning
& Motivation - Advances In Re-
Research & Theory,Vol. 60, 113
-90, Elsevier, Amsterdam 2014

TORSEN, I.
*What Was
Abstract Art?
(From The Point
of View of Heidegger)*
The Jrnl of Aesthetics & Art
Criticism, Volume 72, No.3, 271
John Wiley & Sons, Hoboken 2014

TOSCANO, A.
Beyond
Abstr-
Action:
Marx &The
Critique of The
Critique of Religion
Historical Materialism,
Volume.18, Issue 1, 3-30
Brill, Leiden Netherlands 2010

Materialism
Without
Matter:
Abstr
-Act
-Io
N
,A
-Bse
Nce &
Social Form
Textual Practice
:How Abstract Is It?
Thinking Capital Now
Volume 28, 7, 1221-1240 2014

The
Culture
Of Abstraction
Theory, Culture & Society,
Volume 25, Number 4, 57-76
Sage Publications, London 2008

The Open Secret
Of Real
Abstr
-Act
-Io
-N
R
-Et
-Hin
-King
Marxism
Volume 20,
No. 2, 273-287
Taylor & Francis,
United Kingdom 2008

The Sensuous Rel-
Igion Of The
Multit-
Ude:
Art
&
Ab
-Sra
-Ction
In Negri
Third Text,
Vol.23, No.4, 369-82
Taylor & Francis, UK 2009

TOSHIMA, H. & YONEDA, T.
Efficient Verification By
Exploiting Symmetry
& Abstraction
Systems &
Computers in Japan,
Volume 32, No.14, 41-53
J. Wiley & Sons, Hoboken NJ 2001

TREUR, J. Et al
Specification Of
Interlevel
Relat-
Ions
For
Ag
-Ent
Mod
-Els In
Multiple
Abstraction
Dimensions
Journal on Data Se
-Mantics, 6704, 542-55
Springer-Verlag, Berlin 2011

TRIGG, S.
Introduction: Emotional
Histories-Beyond The
Personalisation Of
The Past & The
Abstraction
Of Affect
Theory
Exemplaria,
Vol. 26, No. 1, 3-15
Maney, Leeds 2014

TRACHTMAN, P.
Back To The Figure:
Rather Than
Choosing
Between
Abstraction
& Representation,
Contemporary Artists Are
Embracing Both & Creating
Something New In The Process
Smithsonian, 38, No.7, 100-111
The McLaughlin Group 2007

TSAMIR, P. & DREYFUS, T.
Comparing Inf-
Inite Sets:
A Proc
-Ess
Of
Abst
-Raction
The Journal
Of Mathematical
Behaviour, V.21, 1, 1-23
Elsevier Pubs, Amsterdam 2002

TUOMI, I. Et al
*Abstraction &
History:
From
Ins-
Ti-
Tut-
Ional
Amnesia To
Organisationll Memory*
Hawaii International Prcdngs:
Conference On System Sciences
Volume 28, Number 4, 308-12
IEEE Digital Journals 1995

TURNER, K.J.
*Abstraction &
Analysis Of
Clinical
Guidance Trees*
Journal of Biomedical
Informatics, 42, 2, 237-250
Elsevier Pubs, Amsterdam 2009

TURVEY, M.
*Dada Between Heaven &
Hell: Abstraction
& Universal
Langu-
Age
In
The
Rhythm
Films Of
Hans Richter*
October, Vol.105, 13-36
MIT Press, Cam. Mass. 2003

UENO, A. Et al
*Learning of The
Way Of
Abstraction
In Real Robots*
IEEE Inter-National
Conference On Systems,
Man & Cybernetics, 2, 746-751
IEEE On-Line Journals 1999

UM, N.A.
***Asian Traditions/Modern
Expressions: Asian
American Art-
Ists & Abs-
Traction,
1945-1970,***
Jeffrey Wechsler
Americanasia Journal,
Volume 25, No.3, 217-218
University Of California 2000

UNGURU, S.
Peter Damerow,
Abstraction And
Representation:
Essays on
The
Cul-
Tural
Evolution
Of Thinking
Isis, Vol. 91, No. 2, 430
University of Chicago Press 2000

VALMARI, A. Et al
Compos-
Ition
& Abs-
Traction
Journal on Data
Semantics, 2067, 58-98
Springer-Verlag, Berlin 1999

URCELAY, G.P.
& MILLER, R.N.
On The Generality
& Limits Of
Abstra-
Ction
In Rats
& Humans
Animal Cognition,
Vol.13, No.1, 21-32
Springer, Berlin 2010

VAN BAEL, P. Et al
A Study of Rescheduling Strategies
& Abstraction Levels For
A Chemical Process
Scheduling
Problem
Produ
-Cto

UROFSKY, R. & ENGELS, D.
Philosophy, Moral Philosophy
& Counselling Ethics:
Not An Abstr-
Action
Coun-
Selling
& Values,
Volume 47,
Number 2, 118-130
American Counselling Assn
Alexandria, Virginia USA 2003

-On,
Pla
-Nning
& Control,
Vol. 10, No. 4, 359-64
Taylor & Francis Ltd, UK 1999

VAN DEN BOSCH, A. Et al
Careful Abstraction From
Instance Families
In Memory-
Based
Lan-
Guage
Learning
Journal Of
Experimental &
Theoretical Artificial
Intelligence, 11, 3, 339-68
Taylor & Francis, UK 1999

VAN DER ZWAN, M. Et al
Illustrati
-Ve Molecular
Visualisation With
Continuous Abstraction
Computer Graphics Forum,
Volume 30, Number 3, 683-90
Basil Blackwell, Oxford 2011

VANDERKERCKHOVE, B. Et al
Selective Impairment Of
Adjective Order
Constr-
Aints
As
Over
-Eager
Abstraction:
An Elaboration Of
Kemmerer Et al (2009)
Journal Of Neurolinguistics,
Volume 26, Number 1, 46-72
Elsevier Pubs, Amsterdam 2013

VAN DYKE, J.A.
Christine Mehring,
Blinky Palermo:
Abstraction
Of An
Era
German
Studies Review,
Volume 33, No.2, 464
The German Studies Assn
John Hopkins UP, Baltimore 2010

VAN LANGE, P.A.M.
*What Should We Expect
From Theories In
Social Psyc-
Hology?
Truth,
Abstr-
Action,
Progress
& Applicability
As Standards (TAPAS)*
Personality & Social Psychology
Review, Volume 17, No.1, 40-55
Sage, Thousand Oaks, Cal. 2013

VAN LIERE, E.N. Et al
*A Look At Modernism
From The Key-
Board:
The
Piano in
The Parlour
& Abstract Art*
Analecta Husserliana, 1, 365-78
Kluwer Academic, Boston 2000

VAN NUFFEL, D. &
DE BECKER, M.
*Multi-Abstr-
Action
Lay-
Er-
Ed
Bus-
Iness
Process
Modelling*
Computers in Industry,
Volume 63, No.2, 131-147
Elsevier Pubs, Amsterdam 2012

VAN SMAALEN, J.W.N.
*Spatial
Abstr-
Action
Based On
Hierarchical
Re-Classification*
Cartographica, 33, 1, 65-74
University of Toronto Press 1996

VERE, B.
*Oversights in Overseeing Mode-
Rnism: A Symptomatic
Reading Of Alfred
H.Barr's
'Cub-
-Is
M
&
Abs
-Tract
Art' Chart*
Textual Practice,
Volume 24, 2, 255-286
Taylor & Francis Ltd, UK 2010

VERELST, J.
*The Influence
Of The Level of
Abstraction on The
Evolvability Of Conceptual
Models of Information Systems*
Empirical Software Engineering,
Volume 10, Number 4, 467-94
Springer-Verlag, Berlin 2005

VERHULST, P.
*Spatio-Geographical Abstraction
In
Sa-
Muel
Beckett's
Not-I/Pas-Moi*
English Text Construction,
Volume 1, Number 2, 267-280
John Benjamins Journals 2008

VIDLER, A.
*Diagrams Of
Diagrams:
Archit-
Ectu-
Ral
A-
Bs-
Tra-
Ction
& Modern
Representation*
Representations, No.72, 1-20
California UP, Berkeley 2000

VOLSIK, P.
*Abstr-
Act-
Ion
W
-Or
-D &
Image:
A Journal
Of Verbal/
Visual Enquiry*,
Volume 11, No.2, 120
Taylor & Francis, UK 1995

VON HELVERSON, B. Et al
*Do Children Profit From
Looking Beyond
Looks?
From
Sim
-Ila
-R
-It
-Y
Ba
-Sed
To Cue
-Abstract
Ion Processes In
Multiple-Cue Judgements*
Developmental Psychology, Vol
46,1,220-29APA,Washgtn 2010

WACHSMUTH, D. Et al
Between Abstraction
& Complexity:
Meta-The-
Oreti-
Cal
Obs-
Ervat-
Ions On
The Asse-
Mblage Debate
City: Analysis Of Urban Trends, Culture, Theory, Policy, Action, Volume 15, No.6, 740-50
Taylor & Francis Pubs UK 2011

WAHLBERG, M.
Wonders of Cinematic Abstraction
J.C. Mol & The Aesthetic
Experience of
Science
Film
Screen, Volume 47, No. 3, 273-90
Oxford University Press Pub 2006

WALKER, G. Et al
Film Art & Film:
Towards The
Function
Of Abs-
Trac-
Tio-
N
Cornell Uni. East Asia Series, 168, 114-124, Ithaca, NY 2013

WALLIS, S.E.
Abstraction & Insight:
Building Better
Conceptual
Systems
To Sup-
Port
Mo-
Re
Ef-
F-
Ec-
Tiv-
E S-
Ocial
Change
Foundations Of Science,19, 4, 353-62
Springer-Verlag, Berlin 2014

WALTER, S. Et al
The Synchronization
Of Plan Activations &
Emotion-Abstraction
Patterns in The
Psycho-
The-
Rapeu-
Tic Process:
A Single-Case Study
Psychotherapy Research, Volume 20, No.2, 214-223
Taylor & Francis, UK 2010

WANG, F.Y.
On The Abstraction Of
Conventional
Dynamic
Syst-
Em-
S:
Fr-
Om
Num-
Erical
Analysis To
Linguistic Analysis
Information Sciences,
Vol.171, No.1-3, 233-259
Elsevier, Amsterdam 2005

WANG,
G-J. Et al
Formation
Of Abstraction
Hierarchies Based on
Definitional Hierarchy
Jinko Chino Gakkai-shi,
Vol.10, No.1, 114
Japanese
Society For
Artificial Intelligence
University of Arizona 1995

WANG, l-G. Et al
Abstraction
Of Hard-
Ware
Con
-Str
-U
-Ct
-Ion
Jour-
Nal On
Data Sem-
Antics, 1074, 264-87
Springer-Verlag, Berlin 1996

WANG, J.
Net-
Work-
Layer
Abstraction &
Simulation of Vehicle
Communication Stack
Wireless Networks,
Number 21, 709-25
Springer-Verlag,
Berlin 2015

WANG, W. & WHANG, D.
Abstraction Assistant:
An Axiomatic Text
Abstraction
System
Journal of
The American
Society For Information
Science And Technology,
Volume 61, No. 9, 1790-1799
J.Wiley & Sons, Hoboken NJ 2010

WANG, W. Et al
*Trace Abstraction
Refinement
For Tim--
Ed A-
Ut-
O-
M-
At a
Lectu-
Re Notes
In Computer
Science,* 8837, 396-410
Springer-Verlag, Berlin 2014

WARD, F.
*Modernism's
Masculine Subjects:
Matisse, The New York School &
Post-Painterly Abstraction*,
By Marcia Brennan
GLQ, 12, 2, 335-7
Duke U Press,
Durham
2006

WARD, T.B. Et al
*The Role Of
Spec-
Ific -
Ity
&
Abst-
Raction
In Creative
Idea Generation*
Creative Research Journal, Vol. 16, N.1, 1-9
L. Erlbaum, Mahwah NJ 2004

WANG, Y. Et al
*Abstraction Of
Complex
Conc-
Epts
Wi-
Th
A
Re-
Fin-
Ed Part-
Ial-Area Taxo-
Nomy of SNOMED*
Journal Of Biomedical Informatics, Vol 45, 1, 15-29
Elsevier Pubs, Amsterdam 2012

WARREN, E. & COOPER, T.J.
Developing Mathematics
Understanding &
Abstraction:
The Case
Of Equi-
Valence
In The Ele-
Mentary Years
Mathematics Education
Research Jrnl, 21, 2, 7 6-95
Springer-Verlag, Berlin 2009

WATT, S.E. Et al
Functions of Att-
Itudes Towar-
Ds Ethnic
Groups:
Effects
Of Lev-
El of Ab-
Straction
Journal Of
Experimental
Social Psychology,
Volume 43, 3, 441-49
Elsevier Pub. Amsterdam 2007

WAVRICK, J.J.
Code
Size,
Abs-
Traction
& Factoring
Forth Dimensions,
Volume 12, Number 2, 25
Forth Interest Group US 1995

WEBER, N.F.
A Never-Ending Embrace:
A Visit To Montparn-
Asse Prompts A
Reflection
On The
Refined
Abstract
Ion & Compl
-Ex Romance Of
Brancusi's, ***The Kiss***
Art News, Vol.112, No.1, 54
ANSS, West St, New York 2013

WEIGEL, C.
Distance, Anger,
Freedom: An
Account
Of The
Role
Of
Abs-
Tract-
Ion In Co-
Mpatibilist &Inc-
Ompatibilist Intuitions
Philosophical Psychology, Vol.
24, 6, 803-23, T & F, UK 2011

WELLING, H.
Cerebellar Creativity: A Bstraction Of Mental Movements
Creativity Research Journal, Vol.19, 1, 55-57
L. Erlbaum, Mahwah NJ 2007

Four Mental Operations in Creative Cognition: The Importance Of Abstr-Action
Creativity Research Journal, Vol.19, 2-3, 163-177
L. Erlbaum, Mahwah NJ 2007

WHITE, J.
From Documents To User Inter Faces – Universal Design In The Emergence Of Abstraction
Australasian Journal Of Information Systems, 12, 66-74
University of Wollongong 2004

WHITE, M.
'Dreaming In The Abstract': Mondrian, Psychoanalysis & Abstract Art In The Netherlands
The Burlington Magazine, Vol.148, No.1235, 98-106
The Burlington Magazine Publications London 2006

WHITE, M. & SCHEUNEMANN, D.
Abstraction, Sublation & The Avant-Garde: The Case Of De Stijl
Avant-Garde Critical Studies, Issue 17, 77-90
Rodopi BV, Amsterdam 2004

WHITMAN, D.G.
*The Rules
Of Ab-
Stra-
Ction
The Rev-
Iew Of Austrian
Economics,* 22, 1, 21-41
Springer-Verlag, Berlin 2009

WIGGINS, G.
*Cue Abstraction, Paradog-
Matic Analysis & Infor
Mative Dynamics:
Towards Music
Analysis By
Cognitive
Model*
Musiciae Scientiae, 14, 307-32
ESCSM Sage Thous. Oaks 2010

WILSON, J.
*'Participation T.V.':
Early Games,
Video Art,
Abstr-
Acti-
On
&
The
Problem
Of Attention*
Convergence, Volume 10, No. 3
83-101, Luton University 2004

WINNEMOLLER, H. Et al
*Real Time Video
Abstraction*
ACM Tra
-Nsactions
On Graphics,
25, 3, 1221-2126
ACM Internl. New York 2006

WINTERS, A.M.
*The Evolutionary
Relevance O
-F Abstr
-Act
-Io
-N
&
R
-Ep
-Rese
Ntation*
Biosemiotics,
Vol. 7, No.1, 125-39
Springer-Verlag, Berlin 2014

WINTERS, N.
& MOR, Y.
Dealing With
Abstraction:
Case Study
General-
Ization
As A
Me-
Th-
Od
For
Elic-
Iting
Design
Patterns
Computers In
Human Behaviour,
Volume 25, No. 5, 1079-88
Elsevier Pubs, Amsterdam 2009

WINTHER, R.G.
Character
Analysis In
Cladistics
:Abstraction,
Reification & The
Search For Objectivity
Acta Bibliotheoretica,
Vol.57, 1-2, 129-62
Springer-Verlag,
Berlin 2009

WISSENBERG, M.
What is Water?
The His-
Tory
Of
A
Modern
Abstraction
Environmental Politics,
Volume 22, No. 2, 356-358
Taylor & Francis, UK 2013

WITHANA, E.C. & PLALE, B.
Sigiri: Uniform Resonance
Abstraction For
Hybrids
& Clouds
Concurrency
& Computation:
Practice & Experience,
Volume 24, No.18, 2632-2680
J. Wiley & Sons, Hoboken NJ 2012

WITT, A. & VINTNER, A.
Artificial Grammar Learning
In Children: Abstraction of
Rules Or Sensitivity
To Perceptual
Features?
Psych
-Ol
-O
-Gi
-Cal R
-Esearch,
Volume 76,
Number 1, 97-110
Springer-Verlag, Berlin 2012

WITTEK, R.
Arthur L. Stinchc-Ombe,
When For Ma-Lity Works: Authority & Abstraction In Law & Organisations
The British Journal Of Sociology, Vol.53, 4, 698-700
Routledge Publns, London 2002

WITTMAN, R.
Architecture, Space & Abstr-Act-Ion In The 18th Century Public Sphere
Representations, Vol. 102, 1-26
California UP, Berkeley, 2008

WOLF, P.
Socio-Cultural Differe-Ntiation, Abstrac-Ction & The Evolution Of The Lite-Ary-Sys-Te M In Early Modern England: A Functional View
European Journal of English Studies, Vol. 5, Part 3, 303--20
Swets & Zeitlinger, London 2001

WOLLAEGER, M.
D.H. Lawrence & The Technological Image: Modernism, Reference & Abstraction in **Women in Love**
English Language Notes, Vol.51 No.1, 75-92, Colorado Un. 2013

WOO, Y.
*Abstraction of Mid-Surfac-
Es From Solid Mod-
Els Of Thin-
Walled
Par-
Ts:
A
Di--
Vide
& Conqu-
Er Approach*
Computer Aided Design, l, 47 1-11
Elsevier Journals Amsterdam 2014

WOOD, T.
*Abstraction
& Adherence in
Discourse Processes*
Journal Of Pragmatics,
Volume 4, No.3, 484-496
Elsevier Pubs, Amsterdam 2009

WOODS, B.
*Making Connections: Movi-
Ng From Representat-
Ion To Objective
Abstraction
In Water
-Col
-Ou
-R*
The
Artist,
Number 906, 42-45
King's Road, SW London 2006

WOODTHORPE, K.
Kate Cregan,
**The Sociology of
The Body: Mapping The
Abstraction of Embodiment**
Sociology, Vol.41, No.3, 587-88
Cambridge University Press 2007

WOOLF, J.
*Switzerland: Two Sensitively
Designed Village
Houses By
Vale
-Rio
-Ol
-G
-Ia
Ti
&
Ma
-Rtin
- Pedr
-Ozzi R
-Epresen
-T Abstrac
Tions Of The
Old* Architecture
Today, 186, 20-6, London 2008

WORDEN, D.
The Politics of Comics: Popular Modernism, Abstraction & Experimentation
Literature Compass, Volume 12, No.2, 59-71
Basil Blackwell, Oxford 2015

WRIGHT, C. Et al
The Metaphysics & Epistemology Of Abstraction
Publicat-
Ions
Of
The
Ludwig
Wittgenstein Society
Volume 11, 195-216
Ontos Publishers Ltd
Heusenstamm 2009

XUAN, Z-F.
Concrete Images-Abstraction-Concrete Images: A Psychological Process In Translation
Journal – Shangqui Teacher's College, Vol. 25, No. 4, 124--32
Shangqui, Henan Province 2009

YAMADA, A. & TSO, T-Y.
The Role of Specific Transformation Process of Solver's Problem Representation During Problem Solving: A Case Of Abstraction/Concretization
PME -- Conference 36 Van.
Volume 4, Number 4-332
International Group Fo
-R The Psychology
Of Mathematic
- S Educatio
-N 2012

YAMAZAKI, Y. Et al
Sequential Learning & Rule Abstr -Action In Benga Lese Finches
Animal Cognition, Vol.151, No.3, 369-77
Springer-Verlag, Berlin 2012

YAN, W. Et al
Matching of Different Abstraction Level Knowledge Sources: The Case Of Inventive Design
Journal on Data Semantics, 6884 445-54, Springer, Berlin 2011

YANG, Y-Q, Et al
Minimal Data Dependence: Abstractions For Loop Transformations
Journal on Data Semantics, No.892, 201
Springer-Verlag, Berlin 1995

YE, N. Et al
Expert-Novice Knowledge Of Computer Programming At Different Levels of Abstraction
Ergonomics, Vol. 39, 3, 461-81
Taylor & Francis Pub, UK 1996

YOSHIDA, H. & SMITH, L.B.
Known & Novel Noun Extensions: Attention At Two Levels Of Abstraction
Child Development, Volume 74, No.2, 564-577
Basil Blackwell, Oxford 2003

YOUNG, J. & NORMAN, K.
Imagining The Source: The Interplay Of Realism & Abstraction In Electro-acoustic Music
Contemporary Music Review, Volume 15, No.1/2, 73-94
Harwood Publishing
Amsterdam
1996

YOUNG, M.D.
Designing Water Abstraction Regimes For An Ever-Changing & Ever-Varying Future
Agricultural Water Management, Volume 145, 32-8
Elsevier Pubn, Amsterdam 2014

ZEIGLER, B.P. & SISTI, A.F.
Review
Of
Th
-Eor
-Ry In
Model
Abstraction
SPIE Proceedings 3369, 1, 2-13
SPIE, Washington DC US 1998

ZEITOUN, M. Et al
Asymmetric Abstraction & Allocation: Israeli-Palestinian Water Pumping Record
Ground Water, 47, 1, 146-60
Basil Blackwell Oxford 2009

ZEITZ, C.M.
Expert-Novice Differences In Memory, Abstraction & Reasoning In The Domain of Literature
Cognition & Instruction, Volume 12, Number 4, 277
L. Erlbaum, Mahwah NJ 1994

ZENG, H.W.
Deadlock Detection Using Abstr -Action Refinement
Journal, Shanghai University, Vol. 14, 1, 1-5
Shanghai University Press 2010

ZHANG,
D-G.
Et al
New
Cha-
Racter -
Abstraction
Method Based On
Generalization & Reduction
Northeastern University Journal
Natural Science, V.25, 6, 550-4
NUJNS Boston,Mass. US 2004

ZHANG,
H. Et al
Analyzing
Emotional
Semantics Of
Abstract Art Using
Low-Level Image Features
Journal on Data Semantics,
No. 7014, 413-23
Springer-
Verlag,
Berlin
2011

Degree Centrality For Semantic
Abstraction Summarization
Of Therapeutic
Studies
Jour-
Nal
Of
Bio-
Medical
Informatics,
Vol.44, No.5, 830-38
Elsevier Jrnls, Amsterdam 2011

ZHANG, J. Et al
Ontology-Driven
Induction Of
Decision
Trees At
Multip
-Le Le
V*els*
Of
A
-Bs
-Tra
Ction
Journal
On Data
Semantics,
2371, 316-23
Springer, Berlin 2002

ZHAO, S.
Line Drawings:
Abstraction
From
3-D Models
Journal on Data
Semantics, 6530, 104-11
Springer-Verlag, Berlin 2011

ZHIYI, Z.
*Preliminary
Discussion On
The Theory Of Abst-
Raction & Object In The
Chinese Classical Garden*
Journal of Anhui Agricultural
Sciences, V. 26, N.6, 187, 1655
Anhui Agricultural Academy 2007

ZILLES, S. & HOLTE, R.C.
*The Computational Complexity
Of Avoiding
Spurious
Stat-
Es
I-
N
State
Space
Abstraction*
Artificial Intelligence,
Vol.174, No.14, 1072-92
Elsevier Pubs, Amsterdam 2010

ZHOU, C.
Et al
*Abstr-
Action For
Model Checking
Multi-Agent Systems*
Frontiers of Computer Science
In China, Volume 5,
Number 1, 14-25
Springer-
Verlag
Berlin
2011

ZHOU, C.W. Et al
*Rate Constants
For Hydrogen
Abstraction By
H2 From N-Butanol*
International Journal Of
Chemical Kinetics,
44, 3, 155-64
Wiley Pubn,
Hoboken
NJ 2012

ABBOTT, R.
*Abstraction,
Emerg
-Ence
And
Thought*
Journal on Data
Semantics, 4612, 391-92
Springer-Verlag, Berlin 2007

ABDULLA,
P.A. Et al
*Monotomic
Abstraction In
Paramaterized Verification*
<u>Electronic Notes In Theoretical
Computer Science</u>, 223, 3-14
Elsevier Pubs, Amsterdam 2008

*Verification Of
Infinite-State
Systems By
Combining
Abstraction &
Reachability Analysis*
<u>Journal on Data Semantics</u>,
No. 1633, 146-59
Springer-
Verlag
Berlin
1999

ACHIRON, R.
*The Art of Ultrasound In
Obstetrics:
From
Abstraction
To Hyper-Realism*
<u>Ultrasound In Obstetrics & Gy-
Naecology</u>, Volume 61, No.1, 1
Parthenon, Nashville USA 1995

ADAJIAN, T.
*Subjects &
Objet-
Ts :
Art,
Essen-
Tialism
& Abstraction*
<u>The British Journal of
Aesthetics</u>, 48, No.3, 356-7
Oxford University Press 2008

ACERON, W.N.
*Outlooking: Notes & Drafts
On Abstraction
& Memory*
<u>Analecta
Husserliana</u>,
Vol. 79, 363-372
Kluwer Academic, Boston 2004

ADAMOWICZ, E.
D. Reynolds,
Symbolist
Aesth-
Etics
& Early
Abstract Art
French Studies,
Volume 53, No.1, 85
Society For French Studies
Oxford University Press 1999

ADAMS, B.
Philip Taaffe: Found Abstraction
Repeated Motifs Drawn
From Myriad
Historical
Sources
Mark
The
Art-
Ist's
Gran-
D-Scale
Painterly
Canvases
Art in America,
Vol.90, No.6, 116-19
Brant Publications, N. York 2002

AITKEN, W. &
BARRETT, J.
Abstraction in
Algorithmic Logic
Journal of Philosophical
Logic, No.37, No.1, 23-43
Springer-Verlag, Berlin 2008

ALBERT, E. Et al
Abstraction-
Carry-
Ing
Code
:A Model
For Mobile
Code Safety
New Generation
Computing, V.26, 2, 171-204
Springer-Verlag, Berlin 2008

ALDEA, A.S.
Husserl's Break
From Brentano
Reconsidered:
Abstraction &
The Structure Of Consciousness
Axiomathes, V. 24, 3, 395-426
Springer-Verlag, Berlin 2014

ALPERT, S.R.
Abstraction In Concept Map &
Coupled
Outline
Knowledge
Representations
Journal Of Interactive Learning
Research, Vol.14, No.1, 31-50
JILR/Copernicus, Gottingen 2003

AMADA, I.
Laser Flash Photolysis Studies
Oh Hydrogen Atom Absence
From Phenol By Triplet
Naphthoquinon-
Es In Acet-
Onit-
Rit-
E
Fa
Ra-
Day
Trans
Actions:
Journal Of The Chemical Soc.
Volume 91, Number 17, 2751
Burlington Hse, Piccadilly 1995

ANALYTI, A. Et al
Contextualiztion As
An Independent
Abstraction
Mecha-
Nism
For
Co-
N-
Ce-
Ptual
Modelling
Information Systems,
Volume 32, No.1, 24-60
Elsevier, Amsterdam 2007

ANAND, S. ET al
Symbolic Execution
With Abstraction
International
Journal on
Softw-
Are
Tools
For Tech-
Nology Transfer,
Vol. 11, No.1, 53-67
Springer-Verlag, Berlin 2009

AMIN, K. Et al
An Abstraction
Model For
A Grid
Exec-
Uti-
On
Fr-
A-
Me-
Work
Journal
Of Systems
Architecture,
Vol.52, No.2, 73-87
Elsevier, Amsterdam 2006

ANDREW, N.
Dada Dance:
Sophie
Taeuber's
Visceral Abstraction
Art Journal, 73, 1, 12-29
Taylor & Francis Ltd, UK 2014

ANGIUS, N.
Abstraction
/Idealization
In The Formal
Verification Of
Software Systems
Minds And Machines,
Volume 23, No.2, 211-226
Springer-Verlag, Berlin 2013

ANON
Annual Review of International
Architecture: Abstraction
Creates Simple,
Sensitive
Buildings
In Even The
Most Remote Sites
Architecture, 87, 10, 95
BPI Comm., Michigan US 1998

ANON
Design Dept Round-Up: In
Europe, Leading De-
Sign Program
Mes Are
Aban
-Don
Ing
Ab
-St
-Act
-Ion &
Embra
-Cing The
Real World
Metropolis, 23,
Number 1, 108-11
Bellerophon, New York 2003

ANON
Early Warning
Abstraction:
The Mea-
Sure of
Strat-
Egic
Power
Defence
& Foreign
Affairs Strate
gic Policy, 30, 12, 2
International Strategic Studies
Association, Washington 2002

ANON
*Letter
To Abs-
Traction
(Each Horse...)*
The Literary Review,
Volume 48, Number 4, 89
Fairleigh Dickinson University
Teaneck, New Jersey, NY 2005

ANON
*Mapping Bamboo Journeys: By
Using Ubiquitous Filipino
Material, Bamboo, Aus-
Tralian Artist Tony
Twigg Draws On
A Convergen-
Ce Of Par-
Allel Ide-
Ntities
To N-
Ull-
Ify
The
Rea-
Ding
Of His
Artwork
As Either
Australian
Or Filipino
But Rather As
A "Journey"
Through The
Language Of
Abstraction*
World Sculpture News, Vol. 9.
2, 38-41 Asian Art Press HK 2003

ANON
*Nicolas de Stael: Figurative &
Abstrait. Le Musée National
D'Art Rend Homage à
Nicolas de Stael Avec
Une Vaste Retro-
Spective. L'
Occas-
Ion
De
Mieux
Comprendre
L'Oeuvre de Cet
Artiste Qui, Le Premier,
Sut Depasser L'Opposition
Entre Figuration Et Abstraction*
Connaissace Des Arts, 603, 32-42
Istra Publications Strasbourg 2003

ANON
*Nitsa
Jaffe
Isr-
Ae
Li
A
-Rt
-Iist
Expl
-EsMi-
Nimalist
Abstraction
In Vessel Forms*
Ceramics Monthly,
Volume 48, Number 3, 55
Professional Publications 2000

ANON
"Thus We See The Ages
As They Appear In
Our Spirits":
Willhelm
Worringer's,
Abstraction
& Empathy"
As Longseller, Or
The Birth of Artistic
Modernism From The
Spirit of The Imagined Other
<u>Journal of Art Historiography</u>,
Number 12-Special June Issue
Department Of History Of Art,
University of Birmingham 2015

ANON
Water Abstraction:
What Price
The
Middle
Eastern Dream?
<u>Water & Environment</u>
<u>International</u>, V.6, 47, 10-13
International Trade Publns 1997

ANTONELLI, G.A.
Notions Of
Invaria-
Ance
Fo-
R
Ab-
Stra-
Ction
Principles
<u>Philosophia</u>
<u>Mathematica</u>, Vol,
18, Number 3, 276-92
University of Toronto Pr 2008

APFELBAUM, P.
Varieties
Of Abs
-Tract
-Io
N
:A
Pa
-Rti
-Al Ta
-Xonomy
<u>Journal of Phi-</u>
<u>Losophy & The Vis-</u>
<u>Ual Arts</u>, Volume 5, 86
Academy Group Publications
Christchurch, New Zealand 1995

APPLIN, J.
Mobile Subjects: Abs-
Traction The Body
And Science In
The Work Of
Bridget Ri-
Iley And
Lilian
E Lijn
<u>Kon</u>
<u>-Sthis</u>
<u>-Torisk</u>
<u>Tidskrift</u>
, Volume 83
, No.2, 96-109
Taylor & Francis, UK 2014

ARBIB, M.A.
From Grasp To Language:
Embodied Concepts
& The Chall-
Enge Of
Abstr-
Act-
Io-
N
Jo-
Urn-
Al Of
Physiol-
Ogy,Vol.102,
Number 1-3, 4-20
Elsevier, Amsterdam 2008

ARCHER, N.P. Et al
Investigating Voice
& Text
Output
Modes With
Abstraction in
A Computer Interface
Interacting With Computers,
Volume 81, Number.4, 323-46
Butterworth-Heinemann Oxf. 1996

ARIELY, D. & NORTON, M.I.
Psychology & Experimental
Economics:
A Gap
In Abstraction
Current Directions
In Psychological Science,
Volume 16, No.6, 336-339
Basil Blackwell, Oxford 2007

ARMSTRONG, J.
The Glorified
Woman:
Abstr-
Acti-
On
&
Do-
Min-
Ation
In *Le Livre*
Du Vois Dit
Romantic Review,
Vol. 102, 1-2, 91-98
Columbia University
New York City, USA 2011

ARORA, R. Et al
Raising The
Level of
Abstraction
For Developing
Message Passing Applications
The Journal of Supercomputing
Volume 59, Number 2, 1079-100
Springer-Verlag, Berlin 2012

ARROITA, M. Et al
Impact of Water
Abstraction
On Storage
& Break-
Down of
Coarse
Organic
Matter In
Mountain Streams
The Science Of The Total
Environment, 503-4, 233-240
Elsevier Jrnls, Amsterdam 2015

ASSILAMEHOU, Y. Et al
How The Linguistic Intergroup Bias Affects Group Perception: Effects of Language Abstraction On Generalisation To The Group
The Journal of Social Psychology: Political, Racial And Differential Psychology, Vol. 153, 1, 98--108
Taylor & Francis Ltd, UK 2013

ASSILAMEHOU, Y. & TESTE, B.
The Effects Of Lingu- Istic Abs- Traction On Evaluation Of The Speaker In An Inter- Group Context: Using The Linguistic Inter- Group Bias M- Akes You A Good Group Member
Journal of Experimental Social Psychology,
Vol.49, No.1, 113-119
Elsevier Pubs, Amsterdam 2013

ATTINELLO, P.
Dialectics of Serialism: Abstract -Ion & -Dec -On -S -Tr Uct -Ion In Schnabel's, Für Stimmen (...Missa Est)
Contemporary Music Review,
Volume 26, Number 1, 39-52
Taylor & Francis, UK 2007

AUTHER, E.
The Decorative, Abstraction & The Hierarchy Of Art & Craft In The Art Criticism Of Clement Greenberg
The Oxford Art Journal,
Volume 27, No.3, 339-364
Oxford University Press 2004

AVNI, G. & KUPFERMAN, O.
When Do -Es Abs -Tract -Ion Help?
Information Processing Letters,
Volume 113, No. 22-24, 901-05
Elsevier Pub, Amsterdam 2013

AVRAAMIDOU, A. Et al
Abstraction Through Game Play
Tech-
Nology
Knowle-
Dge & Le-
Arning Vol.
171, No. 1-2,
1-21 Springer-
Verlag Pub Berlin 2012

BADRINATH, R. Et al
Only Prolonged Time From Abstraction Found To Affect Viable Nucleated Cell Concentrations In Vertebral Body Bone Marrow Aspirate
The Spine Journal, Vol. 14, 6, 990--995
Elsevier Pubn, Amsterdam 2014

BAALEN, P. & KARSTEN, L.
The Social Shaping Of The Early Business Schools In The Netherlands & The Power Of Abstraction
Journal Of Management History, Volume 16, Number 2, 153-173
Emerald Journals, Bradford 2010

BANKS, R. & STEGGLES, L.
An Abstraction Theory For Qualitative Models Of Biological Systems
Theoretical Computer Science, No. 431, 207--218
Elsevier Pubs, Amsterdam 2012

BANN, S.
On Abstract Art
Art Monthly, No.213, 32
Britannia Art Pub, London 1998

BANTINAKI, K.
What is A Picture? Depic-Tion, Realism, Abstraction,
By Michael Newall
Mind, Vol. 123, No. 491, 234
Oxford University Press 2014

BARBARO, P.
Nino Migliori: Between Realism & Abstraction
History of Photography, Volume24, No.3, 209-213
Taylor & Francis, UK 2000

BARBER, M.
Somatic Apprehe-Ension & Ima-Ginative Ab-Straction: Cairns' Critic-Ims of Schutz's Criticisms Of Husserl's Fifth Meditation
Human Studies: A Journal For Philosophy And The Social Sciences,
Volume 33, Number 1, 1-21
Springer-Verlag Pub, Berlin 2010

BARRENA, R. & SANCHEZ, M.
Abstraction & Product Categories As Explan-Atory Var -Ia -B -L Es For Food Consumption
Applied Economics, Volume 44, No.30, 3987-4003
Taylor & Francis Pub UK 2012

Differences in Consumer Abstraction Levels As A Function Of Risk Perception
Journal of Agricultural Economics, Vol. 61, 1, 34--59
Basil Blackwell, Oxford 2010

The Link Between Household Structure & The Level Of Abstraction in The Purchase Decision Proc-Ess: An A -Na -Lysis Using A Functional Food
Agribusiness, Vol.26, 2, 243-64
Wiley & Sons, Hoboken NJ 2010

BARSALOU, L. & SAITTA, L.
Abstraction In
Perceptual
Symbol
Systems
Philosophical
Transactions of The
Royal Society of London,
Series B Biological Sciences,
Vol.358, No.1435, 1177-1188
The Royal Society, London 2013

BASLER, G.R. Et al
Context-Aware
Counter
Abstraction
Formal Methods in System
Design, Vol.36, 3, 223-245
Springer Pubrs Berlin 2010

BATT, G. Et al
Style & Spec-
Tral Power:
Processing
Of Abstract &
Representational Art
In Artist & Non-Artists
Perception, 39, 12, 1659-71
Pion, Brondesbury London 2010

Symbolic
Reach-
Abil-
Ity
A-
Na-
Lys-
Es Of
Genetic
Regulatory
Networks Using
Discrete Abstraction
Automatica, 44, No.4, 982-989
Elsevier Pub, Amsterdam 2008

BECK, D. & LAKEMEYER, G.
Reinforcement
Learning
For
Golog
Programs
With First-Order
State-Abstraction
Logic, Vol.20, No.5, 909-942
Oxford University Press 2012

BENJAMIN, A.
Lines & Colours
:Cezanne's
Abstraction &
Richter's Figuration
Angelika, Vol. 8, 1, 27-42
Carfax Publrs, London 2003

BENNETT, J. & MULLER, U.
The Development Of Flex-
Ibility & Abstract
Ion In Pre-
School
Children
Merrill-Palmer
Quarterly, 56, 4, 455-73
Wayne State UP, Detroit 2010

BERDIT, N.
At The
HeART of
Abstraction:
Reinterpreting A
Well-Known
Symbol
School Arts,
Vol.105, No.6, 36-37
Davis Pub, Worcester MA 2006

BERJEMO, V. & DIAZ, J.J.
The Degree Of Abstraction
In Solving Addition
& Subtr-
Acti-
On
Pro-
Blems
Spanish
Journal Of
Psychology, Vol. 10, 2, 285-93
The Faculty Of Psychology, Co-
Mplutense Univ. Madrid 2007

BERNARD, A.
'Who Would Dare
To Make It
Into An
Abstr
-Act
-Io
N'
:Mo
Urid
Barg-
Houti's,
I Saw Ramallah
Textual Practice, V.
21, Number 4, 665-686
Taylor & Francis Ltd, UK 2007

BERNARD, A.I.
An Onset Is An Onset: Evidence
From Abstraction Of
Newly-Learn-
Ed Pho
-Nota
-Cti
-Co
-N
-Str
Aints
Journal
of Memory
& Language,
Number 78, 18-30
Elsevier Pubs, Amsterdam 2015

BERNARDO, A.B.I.
*Principle Explanation &
Strategic Schema
Abstraction
In Prob-
Lem
So
Lving*
Memory
& Cognition,
Vol.29, 4, 627-33
Psychonomic Society
Madison, Wisconsin 2001

BEWES, T.
*To Think Without Abstraction:
On The Problem of
Standpoint
In
Cul-
Tural
Criticism*
Textual Practice,
Vol.28, No.7, 1199-1220
Taylor & Francis Pub, UK 2014

BETTIS, P.J.
*Ur
-Ban
-Abst
Raction
In A Central
City High School*
The Urban Review,
Vol.28, No.4, 309-336
Eurospan Ltd, London 1996

BHATT, S.
*'India Seems
A Greater
Abstrac-
Tion
To
Me
Than
Europe':
A Conversation
With Rana Dasgupta*
Journal Of Postcolonial
Writing,Vol.42, No.2, 206-11
Taylor & Francis Pub, UK 2006

BEUKEBOOM, C.J. Et al
*When Feelings Speak:
How Affective
& Propr-
Ioce-
Pti-
Ve
C-
Ues
Change
Language Abstraction*
Journal of Language & Social
Psychology, Vol.27, 2, 110-22
Sage, Thousand Oaks CA 2008

BIDNEY, M.
*Neo-Blakean Vision in
The Verse Of E.P.
Thompson:
The
"Abs
Traction"
Of Labour &
Cultural Capital*
Science & Society,
Vol. 68, No.4, 396-420
The Guildford Press, NY 2004

BINFET, T.
*It's All In
Their
Heads:
Reflective
Abstraction As
An Alternative To The
Moral Discussion Group*
Merrill-Palmer Quarterly,
Vol.50, No.2, 181-200
Wayne State UP
Detroit
2004

BING, B. Et al
*Direct Dynamics Studies On
The Hydrogen Abstraction
Reactions CF_3O+CH_4
$(CD_4)CF_3OH$
(CF_3OD)
$+CH_3(CD_3)$*
Journal of Molecular
Structure, 732, 1-3, 225-231
Elsevier Pubs, Amsterdam 2005

BISANTZ, A.M. &
VICENTE, K.J.
*Making The
Abstr-
Action
Hierarchy Concrete*
International Journal of Human
Computer Studies, 40, No.1, 83
Academic Press, Waltham 1994

BLANC, D.
*Jawlensky – Musée De La
Seita: Sur La Thematique
De Tableau-Icone, La
Construction D'
Une Oeuvre
<Mode-
Rne>,
Qui
Co-
Ncilie
L'Abst-
Raction &
La Figuration*
Connaissance Des
Arts, Volume 569, 100-101
Istra Publrs, Strasbourg 2000

BLOMLEY, N. &
STURGEON, J.C.
*Prope
-Rty
As
Abs-
Traction*
International
Journal of Urban
& Regional Research,
Vol.33, No.2, 564-566
Blackwell, Oxford 2009

BLUMB
-ERG, I.M.
*Stealing The
"Parson's Surplice"
/The Person's Surplus:
Narratives of Abstraction
& Exchange in **Silas Marner***
19th Century Literature,
Vol.67, No.4, 490-519
The University Of
California Pr.
Berkeley
2013

BONE, M.
*Capitalist Abstr-
Action & The
Body Pol-
Itics Of
Place in
Tonicade
Bambard's,*
**Those Bones
Are Not My Child**
Journal of American Studies,
Volume 37, Number 2, 229-46
Cambridge University Press 2003

BODEN, M.
*Generaliza-
Tion By
Symb-
Olic
Abs-
Tr-
A-
Ct-
Ion
In Ca-
Scaded Re-
Current Networks*
Neurocomputing, 57, 87-104
Elsevier Pubs, Amsterdam 2004

BOSSE, T. Et al
*A 3-Dimensional Abs-
Traction Frame-
Work To
Compare
Multi-Agent
System Models*
Journal On Data Sem-
Antics, No. 6421, 306-319
Springer-Verlag, Berlin 2010

BOISOT, M. & LI, Y.
*Codification, Abstraction
& Firm Differences:
A Cognitive
Information-
Based Perspective*
Journal of Bioeconomics,
Volume 7, Number 3, 309-34
Springer –Verlag, Berlin 2005

BOULTON, M.
The Politics of Abstraction: The 10th Inter-American Conference, Caracas, Ven. 1954
The Latin Americanist, Volume 52, No.1, 83-94
Blackwell, Oxford 20

BOUREAU, A.
Droit Naturel & Abstraction Judiciaire: Hypotheses Sur La Nature Du Droit Medieval
Annales, 57, 6, 1463-90
Editons De L'Ehess, Paris 2002

BOWMAN, C.F.
Objectifying Motif: With The Motif Windows Library, GUI Developers Can Use Object-Oriented Concepts To Increase Software Abstraction & Thus Decrease Software Complexity
X Journal, Issue 5, 44-53
Sigs Pubs Inc, New York 1999

BOWMAN, H. Et al
Time Versus Abstraction In Formal Description
IFIP Transactions, 22, 467
Elsevier, Amsterdam 1997

BRENEZ, N. Et al
Frankly White, Actualités De L'Abs-Traction Dans La Construction Figurative
Iris Journal, Volume 24, 185-205
IRIS, Birmingham University 1997

BROCKINGTON, L.G.
Thomas B.F. Cummins,
**Toasts With The Incas:
Andean Abstraction &
Colonial Images On
Quero Vessels**
Ethno-
History,
Volume 52,
Number 3, 671-672
Duke UP, Durham US 2005

BROCKMEYER, M.
*Abstraction Relation-
Ships For Real-
Time Spec-
Ificat-
Ions*
Con-
Ference
Publication,
No.210100, 13-22
NASA, Washington 2000

BROWN, A. Et al
*Driven To Abstraction?
Critical Realism &
The Search For
The 'Inner
Conn-
Ect-
Io-
N'
Of
Social
Phenomena*
Cambridge Journal
Of Economics, V.26, 6, 773-88
Oxford University Press 2002

BROWN, J.S. & CARR, T.H.
*Limits on Perceptual Abstraction
In Reading: Asymmetric
Transfer Between
Surface Forms
Differing In
Typicality*
Journal
Of Ex-
Peri
Me -
Ntal
Psycho-
Logy, Vol-
Ume 19, No. 6, 1277
American Psychological Assn.
Clark University Worcester 1993

BROY, M.
*Time, Abstraction, Causality
& Modularity In
Interactive
Systems*
Electronic
Notes in Theoretical
Computer Science, 108, 3-9
Elsevier Pubn, Amsterdam 2004

BUCHANAN, I.
What
Is
Abs-
Traction?
Southern Review,
Vol.30, No.1, 100-102
University of Adelaide 1997

BUCHANAN, P.
Aloof Abstr-
Action:
Museum Of
Contemporary Art
Architecture, 85, 2, 70-9
AIA, Washington DC 1996

BUCHHEIM, A. &
MERGENTHALER, E.
The Relationship Among
Attachment Representation,
Emotion-Abstraction Patterns
& Narrative Style:
A Computer
Based
Text
Analysis
Of The Adult
Attachment Interview
Psychotherapy Research,
Volume 10, Number 4, 390-407
Guildford Pub, New York 2000

BUCHWALD, A. & MIAZZO, M.
Finding Levels Of
Abstraction In
Speech Pro
-Duction
:Evide
-Nce
Fro
-M
So
-Und
-Product
Ion Impairment
Psychological Science,
Volume 22, No.9, 1113-19
Sage, Thousand Oaks CA 2011

BURGESS, T. Et al
'How One Learns
To Discourse':
Writing &
Abstr
-Act
-Io
-N
In
The
Work
Of James
Moffett &
James Britton
Changing English,
Volume 17, No.3, 2010
Taylor & Francis Ltd, UK 2010

BURGOON, E.M. Et al
*There Are Many
Ways To See
The Forest
For The
Trees:
A Tour
Guide for
Abstraction*
Perspectives On
Psychological Science,
Volume 8, No. 5, 501-520
Sage, Thousand Oaks CA 2013

BUSLER, G.R. Et al
*Context-Aware
Counter
Abstraction*
Formal Methods
In System Design,
Volume 36, No.3, 223-45
Springer-Verlag, Berlin 2010

BURWICK, K.
*Letter To
Abstraction
(So Many Letters...)*
The Literary Review,
Volume 48, Number 4, 88
Literary Review, London 2005

BUSEMEYER, J. Et al
*The Abstraction
Of Intervening
Concepts From
Experience With Mul-
Tiple Input-Multiple Out-
Put Causal Environments*
Cognitive Psychology,
Volume, No.1, 1-48
Academic Press,
Waltham
1997

BUTLER, M.
*Mastering
Systems Analysis
& Design Through
Abstraction & Refinement*
NATO Security Through Science
Series D – Information &
Communication
Security,
Vol.34,
49-78
IOS Press,
Amsterdam 2013

BUTLER, R.
*What
Was Abstract
Expressionism?
Abstract Expression-
Ism After Aboriginal Art*
Australian & New Zealand
Journal Of Art,
No.14, 76-91
ANZJA
2014

CABEZA, D. Et al
*Hiord: A Type-Free
Higher Order Logic
Programming
Language
With
Pre-
Dicate
Abstraction*
Journal on Data
Semantics, 3321, 93-108
Springer-Verlag, Berlin 2004

CALDWELL, B.W.
& MOCKO, G.M
*Validation Of
Function
Prun
-Ing
Rules
Through
Familiarity
At Three Lev
-Els Of Abstraction*
Journal of Mechanical Design,
Vol.134, Issue 4, No.041008
The American Society
Of Mechanical
Engineers,
N. York
2012

CALL, J. & SAITTA, L.
*Beyond Learning Fixed
Rules & Social Cues:
Abstraction in The
Social Arena*
Philosophical
Transactions of
The Royal Society
Of London, Series B.
The Biological Sciences,
Vol.358, 1435, 1189-1196
The Royal Society 1999, 2003

CALLAHAN, D.
*Ethics Without
Abstraction:
Squaring
The Circle*
Journal of Medical
Ethics, 22, No.2, 69-71
BMJ Journals, London 1996

CAMBOUROPOULOS, E.
*Melodic Cue Abstraction,
Similarity &
Category
Formation*
Music Perception,
Volume 18, No.3, 347-370
California UP, Berkeley 2001

CAMDEN, J.P. Et al
*H+CD-4 Abstr-
Action
Reaction
Dynamics:
Excitation Function
& Angular Distributions*
The Journal of Physi-
Cal Chemistry, A.
Molecules,
Spectros-
Copy,
Kinetics,
Environment
& General Theory,
Volume 110, 2, 677-686
ACS, Washington DC, 2006

CAMPBELL, V.
*Inquiring Mind:
Emerging
Colorado
Artist Mark
Nelson Paints The
Terrain Where
Realism
Meets
Abstraction*
Southwest Art,
September, 138-140
Cowles Mag, Minneapolis 2003

*The Language of
Abstraction:
Jamie
Chase's
Abstracted
Figurative Works
Are Rooted in The Classics*
Southwest Art, Nov, 118-123
Cowles Mag, Minneapolis 2006

*Where Realism Meets
Abstraction: Bold
Paintwork
Animates Doug
Braithwaite's Paintings*
Southwest Art, April, 96-99
Cowles Mag, Minneapolis 2007

CAMPOS, M. E al
*Using Temporal
Constraints
For Tem-
Poral
Abs-
Tr-
A-
Ct-
Ion*
Jour-
Nal of
Intelligent
Information Systems,
Volume 34, No.1, 57-92
Springer-Verlag, Berlin 2010

CANDEA, M.
*Derrida en
Corse?:
Hospit-
Ality
As
Sc-
Ale-
Free
Abstr-
Action*
The Journal
Of The Royal
Anthropological
Institute,181, Supp, 22-48
Basil Blackwell, Oxford 2012

CARETTE, J. Et al
*Multi-Stage Programming With
Functors & Monads
Eliminating
Abstr
-Act
-Io
-N
O
-Ver
-Head
From G
-Enetic Code*
Journal On Data
Semantics, 3676, 256-74
Springer-Verlag Pub, Berlin 2005

CARMONA, J.C. Et al
*Generalized Discrete Event
Abstraction of Continuous
Systems: Application
To An Integrator*
Journal Of Intelligent & Robotic
Systems, Volume 41, 1, 36-74
Kluwer Academic, Boston 2004

CARPENTER, B.
& DIRSMITH, M.
*Sampling & The
Abstraction
Of Knowledge
In The Auditing
Profession: An Extended
Institutional Theory Perspective*
Accounting, Organisations &
Society, Volume 18, No. 1, 41
Pergamon Press, Oxford 1993

CARRAULT, G. Et al
*Temporal Abstraction
& Inductive Logic
& Programming
For Arrhythmia
Recognition From
Electrocardiograms*
Artificial Intelligence in
Medicine, Vol. 28, 3, 231-63
Elsevier Pubn, Amsterdam 2003

CARRIER, J.G.
*Social
Asp-
Ects
Of Abs-
Traction*
Social Anthropology,
Volume 9, No.3, 243-256
Cambridge University Press 2001

CASEY, M.
*Rupturing The Modernist
Gland: Only A Few
Finnish Painters
Most Notably
Leena Luos-
Starinen –
Confront
The Cri-
Sis Of
Abstr-
Action
In Signi-
Ficantly Re-
Flexive Terms*
Form, Function,
Finland, Vol, 54-7
FSCD, Design Forum
Finland, Helsinki 1997

CASTELLAZZI, A. Et al
*Multi-Domain Multi-level
Abstraction Modelling
Of Integrated
Power Devices*
Solid-State Electronics,
Vol.53, No.11, 1202-1208
Elsevier Jrnls, Amsterdam 2009

CASTREE, N.
*Book Review:
What Is
Wat
-Er
?
T
He
His
Tory
Of A
Modern
Abstraction*
Progress in Human
Geography, 36, 5, 689-692
Sage, Thousand Oaks CA 2012

CASTRO, J.G.
*Martin
Puryear:
The Call of
History – 2 Public
Sculptures & 2 Design
Projects Demonstrate
Martin Puryear's
Continuing
Exploration
Of
Abstraction,
Public Space &
Metaphorical Resonance*
Sculpture, 17, No.10, 16-21
TISC, Hamilton, New Jersey 1998

CAUGHLIN, D. Et al
*A Summary
Of Model
Abstraction
Techniques*,
SPIE Proceedings,
No.3083, 38, 2-13
International Society
For Optical Engineering,
Bellingham, Washington 1997

CAUVET, C. Et al
*Abstraction Forms In
Object-Oriented
Conceptual
Modell
Ing:
Lo
-C
-Al
-Iza
Ion,
Agg-
Rega-
Tion &
Generalizat
-Ion Extensions*
Journal On Data Semantics, No.811, 149
Springer-Verlag, Berlin 1994

CAVIN, R. & ZHIRNOV, V.V.
*Generic Device Abstractions
For Information
Processing
Technologies*
Solid-State Electronics,
Volume 50, No.4, 520-526
Elsevier Jrnls, Amsterdam 2006

CERNUSCHI, C. &
HERCZYNSKI, A.
*The Subversion of
Gravity In
Jackson
Pollock's
Abstractions*
The Art Bulletin,
Volume 90, No.4, 616-39
College Art Assn, New York 2008

CHAN, S.W.
Beyond Keyword & Cue-Phrase
Matching: A
Science-
Ba-
Sed
Abst-
Raction
Technique For
Information Extraction
Decision Support Systems,
Volume 42, Number 2, 759-77
Elsevier Pubn, Amsterdam 2006

CHAVEZ-JIMINEZ, M.
The Politics
Of Theory
:From
Abstr
-Action
To Praxis
International
Studies in Philosophy,
Volume 35, Number 1, 13-20
New York State University 2003

CHEMLA, K.
Generally Above Abstract
Ion: The General
As Expressed
In Terms
Of The
Par-
Ad-
Ig-
Ma-
Tic In
Ancient China
Science in Context,
Volume 16, No.3, 413-458
Cambridge University Press 2003

CHEN, B-N. Et al
Knowledge-Abstraction
In Chinese
Endgame
Databases
Journal on Data
Semantics, 6515, 176-87
Springer-Verlag, Berlin 2011

CHEN, J.F. Et al
Level of Abstraction
& Feelings of
Presence in
Virtual
Space:
Bus-
In-
Ess
English
Negotiation In
Open Wonderland
Computers & Education,
Vol.57, No.3, 2126-2134
Elsevier Pubs, Amsterdam 2011

CHO, E.-S. Et al
*Abstraction For
Privacy In
Cont-
Ext-
Aware
Environment*
Journal on Data
Semantics, 3744, 384-93
Springer-Verlag, Berlin 2005

CHOI, Y. & KIM, M.
*Controlled Composition
& Abstraction For
Bottom-Up
Integ-
Ration &
Verification Of
Abstract Components*
Information & Software
Technology,54,1, 119-136
Elsevier Pubs, Amsterdam 2012

CHOUDHURY, M.A.
*Integrity: A System of
Philosophico-
Economic
Abstr-
Action*
Kybernetics,
Vol.44, No.3, 368
Emerald, Bradford 2015

CHRISTOFF, K. Et al
*Prefrontal Organisation
Of Cognitive Control
According To
Levels
Of
Abs-
Traction*
Brain Research,
Volume 1286, 94-105
Elsevier Pubs, Amsterdam 2009

CHUNG, C-M. Et al
*Tool Integration
In A Know-
Ledge
Abs-
Tr-
A-
Ct-
Ion
Env-
Iron-
Ment*
Information
Sciences,
Volume 105,
No.1-4, 279-98
Elsevier Pubs, Amsterdam 1998

CIMATTI, A. Et al
*Boosting Lazy Abstract-
Ion For System C
With Partial
Order
Reduction*
Journal on Data
Semantics, 6605, 341-356
Springer-Verlag, Berlin 2011

CLANCEY,
W.J. Et al
*Conceptual
Co-ordination: Abstr-
Action Without Description*
International Journal Of Educat-
Ional Research, Volume 27, No.
1, 5-20, Pergamon, Oxford 1997

CLARK, A.E. Et al
*Local Spin III: Wave Function
Analysis Along A Reaction
Coordinate, H Atom
Abstraction &
Additional
Processes
Of Benzyne*
The Journal Of Physical
Chemistry,106, 29, 6890-6
ACS, Washington DC, US 2002

CLARK, S.R.L.
***Paul K. Feyerabend, Conquest
Of Abundance: A Tale of
Abstraction Versus
The Richness
Of Being***,
*Ed. Bert
Terpstra*
Inquiry, 45,
Number 2, 249-268
Scandinavian UP, Oslo 2002

CLARKE, D.
*Paths To
Disso-
Lution:
Water &
Abstract Art*
Art Criticism, 24, 1, 34-68
State University New York 2009

CLEEREMANS, A.
*Awareness
& Ab-
Stra-
Cti-
On
A-
Re
Gr-
Ade-
D Di-
Mensions*
The Behav-
ioural & Brain
Sciences, Volume
Number 17, No.3, 402
Cambridge University Press 1994

CLEMENT, T.
*Data Reification
Without
Exp-
Li-
Cit-
Abst-
Raction
Functions*
Journal On Data
Semantics, 1051, 195-213
Springer-Verlag, Berlin 1996

COBO, L.C. Et al
*Abstraction From Demonstration
For Efficient Reinforcement
Learning in High-
Dimensional
Domains*
Artif
-Ici
-Al
-I
-Nt
-Elli
Gence,
Volume
216, 103-128
Elsevier Pubn, Amsterdam 2014

COHEN, E.
*Data Abs-
Traction
In VCC*
NATO
Security
Through Science
Series D – Information
& Communication Security,
Volume 34, Number 79, 114
IOS Press, Amsterdam 2013

COLBURN, T.R.
*Software,
Abstr-
Action
& Ontology*
The Monist,
Vol.82, 1, 3-19
The Hegeler Institute
Lasalle, Illinois US 1999

COLBURN, T.
& SHUTE, G.
*Abstraction in
Computer Science*
Minds & Machines,
Vol.17, No.2, 169-184
Springer-Verlag, Berlin 2007

*Abstraction,
Law &
Freedom In
Computer Science*
Metaphilosophy, 41, 3, 345-64
Baseil Blackwell, Oxford 2010

COLLAR, A. Et al
*Networks In Arch
Aeology: Phe-
Nomena,
Abstr-
Acti-
On ,
R-
Ep-
Rese-
Ntation*
Journal of
Archaeological
Method & Theory,
Volume 22, No.1, 1-32
Springer-Verlag, Berlin 2015

CONG, L.
*Selective
Image
Abstr-
Act-
Ion*
The
Visual
Computer,
Vol.27, 3, 187-198
Springer-Verlag, Berlin 2011

COMAROFF, J.
& COMAROFF, J.L.
*Occult Economies
& The Viol-
Ence Of
Abstr-
Act-
Ion:
No-
T-
Es
Fr-
Om
The
South
African
Postcolony*
The American
Ethnologist, Vol
26, Number 2, 279-303,
American Anthropological
Assocn Arlington, Virginia 1999

CONNOLLY, M.
*Abstraction &
Dislocation
In Recent
Works By
Gerard Byrne*
Circa, 113, 29-40
Circa Pubns, Sunderland 2005

CONWAY, P. & PEETZ, J.
When Does Feeling Moral Make You A Better Person? Conceptual-Abstraction Moderates Whether Past Moral Deeds Motivate Consistency Or Compensatory Behaviour
Personality & Social Psychology Bulletin, Vol. 36, No.7, 907-19
Sage, Thousand Oaks, Cal. 2012

COOK, J.A. Et al
Outcomes of Programs Serving Mothers With Psychiatric Disabilities & Their Young Children: A Multisite Case File Abstraction Study
Psychiatric Rehabilitation Journal, Vol.37, No.3, 232-41
APA Journal, Washington 2014

COOK, R.G. & SMITH, J.D.
Signs of Abstraction & Exemplar-Memorization In Pigeon Category Learning
Psychological Science, Volume 17, N.12, 1059-1067
Basil Blackwell, Oxford 2006

COOLEY, L.
Writing In Calculus & Reflective Abstraction
The Journal Of Mathematical Behaviour, 21, 3, 255-82
Elsevier Pubn, Amsterdam 2002

COOLIDGE, F.L.
Numerosity,
Abstraction &
The Emergence
Of Symbolic Thinking
Current Anthropology,
Vol.53, No.2, 204-05
University of
Chicago
Press
2012

COOPER,
E. Et al
The Essence
Of Form Abstraction
Journal on Data Semantics,
No. 5356, 205-220
Springer-
Verlag
Berlin
2008

COPELAND, R.
Fatal Abstraction, Merce
Cunningham,
Formalism
& Identity Politics
Dance Theatre Journal,
Volume 14, Number 1, 38-42
The Laban Centre, S London 1998

CORRIGAN, P.W.
& GREEN, M.
Schizophrenic
Patients'
Sens
-Itiv
-Ity
To
Soci
-Al Cues
:The Role
Of Abstraction
The American Journal Of Psyc-
Hiatry, Volume 150, No. 4, 589
APA, Arlingto, Virginia 1993

CORRIS, M.
'What Do You Represent?'
When Titles Do Not
Say & Pictures
Do Not Show:
Briony Fer,
On Abs-
Tract
Art;
In-
Vis-
Ible
Colo-
Urs: A
Visual Hi-
Story Of Titles,
By John C. Welchman
Art History, Vol. 21, 4, 603-7
Basil Blackwell, Oxford 1998

COURTIN, C.
Does Sign Language Provide Deaf Children With An Abstraction Advantage? Evidence From A Categorization Task
Journal of Deaf Studies & Deaf Education, Vol. 2, No.3, 161-171
Oxford UP
1997

CRETIN, J. & REMY, D.
On The Power Of Coercion Abstraction
ACM SigPlan Notices, Vol.47, No.1, 361-372
ACM, New York 2012

CROUCH, D. & TOOGOOD, M.
Everyday Abstraction: Geographical Knowledge In The Art Of Peter Lanyon
Ecumene, 6 Number 1, 72-89
Arnold Publications, London 1999

CUNNINGHAM, D.
Asceticism Against Colour, or Modernism, Abstraction & The Lateness Of Beckett
New Formations Volume 55, 104-119
Lawrence & Wishart, London 2005

CURIEN, P.L.
Definability & Full Abstraction
Electronic Notes In Theoretical Computer Science, 172, 301-10
Elsevier Pubn, Amsterdam 2007

CURTIS, R.
*Einfühlung & Abstraction
In The Moving Image:
Historical &
Contemp-
Orary
Refl-
Ect-
Ions*
Science
In Context,
Vol. 25, No.3, 425-446
Cambridge University Press 2012

DAHL, A.C. Et al
*Bendix: Intuitive
Helix
Geo-
Metry
Analysis
& Abstraction*
Bioinformatics,
Vol. 28, No.16, 2193-94
Oxford University Press 2012

DAHL, E.
*Towards A Phenomenology
Of Painting:
Husserl's
Horizon
& Rothko's
Abstraction*
The Journal Of
The British Society
For Phenomenology,
Volume 41, No.3, 229-245,
Haigh & Hochland, Man. 2010

DALY, S.
*The Ladder Of Abstraction:
A Framework For
The Systematic
Classification Of
Democratic Regime Types*
Politics, V. 23, No. 2, 96-108
Basil Blackwell, Oxford 2003

DALY, T. & BELL, P.
*Visual Abstraction &
Anatomy:
Pre-
&
Post-
Modern Imagery*
Visual Communication,
Volume 7, No.2, 183-198
Sage, Thousand Oaks CA 2008

DAMIANI, E. Et al
Hydrogen Abs-
Traction
Ability
Of Dif-
Ferent
Aromatic
Nitroxides
Free Radical Research,
Volume 38, No.1, 67-72
Taylor & Francis, UK 2004

DAN, A.M. Et al
Predicate
Abstr-
Act-
Io-
N
F-
Or
Rel-
Axed
Memo-
Ry Models
Journal on Data Sem-
Antics, Number 7935, 84-104
Springer-Verlag, Berlin 2013

DANIELL, T.
The Visceral & The Ephemeral:
Abstraction In
Contemp-
Orary-
Japa-
Nese
Archi-
Tecture
Archis, No.3,
8-23, Senenfelder Misset,
Doetinchem, Netherlands 1999

DANTO, A.C.
Art:
Abstr-
Action
The Nation,
Vol. 262, No. 14, 42-4
The Nation, Washington 1996

DEATH, R.G. Et al
Is Structure or Function A Better
Measure of The Effects Of
Water Abstraction
On Ecosystem
Integrity?
Fresh-
Water
Biology,
Volume 54,
Number 10, 2037-50
Basil Blackwell, Oxford 2009

DE AZEVEDO, F.
Cecilia de Sousa: Abstract-Ion Of Po-Etry
Cera-mics, Art & Perception, 41, 31-32
CAAP Ltd, Sheridan 2000

DEDIC, J. Et al
A Methodology For Supporting System-Level Design Space Exploration At Higher Levels Of Abst-Raction
Journal of Circuits, Systems & Computers, 17, 4, 703-28
World Scientific, London 2008

DELIEGE, I.
Cue Abstr-Action As A Co-Mp-One-Nt Of Categ-Orization Processes In Music Listening
Psychology of Music, Volume 24, 2, 131-56
Society For Research In The Ps-Ychology Of Music Lon. 1996

Introduction: Si Milarity Per-Ception 'Cate-Gori-Zat-Io-N' C-Ue-Abs-Trac-Tion
Music Perception, Volume 18, Number 3, 233-244
University of California Press 2001

DE LOSH, E.L. Et Al *Extrapolation: The Sine Qua Non For Abstr-Act-Ion In Fun-Ction Learning*
Journal of Experimental Psychology, Vol. Number 23, 4, 968-86
APA, Washington DC 1997

DENISOV, E.T.
New Empirical
Models
Of Radical
Abstraction Reactions
Russian Chemical Reviews,
Volume 66, No.10, 859-876
Turpion Ltd/IPP London 1997

DEVETAK, R.
Waltz, The
State of
Inter-
Na-
Tion-
Al Relat-
Ions & Theor-
Etical Abstraction:
Contextualising A Legacy
Australian Journal of Political Science, Vol. 49, No.3, 552-57
Taylor & Francis Ltd, UK 2014

DESMOULIN,
B. Et al
Abst-
Ra-
C
Ti-
Ons
Pour
Rodin
Techn-
Iques Et
Architect-
Ures , 451,
72-5, Altedia
Communication Paris 2001

DEVEZE, L.
De L'Abstction Comme
Experience Amoureuse
Annales Littéraires
De L'Université
De Besançon,
886, 29-44
Dialogu-
Es D'
His-
-To
-Ir
-E
An
-Ci
Enne
Presse
Univer-
Sitaires De
Franche-Comté
Besançon, France 2011

DEVLIN, K.
*Finding Your
Inner Ma-
Thema-
Tician:
As The Ab-
Straction Turns*
The Education Digest, Volume 66, No.4, 63-66
Prakken, Ann Arbor Mn. 2000

*Uni-Variate
Bracket
Abstr-
Act-
Io-
N
U-
Si-
Ng
A S-
Tring
Repres-
Entation
For Combinators*
Cognitive Science Research Papers, No.12 All University of Birmingham 2004

DILLER, A.
*Efficient Bracket
Abstraction
Using Iconic
Representation
For Combinators*
School Of Computer-Science Research Reports 5 All University of Birmingham 2011

DI PIERRO, A. & WICKLICKY, H.
*Semantic Abtr-
Action &
Quantum
Computation*
Electronic Notes In Theoretical Computer Science, Volume 210, 49-63
Elsevier Pubn, Amsterdam 2008

*Effi-
Cient
Multi-
Variate
Abstract-
Ion Using
An Array
Representation
For Combinators*
Information Processing Letters,Vol.84, No.6, 311-17
Elsevier Pubn, Amsterdam 2002

DOBBIN, F.
***When Formality Works:
Authority & Abstr-
Action in Law &
Organisations,***
By Arthur L. Stinchcombe
The American Journal of Sociology, Vol.109, No.5, 1244-1245
University Of Chicago Press 2004

DOEST, L.T. Et al
*Linguistic Context
& Social
Percep
-Tion
:Does
Stimulus
Abstraction
Moderate Processing Style?*
Journal Of Language & Social Psychology, Vol.21, 3, 195-229
Sage, Thousand Oaks CA 2002

DOGAN, F. & NERSESSIAN, N.
Generic Abstraction in Design Creativity: The Case of **Staatsgalerie,** *By James Stirling*
Design Studies, Vol.31, No.3, 207-236
Elsevier Pubn, Amsterdam 2010

DOLIDON, A.
*Shifting Wittigian Binaries:
Abstr-
Action
& The Re-
Materialization
Of The Lesbian Body
In Sande Zeig's,* **The Girl**
Feminist Review, 92, 1, 72-90
Palgrave-Macmillan, Bas. 2009

DOMSHLAK, C. Et al
*Landmark-Enhanced
Abtract
-Ion
Heu-
Ristics*
Artificial Intelligence, Volume 189, 48-68
Elsevier Pubn, Amsterdam 2012

DONALDSON, A. Et al
*Symmetry-Aware Predicate Abstraction For Shared-Variable Con-
Current
Progr-
Ams
Jo-
Urnal*
On Data Semantics, No. 6806, 356-371
Springer-Verlag, Berlin 2011

DORRILL, L.
*Between Representation & Abstraction: Magic & Whimsy In The Works Of Kath
-Erine
Bradford*
The Gettys -Burg Review, Volume 23, 2, 246
Gettysburg College PA 2010

DORST, L.
*Analysing The Be-
Haviours Of
A Car: A
Study In
Abstract
ion Of Goal-
Directed Motions*
Man & Cybernetics.
Part A -Systems & Humans,
Volume 28, Number 6. 811-822
IEEE, Piscataway New Jersey 1998

DOUGLAS, K. & SUTTON, R.
*By Their Words Ye Shall Know
Them: Language
Abstraction
& The
Likeability
Of Describers*
European Journal
Of Social Psychology,
Volume 40, No.2, 366-374
J.Wiley & Sons, Hoboken NJ 2010

*Effects of Communication Goals
& Expectations On Lan-
Guage Abs-
Traction*
Journal Of
Personality &
Social Psychology, V. 84, No.4,
682-96, APA, Washington 2003

*When What You Say About
Others Says Something
About You: Language
Abstraction &
Inference
About
Desc
-Rib
-Er
-S'
A
-T
-Tit
Udes
& Goals*
Journal of
Experimental
Social Psychology,
Volume 42, No.4, 500-508
Elsevier Pubn, Amsterdam 2006

DOU, H.Y. Et al
*'Magic Blue' – Subtle Reagent
For EPR Studies On
H-Abstraction
From Va-
Rious-
Subs-
Trates*
Magnetic
Resonances
In Chemistry,
Volume 44, 5, 515-20
J.Wiley & Sons, Hoboken NJ 2006

DOWNES, S.M.
*Paul Feyerabend's, **Conquest Of Abundance: A Tale of Abstraction Versus The Richness of Being**;*
John Preston
Et al,
The Worst Enemy Of Society? Essays In Memory Of Paul Feyerabend
Science, Technology & Human Values, Volume 27, No.1, 160-4
Sage, Thousand Oaks, Ca 2002

DREYFUS, T. & GREY, E.
Abstraction: Theories About The Em- Erg- Ence Of Know- Ledge Structures Introductory Remarks
PME Conference 26,
Volume 1, 1-113
IGPME 2002

DUDEK, G.L.
Environment Representation Using Multiple Abstr- Action Levels
IEEE Proceedings,
Vol.84, No.11, 1684-1704
IEEE Piscataway New Jersey 1996

DUIGNAN, M. Et al
Abstraction & Activity In Computer -Media -Ted Mu -Sic Prod -Uction
Computer Music Journal,
Volume 34, 4, 22-33
MIT Press, Cam Mass 2010

DUNCAN, M.
John McLaughlin: Transcending The Particular - The Influence Of Asian Art Shaped The Painter's Reductive Approach To Geome- Tric Ab -St -R -Ac Tion
Art In America,
Volume 85, Number 9, 84-87
Brant Publications New York 1997

DWYER, P.D. & MINNEGAL, M.
Where All The Rivers Flow West: Maps, Abs-Traction & Change In The Papua New Guinea Lowlands
The Australian Journal of Anthropology, 25, No.1, 37
J.Wiley & Sons, Hoboken NJ 2014

EBONY, D.
Morphological Totems: In His Bold 1940's Abstractions, Painter Steve Wheeler Combined Modernist Visual Principles & Native Americ-An Motifs
Art In America, Volume 86, No.12, 82-87
Brant Pubns
New York
1998

EDWARDS, P.
Wyndham Lewis's ***Timon Of Athens*** *Portf-Olio :The Em -Erg -Ence Of V-Orticist Abstraction*
Apollo, 148, Number 440, 34-40
Apollo Magazine, London 1998

DYCK, E.F.
The Rhetoric Of Geo-Metric Abstraction: Marko Spalatin
Word & Image: A Journal Of Verbal/Visual Enquiry, Vol. 23, Number 1, 59-71, T & F, 2007

EJAZ, N. Et al
MRT Letter: Visual Attention Driven Frame-Work For Hysteroscopy Video Abstraction
Microscopy Research & Technique, Vol.76, 6, 559-63
Wiley & Sons, Hoboken NJ 2013

EFRAN, J.S. & FORSTER, J.*Mystery, Abst-Raction & Narrative Psychotherapy*
Journal of Constructive Psychology, V.7, No.4, 219
Taylor & Francis Ltd, UK 1994

ELLMAN, T.
Abstraction Via Approximate Symmetry
International Joint Conference On Artificial Intelligence, Vol.13, 2, 916
L. Erlbaum, New Jersey 1993

EHN, E.
Channels Of Witness: Space, Abstr-Action & The Commemor-Ation of Geno-Cide
Journal of Dramatic Theory & Criticism, Vol. 27, No.2, 67-104
Department of Theatre & Film, The University of Kansas 2013

ELMAS, T. Et al
Simplifying Linear-Izability Proofs With Reduc-Tion & Abstr-Act-Io-N
Jo-Urnal On Data Semantics, 6015, 296-311
Springer-Verlag, Berlin 2011

ENGLAR-CARLSON, M.J.
*Enough About Models &
Abstractions, Let Your
Therapeutic Soul
Be Free: An
Interview
With
Bra-
Dford
Keeney*
<u>The Family
Journal: Coun-
Selling & Therapy
For Couples & Families,</u>
Volume 11, No.3, 309-314
American Counselling Assn
Alexandria, Virginia US 2003

ENGLISH, L. & SHARRY, P.
*Analogical Reasoning & The
Development of
Algebraic
Abstraction*
<u>Educational Studies in
Mathematics,</u> 30, 2, 135-7
Kluwer Publications, Boston 1996

ESCH, J.
*Environment Representat-
Ion Using Multiple
Abstraction
Levels:
Pro-
Log*
<u>IEEE
Proceedings,</u>
Volume 84, 11, 1682-1683
IEEE, Piscataway New Jersey 1996

ESSIF, L.
*Lost In
Space:
American
Characters
As Creatures of A
Culture/Dramaturgy of
Abstraction In Kolte's,* **Salinger**
<u>Mosaic,</u> Vol.39, 1, 79-98
The Mosaic Press,
Oakville ON
2006

ETINSON, A.
*Human Rights,
Claimability
& The
Uses
Of
Abs-
Traction*
<u>Utilitas,</u> Vol. 25, No. 4, 463
Cambridge University Press 2013

EVANS, W.S.
*Clone
Detect
-Ion Via
Structural
Abstraction*
<u>Software Qual-
Ity Journal,</u> Volume
17, Number 4, 309-330
Springer-Verlag, Berlin 2009

FARRELL, M.H. Et al
A Structured Implicit Abstr- Action Method To Evaluate Whether Content of Counseling Before Prostate Cancer Screening Is Consistent With Recommendations By Experts
Patient Education & Counseling, Volume 77, Number 3, 322-327 Elsevier Pubn, Amsterdam 2009

FAUNTLEROY, G.
Allen's Vibrant Works Walk The Line Betwe- En A- Bs- Trac- Tion & Realism
Southwest Art, April, 92-95
Cowles Mag, Minneapolis 2000

FEEKE, S.
The Hepworth Wakefield Geometric Abstrac- Tion Thrills Both In- Side & Outside This New Gallery
Museums Journal, V. 111, Number 9, 46-49
Museums Assn, London 2011

FEIST, G.J. & BRADY, T.R.
Openness To Experience, Non-Conformity & The Preference For Abstract Art
Empiric -Al St Udi -Es Of The Arts, Volume 22, 1, 77-90 Baywood Publishing, Amityville, NY 2004

FERNANDEZ-MADRIGAL, J-A. Et al
Abstract -Ion & Multi- Ple Ab- Straction In Symbolic Modelling Of The Environment Of Mobile Robots
Journal On Data Sem- Antics, Volume 3607, 358-59
Springer-Verlag, Berlin 2005

FINCH, C.
Art –
Bay
Area
Figu-
Rative
Painting:
California
Artists Who
Looked Beyond
1950's Abstraction
Architectural Digest,
Vol.53, No.3, 120-143
Knapp Cmns, Dunnigan CA 1996

FINELLI, R.
Abstraction Versus
Contradiction:
Observati-
Ons On
Chris
Arth-
Ur-
's,
T-
He
New
Dialectic
& Marx's Capital
Historical Materialism,
Volume 15, N.2, 61-74
Brill, Leiden Neth 2007

FIRMAT, G.P.
Richard
Rodr
-Igu
-Ez
&
The
Art Of
Abstraction
Colby Quarterly
Vol.32, No.4, 255-66
Colby College, Waterville
Berkeley Electronic Press 1996

FISHER, C. Et al
Abstraction &
Specificity in
Preschool-
Ers' Rep-
Resen-
Tati-
Ons
Of
N-
O-
Vel
Spo-
Ken
Words
Journal
Of Memory
& Language,
Vol.45, 4, 665-87
The Academic Press,
Elsevier Pbn Amsterdam 2001

FISHER, D.
*Intimacy &
Self-Abstraction:
Radio As New Media
In Aboriginal Australia*
Culture, Theory & Critique,
Volume 54, No. 3, 372-393
Taylor & Francis, UK 2013

FLEMMING, T.M. Et al
*Baboons, Like Humans,
Solve Analogy By
Categorical
Abstr
-Action
Of Relations*
Animal Cognition,
Vol.16, No.3, 519-524
Springer-Verlag, Berlin 2013

FISS, A.
*Problems of Abstraction: Defining
An American Standard For
Mathematics Education
At The Turn Of The
Twentieth Century*
Science & Education,
Volume 21, No.8, 1185-97
Springer-Verlag Pubn, Berlin 2012

FLEMING, L.
*Taxonomy & Taboo: The (Meta)
Pragmatic Sources
Of Sem-
Antic
Abstraction In
Avoidance Registers*
Journal Of Linguistic
Anthropology, Vol.25, 1, 43
J. Wiley & Sons, Hoboken NJ 2015

FLORIDI, L.
*Levels of
Abstr
-Acti
-On
&
The
Turi-
Ng Test*
Kybernetes,
Vol. 39, No.3, 423-40
Emerald, Bradford UK 2010

FONESCA, R.L. Et al
*Automatic Representa-
Tion of Semantic
Abstraction
Of Geog-
Raph-
Hic-
Al-
D-
Ata
By M-
Eans Of
Classification*
Journal on Data
Semantics, 6419, 557-68
Springer-Verlag, Berlin 2010

FRANK, A.U.
*One Step Up The Abstracti-
On Ladder: Combining
Algebras - From
Functional
Pieces
To A
Whole*
Journal
On Data
Semantics
1661, 95-108
Springer-Verlag, Berlin 1999

FOSTER, J.
*Abstraction
In Economics:
Incorporating
The Time Dimension*
International Journal of Social
Economics, 25, 2-4, 146-167
Emerald Jrnls, Bradford 1998

FRANKFORD, D.M.
*Neoclassical Health Economics
- The Debate Over National
Health Insurance:
The Power of
Abstraction*
Law & Social
Enquiry, Vol.18, 2, 351
University of Chicago Press 1993

FOTI, V.M.
*Heidegger &
'The Way of Art':
The Empty Origin &
Contemporary Abstraction*
Contemporary Philosophical
Review, Vol.31, No.4, 337-351
Kluwer Academic, Boston 1998

FREEDMAN, E.G.
*The Rule of Diatonicism In The
Abstraction & Repre-
Sentation Of
Contou-
R & I-
Nterval
Formation*
Music Perception,
Volume 16, 3, 365-385
University of California Press
Berkeley, San Francisco 1999

FRENCH, S.
Abstract-
Ion &
Concept
Formation
Metascience,
Vol.16, 3, 539-42
Springer-Verlag, Berlin 2007

FUGAMI, T.
Brancusi &
Noguchi: On
Abstraction &
Representation
Sculpture Review,
Volume 54, No.3, 16-19
National Sculpture Soc. NY 2005

FROMMBERGER, L. Et al
Spatial Abstraction:
Aspectualization,
Coarsening &
Conceptual
Classific
Ation
Jou-
Rnal
On Data
Semantics,
Number 5248, 311-27
Springer-Verlag, Berlin 2008

FUJITA, K. & ROBERTS, J.C.
Promoting Prospective Self-
Control Through
Abstraction
Journal of
Experimental Social
Psychology, 46, 1049-1054
Elsevier Pubn, Amsterdam 2010

FU, D. Et al
The Abstraction of The Power
Spectrum Exponent of
Seismic Reflection
Sequence
Shiyou Wutan,
Vol.35, No.2, 68-72
Geophysical Prospecting For
Petroleum, Wiley-Blackwell
Publishing, New York 1996

FULLER, M. & GOFFEY, A.
Digital Infrastructures
& The Machinery
Of Topologic
-Al Abstraction
Theory, Culture &
Society, 29, 4-5, 311-33
Sage, Thousand Oaks CA 2012

FUNKENSTEIN, S.L.
Engendering Abstraction:
Wassily Kandinsky,
Gret Palucca &
"Dance Curves"
Modernism/Modernity,
Volume 14, No.3, 389-406
John Hopkins UP, Baltimore 2007

FURNHAM, A. & WALKER, J.
Personality & Judgements
Of Abstract, Pop &
Represent-
Ation
-Al
-Pai
Ntings
European Journal of
Personality, Vol.15, No.1, 57-72
Wiley & Sons, Hoboken NJ 2001

FYFE, J. & KERLIDOU, G.
Le Tableau - French Abstraction
& Its Affinities, Curat
Ed By Joe Fyfe.
The Cheim
& Reid
Gal-
Le-
Ry,
New
York,
24th June-
3rd Sept.2010
Contemporary
French & Francophone
Studies, Vol. 15, 3, 363-371
Taylor & Francis Pub, UK 2011

GACEK,
A. Et al
Nominal
Abstraction
Information &
Computation, 209,
Number 1 48-73
Elsevier Pubn,
Amsterda-
M 2011

GACITUA, R. Et al
Relevance-Based
Abstraction
Identifi-
Cation:
Technique
& Evaluation
Requirements Engineering, 16,
13, 251-65 Springer, Berlin 2011

GALANO, A. Et al
Rate Co-Efficient &
Mechanism Of The
Gas Phase OH
Hydrogen
Abstract-
Ion Reaction
From Formic
Acid: A Quantum
Mechanical Approach
The Journal of Physical
Chemistry,106, 41, 9520-28
ACS, Washington DC US 2002

GALENSON, D.W.
Two Paths To
Abstract Art:
Kandinsky
& Malevich
Working Paper
Series, No. 12403, All
NBER, United States 2006

GALLAGHER, S. Et al
Enactive & Behavioural
Abstraction
Accounts
Of Social
Understanding
In Chimpanzees,
Infants & Humans
Review of Philosophy
& Psychology, 3, 1, 145-169
Springer-Verlag, Berlin 2012

GANGELHOFF, B.
On
The
Verg-
E:Terry
St John's
Colourful
Figurative &
Landscape
Painting-
S Exis-
T On
The
Bor
-Der
Bet-
Ween
Realism
& Abstraction
Southwest Art, April, 108-111
Cowles Mag, Minneapolis 2004

GALLESE, V.
Motor Abst-
Raction: A
Neurosc-
Ientific
Acco-
Unt
Of
How
Action
Goals &
Intentions
Are Mapped
& Understood
Psychological Research,
Volume 73, No.4, 486-498
Springer-Verlag, Berlin 2009

GARCHA, A.
Conclusion "Nothing Democratic":
Intelligence,
Abstract
-Ion &
Avant
-Garde
Plotlessness
Cambridge Studies In
Nineteenth Century Literature
& Culture, Volume 67, 219-240
Cambridge University Press 2009

GARCIA, G.T.
*The Internatio-
Nalization of
Spanish Art
(1950-62)*
Third Text,
Vol.20, No.2, 241-149
Taylor & Francis, UK 2006

GASCHE, R.
*On Seeing
Away:
Att-
En-
T-
I-
O-
N
&
A-
Bs-
Tra-
Ction
In Kant*
CR - The New Centennial Rev-
Iew, Volume 8, Number 3, 1-28
Michigan State University Press
East Lansing, Michigan US 2008

GARCIA-MARQUES, L. Et al
*Stereotypes: Static
Abstract-
Ions
Or
Dy-
Na-
Mic
Know-
Ledge S-
Tructures?*
Journal Of
Personality &
Social Psychology,
Vol.91, No.5, 814-831
APA, Washington DC 2006

GELMAN, I.A. Et al
*Abstra-
Ction
Techn-
Iques &
Their Value*
Journal on Data
Semantics, No.2371, 333-334
Springer-Verlag, Berlin 2002

GHITA, N. & KLOETZER, M.
*Trajectory
Planning
For A
Car-
Like
Robot
By Environ-
Ment Abstraction*
Robotics & Autonomous
Systems, Vol. 60, 4, 609-619
Elsevier Pubs, Amsterdam 2012

GIAMBIASI, N.
& CARMONA, J.C.
*Generalized Discrete
Event Abstraction
of Continuous
Systems:
GDEVS
Formation*
Simulation Modelling
Practice & Theory,14, 1, 47-90
Elsevier Jrnl, Amsterdam 2006

GILEAD, M. Et al
*Constructing Cou
-Nter Factual
Worlds
: The
Role
Of Ab
-Straction*
European Jrnl
Of Social Psychology,
Volume 42, No.3, 391-397
Wiley & Sons, Hoboken NJ 2012

*From Mind
To Matter:
Neural
Corr-
Ela-
Tes of
Abstract-
Ion & Conc
Rete Mindsets*
Social Cognitive &
Affective Neuroscience,
Volume 9, Number 5, 638
Oxford University Press 2013

GINZBURG, J.
*Abstraction & Ontolo-
Gy: Questions As
Propositional
Abstracts In
Type Theory
With Records*
Journal Of Logic
& Computation, Vol
-Ume 15, Number 2, 113-30
Oxford University Press 2005

GIRGENSOHN, A. Et al
Dynamic Forms:
An Enhanced
Interaction
Abstrac-
Tion
Based
On Forms
Interact – IFIP
Conference, 5, 362-7
Elsevier Jrnl, Amsterdam 1995

GIUNTI, M.
Static Sem-
Antics of
Secret
Channel
Abstraction
Journal on Data Semantics 87-88,165-80 Springer Berlin 2014

GLIMM, B. Et al
A Refinement
For Ontol-
Ogy M-
Ateri-
Aliz-
Ati-
O-
N
J-
Ou-
Urn-
Al On
Data S-
Emantics,
8797, 180-95
Springer- Ver-
Lag, Berlin 2014

GLUCK, M.
Interpreting Primitivism,Mass
Culture & Modernism:
The Making of
Wilhelm
Worr-
Ing-
Er's,
Abs-
Trac-
Tion &
Empathy
New German
Crtique, No. 80, 149-70
Telos Press, Candor NY 2000

GOBBO, F. & BENINI, M.
The M-
Inimal-
Levels Of
Abstraction
In The History
Of Modern Computing
Philosophy & Technology, Vol. 27, 3, 327-343, Springer 2014

GOLDBERG, B. & PARKER, I.
A Psychology of Need & The
Abstraction of 'Value':
Creating Dema-
Nd In Psych-
Ological
Practice
Theory & Psychology,
Volume 9, Number 3, 353-366
Sage, Thousand Oaks Cal. 1999

GOMEZ, E.M.
Another World:
Abstract Art
Isn't So
My
Ster-
Rious
When
You Know
The Language
Art & Antiques,
Vol.27, No.8, 46-53
Transworld Publishing Co.
Uxbridge Road, London 2004

GOMEZ, R. & LAKUSTA, L.
A First Step in Form-
Based Category
Abstraction by
12-Month
Old Infants
Developmental
Science, 7, 1, 567-580
Basil Blackwell, Oxford 2004

GOMEZ, R.L. Et al
Naps Promote
Abstract-
Ion In
Language-
Learning Infants
Psychological Science,
Volume 17, No.8, 670-674
Basil Blackwell, Oxford 2006

GONG, Y. & ZHANG, Z.
Cell Frame: A Data Structure
For Abstraction of Cell
Biology Experiments
& Construction
Of Perturba-
Tion Net-
Works
Ann-
Als
O
-F
N
-E
-W
-York
Academy
Of Sciences,
Volume 1115, 249-266
Basil Blackwell, Oxford 2007

GONZALEZ, C.
Animation in User Interfaces
Designed For Decision
Support Systems:
The Effects
Of Image
Abstraction,
Transition &
Interchange on
Decision Quality
Decision Sciences,
Vol.28, No.4, 793-824
DS Inst. GSU Atlanta 1997

GOODSON-EPSY, T.
*The Roles of Reification &
Reflective Abstraction
In The Developme-
Nt Of Abstract
Thought:
Transitions From
Arithmetic To Algebra*
Educational Studies In
Mathematics, 3, 3, 219-45
Kluwer, Boston Mass 1998

GRAEFE, O.
Book Review:
What is Water?
The History
Of
A
Modern
Abstraction
Social & Cultural
Geography, 14, 1, 125-27
Taylor & Francis, UK 2013

GRAFF, C. Et al
*Fish Perform
Spacial Pa-
Ttern Re-
Cogni-
Ton &
Abstrac-
Tion By
Exclusive
Use of Active
Electrolocation*
Current Biology,
Volume14, No. 9, 818-23
Elsevier Pub, Amsterdam 2004

GRAY, E. & TALL, D.
*Abstraction As A Nat-
Ural Process
Of Me-
Ntal
Com-
Pression*
Mathematics
Education Research
Journal, Vol.19, No.2, 23-40
Springer-Verlag, Berlin 2007

GRAF, S. Et al
*A Tool For
Symbolic
Program
Verification
& Abstraction*
Journal On Data
Semantics, No. 697, 71
Springer-Verlag, Berlin 1993

GRAY, J. & CORRY, L.
*Anxiety & Abstraction
In
19th
Century
Mathematics*
Science in Context,
Volume 17, No. 1-2, 23-48
Cambridge University Press 2004

GREEN, T.
*The Origins
Of Abstract Art*
Modern Painters, March, 38
Louise Blouin, New York 2013

GREGG, G.
*Streams of Consciousness: Amy
Sillman's Paintings Are
Quirky Fusions of
Figuration &
Abstraction,
Humour
Pathos -
Each
Tells
A Meandering Tale*
Art News, V.100, No.4, 120-3
ANSS, West St, New York 2001

GREIJDANUS, H.
*When
Abstract-
Ion Does Not
Increase Stereotyping:
Preparing For Intergroup
Communication Enables
Abstract Construal
Of Stereotype-
Inconsist-
Ent Inf-
Orm-
Ati-
On*
Social Cognition,
Vol.32, No.6, 505-27
Guildford, London & NY 2014

GRIDLEY, M.C.
*Concrete &
Abstract
Think
-Ing
St-
-Yl
-E
S
&
Art
Pref-
Erences
In A Sample
Of Serious Art Collectors*
Psychological Reports, Volume
98, 3, 853-7, Perceptual & Motor
Skills, Ammons Sage Pub 2006

GRIEVE, A.
*Light Flirtation or Serious
Affair? Ben Nicholson,
Victor Pasmore &
Abstract Art in
St Ives &
London In
The Early 1950's*
The Burlington Magazine
Volume 151, No.1273, 234-242
BM Pubs, Duke's Rd London 2009

GU, D. & LIN, B.
*Application & Abstraction
Of Shaft Drilling
Technique In
Coal Mine
Constr-
Uct-
Ion
In
Ch-
Ina*
Mining
Engineering,
Volume 45, No.8, 1084
SME Englewood CO1993

GUERRIN, J.
Book Discussion: Jamie Linton
**What is Water? The History
Of A Modern Abstraction**
Natures, Sciences,
Societies,
Vol.20,
NO.2, 235
EDP Sciences,
Les Ulis Publishers, Paris 2012

GUP, Y. Et al
*State Space Reduction
In Modelling
Checking
Param-
Ater-
Ized
Cache
Coherence
Protocol By Two-
Dimensional Abstraction*
The Journal of Supercomputing,
Volume 62, Number 2, 828-854
Springer Publishing, Berlin 2012

GUTTMANN, W.
*Imperative Abs-
Tractions
For Fu-
Ncti-
On-
Al
Act-
Ions*
The Journal
Of Logic & Algebraic
Programming, 79, 8, 768-793
Elsevier Pubs, Amsterdam 2010

HABERMAN, B.
*High-School Stu
-Dent Attitude
-S Regard
-Ing Pro
-Ceed
-Ural
Abs
-Tr
-A
-Ct
Ion*
Edu
-Catio
-N & In
-Formati
-On Techn
Ologies, Vol.
9, No. 2, 131-45
Kluwer Ac. Pubns,
Boston Mass. 2004

HAFEZ, Z.
The Arab Mind: An Ont-Ology of Abstraction & Concreteness
Contemporary Arab Affairs, V.3, N.3, 362-396
Taylor & Francis Pub, UK 2010

HAHNLE, R.
Many- Val-Ued Logic, Partiality & Abs-Trac-Tion In F-Or-M-Al S-P-Ec-Ifi-Ca-Tion Lang-Uages
Logic, Vol.13, No.4, 415-433
Oxford University Press 2005

HAITZER, T. Et al
Semi-automated Architectural Abstraction Specifications For Supporting Software Evolution
Science Of Computer Programming, N.90, B, 135-160
Elsevier Pbn, Amsterdam 2014

HAKEN, L. & BLOSTEIN, D.
The Tilia Music Represent-Ation: Extensibility, Abstraction & Notation Cont-Exts For The Lime Music Editor
Computer Music Journal, Volume.17, Number.3, 43
MIT Press, Cambridge Mass 1993

HALE, B. & WRIGHT, C.
Abstraction & Additional Nature
Phil-Osophia Mathematica, Vol.16, No.2, 182-208
University of Toronto Press 2008

HALEY, M.
Occupation & The Renewal Of Business Tenancies: Fact, Fiction & Legal Abstraction
Journal of Business Law, Oct. Issue, 759-77
Sweet & Maxwell, London 2007

HALLIDAY, M.
Abstraction Resisted (Or, H Still H)
Chicago Review, Vol.47, No.1, 81-101
CR Press, Illinois 2001

HALPER, M. Et al
Abstraction Networks For Terminologies: Supporting Management Of "Big Knowledge"
Artificial Intelligence In Medicine, Volume 64, No.1, 1-16
Elsevier Pbn, Amsterdam 2015

HAMPTON, J.A. & SAITTA, L.
Abstraction & Context In Concept Representation
Philosophical Transactions Of The Royal Society: Series B Biological Sciences, Vol.358, 1485, 1251-1260
The Royal Society London 2003

HAN, B. Et al
Head Pose Estimation Using Image Abstraction & Local Directions Quaternary Patterns For Multiclass Classification
Pattern Recognition Letters, Volume 45, 145-153
Elsevier Journals Amsterdam 2014

HANHARDT, J.G. Et al
Film Image/Electric Image:
The Construction of
Abstraction,
1960-90
Visible
Language,
Vol.29, 2, 138
RI School of Design
Providence, Rhode Island 1995

HANLEY, W.
Niall McClelland: An Abstract
Art of Printer
Cartridges
& Photocopies
Modern Painters, February, 48
Louise Blouin, New York 2012

HANNAY, J.E. &
HAEBERER, A.M.
Abstraction
Barriers in
Equational Proof
Journal on Data Semantics,
Number1548, 196-213
Springer-Verlag
Journals
Berlin
1998

HARDY, I. & BOYLE, C.
My School? Critiquing
The Abstraction
& Quantific
-Ation Of
Educa
-Ation
Asia
-Paci
- Fic J
-Ournal
Of Teac
-Her Education,
Volume 39, 3, 211-22
Taylor & Francis, UK 2011

HARRISON, W.L.
& KOBAYASHI, N.
Proof Abstraction For
Imperative Languages
Journal on Data Semantics,
Number 4279, 97-113
Springer Media
Journal,
Berlin
2006

HAYES, B. & CONWAY, R.N.
Concept Acquisition in Childr-
En With Mild Intellectual
Disability: Factors
Affecting The
Absence
Of
Proto
-Typical
Information
Journal of Intellectual
& Developmental Disability,
Volume 25, Number 3, 217-234
Taylor & Francis Pub, UK 2000

HAYS, P.L.
*Steinbeck's Plays:
From Realism
To Abstraction*
Studies In The Humanities
Volume 31, Number 1, 92-98
University of Edinburgh 2004

HE, F. Et al
Heuristic-Guided Abs-Tr-A Ct-Ion Ref-Inement
The Computer Journal,
Volume 52, No.3, 280-287
Oxford University Press 2009

HEISENBERG, W.K.
*Abstraction
In Modern
Science*
Lect
-Ure
Notes
In Physics,
No.746, 1-16
Springer-Verlag, 2008

HELAL, K.M.
*Anger, Anxiety, Abstraction:
Virginia Woolf's,
"Submerged Truth"*
South Central Review,
Volume 22, Number 2, 78-94
Texas A & M University 2005

HENDERSON, M.D. Et al
*The Effects of Abstraction On
Integrative Agreements:
When Seeing The
Forest Helps
Avoid
Get
-T
-Ing
Tang
-Led In
The Trees*
Social Cognition,
Volume 27, No.3, 402-17
Guildford Press, New York 2009

HEATH, S.
*Key-Words:
Abstract,
Abstraction*
The Critical Quarterly,
Volume 55, Number 3, 1-10
Basil Blackwell, Oxford 2013

HERBERT, M.
Between
Let-
Ters
& Abs
Traction
Art Monthly, No.284, 33
Brittania Art Pub, London 2005

HERSHKOWITZ, R. Et al
Abstraction In Context:
Epistemic
Action
Journal For
Research in Mathematics Education, Volume 32, No2, 195-222
NCTM, Reston Vancouver 2001

HILBERG, W.
Neural Net-
Works In Higher
Levels of Abstraction
Biological Cybernetics,
Volume 76, Number 1, 23-40
Springer-Verlag, Berlin 1997

HILL, R.C.
Modular Supervisory Control
With Equivalence-Based
Abstraction &
Covering-
Based
Conflict
Resolution
Discrete Event
- Dynamic Systems
Theory & Applications,
Volume 20, No.1, 139-185
Springer-Verlag, Berlin 2010

HINDS, P.J. Et al
Bothered By Abstraction: The
Effect of Expertise On
Knowledge Tra-
Nsfer & Sub
-Sequent
Nov
-Ic
-E
P
-Er
-For
Mance
The Jour-
Nal Of App-
Lied Psychology,
Vol.86, No.6, 1232-1243
APA, Washington DC 2001

HIXSON, K.
Feminine Wiles: Modern Art's Fear of The Female – Women Artists Are Now Reclaiming Feminine Content From Modernism's Fearful Dismissal Of Kitsch & From Camp's Appropriation Of It As A Flat, Generalized Abstraction Of The Fem Ale & Then Injecting It With A Newly- Found Power
New Art Examin-
Er, Vol. 24, 6, 21-24
D. Guthrie & J. Allen, Chicago 1997

HOFFMAN, D. Et al
State Abstraction & Modular Software Development
Software Engineering Notes, Vol.20, 14, 53
ACM, New York 1995

HOFFMANN, T. Et al
The Abstraction Principle: A Pillar Of The Future Estonian Intellectual Property Law?
European Review Of Private Law, 21, 3, 823-42
Kluwer International, Boston 2013

HOICKA, E.
Humor, Abstr- Action & Disbelief
Cognitive Science, Vol.32, No.6, 985-1002
Elsevier Pubs, Amsterdam 2008

HOLBRAAD, M. Et al
Planet M:
The Intense Abstraction Of Marilyn Strathern
Cambridge Anthropology, Volume 28, Number 3, 43-65
Berghahn, Oxford & NY 2009

HOLT, R.
Lyrical Abstractions: In Liner Notes & Notational Drawings, The Markings of A Musician Offer An Insight Not Only Into The Songs But The Personality
World Art, Vol. 87, No. 4, 134-7
Taylor & Francis, UK 1999

HOMENDA, W.
Granular
Computing
Abstraction As An
Abstraction Of Data
Aggregation – A View On
Optical Music Recognition
Archives of Control Sciences,
Volume 12, Number 4,
433-56, Politechnika
Slaska Gliwice,
Poland
2002

HOORENS, V. Et al
When Words Speak
Louder: The
Effect
Of Verb
Abstraction
On Inferences
From Interpreted Events
Social Cognition, 30, 3, 253-88
Guildford Press,
New York
2012

HORST, C.
Harmonious
Triptychs:
From
Real-
Ism To
Abstraction
School Arts, Vol.106, 4, 36-37
Davis Pub, Worcester MA 2006

HOUDE, O.
Abstract
After All?
Abstraction
Through Inhibition
In Children & Adults
The Behavioural & Brain
Sciences, Vol.32, No.3-4, 339
Cambridge University Press 2009

HUDSON, A. Et al
Free Radicals From Cyclic
Enones: An Electron
Paramagnetic
Resonance
Investig
-Ation.
Par-
T1:
Ra
-D
-Ic
-Als
Form
-Ed By
Hydrogen
Abstraction
Journal Of The
Chemical Soc. Perkin
Transactions 2, 12, 2467-90
Chemical Society London 1997

HUE, S-Y, & LEE, J-W.
Providing Approximate Answers Using A Knowledge Abstraction Database
Journal of Database Management, Vol. 12, 2, 14-24
Idea Group Pub, Hershey PA 2001

HUGHES, G.
*Envisioning Abstraction: The Simultaneity of Robert Delaunay's First **Disk***
The Art Bulletin, 89, 2, 306-32
College Art Assn, New York 2007

The Painter of Mental Scenery: Robert Delaunay's Sensory Abstraction & Modern Perceptual Theory
Critical Matrix, Volume 12, 1-2, 78-111
CM, New Jersey, N. York 2001

HUTCHINGS, S.
Plotting Against Abstraction In Russian Literature's Provincial Hell: Fedor Sologub's Aesthetics of Embodiment
The Modern Language Review, Volume 91, Number 3, 655-676
Maney Publications, Leeds 1996

HUTH, M.
Abstraction & Probabilities For Hybrid Logics
Electronic Notes In Theoretical Computer Science, No.112, 61-76
Elsevier, Amsterdam 2005

IMBS, D. Et al
Reliable Shared Memory Abstraction On Top Of Asynchronous Byzantine Message-Passing Systems
Lecture Notes in Computer Science, Number 8576, 37-53
Springer Journals Berlin 2014

NCE, C. Et al
Analysis of The
Abstraction
Of Wat-
Er F-
Ro-
M
F-
Re-
Shly
Mixed
Jointing
Mortars In
Masonry Construction
Materials & Structures,
Volume 43, No.7, 985-992
Springer Journal, Berlin 2010

IND, N.
Beyond Branding:
From Abstr-
Action
To Cubism
The Journal of Product
& Brand Management,
Vol.15, No.2, 148-49
Emerald Bradford 2006

IRWIN, M.
Orpheus,
Parzifal
& *Bartleby:*
Ways of Abstr-
Action in Poetry
Literary Imagination,
Volume 15, No.2, 219-244
Association of Literary Scholars
& Critics, Oxford Journals 2013

ISENBERG, T.
Visual
Abstraction
& Stylising Maps
Cartographic Journal,
Volume 50, Number 1, 8
Maney Publishing, Leeds 2013

ISHIZAWA, J. &
FERNANDEZ, E.G.
Loving The World
As It Is:
Western
Abstraction &
Andean Nurturance
Revision - Cambridge Mass. Then
Washington, Vol.24, No.4, 21-6
Heldref Pub, Washington DC 2002

JACKSON, D,
The Zen Of Painting:
Santa Fe's Forrest Moses
Straddles The Line Between
Impressionism & Abstract-
Ion With His Landscapes
Southwest Art
Journal,
April, 104-107
Cowles Mag, Minneapolis 2004

JACOBS, S.
*Conquest Of
Abundance: A Tale
Of Abstraction Versus
The Richness Of Being*
Philosophy of The Social
Sciences, Vol.36, 3, 386-89
Sage, Thousand Oaks CA 2006

JACOBSEN, C.
*Musical Abstractio-
Ns: Vivian Cohen
Combines
A Passion
For Musical
Instruments & Clay*
Pottery In Australia,
Volume 35, 1, 45-7
Potter's Society
Of Australia
NSW1996

JAIN, H. Et al
*Using Statist
Ically Co-
Mputed
Invari-
Ants
Insi-
De The
Predicate
Abstraction &
Refinement Loop*
Journal on Data Semantics 4144
137-51Springer Pub Berlin 2006

JALALA, S. Et al
*Characterizing
The Socio-Ec-
Onomic Dri-
Ving Forces
Of Groundw-
Ater Abstract-
Ion With Artificial
Neural Network &
Multivariate Techniques*
Water Resources Management,
Volume 25, No. 9, 2147--2175
Springer Publishing Berlin 2011

JAMES, D.
*Realism, Late Modernist
Abstraction &
Sylvia
Tow
-Nsend
Warner's
Fictions Of
Impersonality*
Modernism/Modernity,
Volume 12, No.1, 111-112
John Hopkins UP, Baltimore 2005

JAPPE, A.
*Sohn-Rethel & The Origin Of
'Real Abstraction':
A Critique
Of Pr-
Oduc-
Ion
Or
A
Cr-
Itiq-
Ue Of
Circulation?*
Historical Materialism: Resear-
Ch In Critical Marxist Theory,
21, 1, 3-14, Brill, Leiden 2013

JARIWALA, B.N. Et al
*Facile Abstraction of Hydrogen
Atoms From Graphene, Di-
Amond & Amorphous
Carbon Surfa-
Ces: A First-
Principles
Study (7-
Pages)*
Phy-
Si-
C -
Al-
Rev-
Iew. B.
Condensed
Matter & Materials
Physics, 82, 8, 085418
American Physical Society
ACP, College Park, MD 2010

JASEN, P.
*A Transversal
Language:
Percep
-Tual
Abstraction
From Eleh to Op Art*
The Senses & Society,
Volume 9, Number 1, 16-32
Bloomsbury Pubs, London 2014

JENKINS, P.
Jeff Strayer,
**Subjects &
Objects:
Art,
Esse-
Ntialism
& Abstraction**
Philosophy in Review,
Volume 28, No.2, 153-155
University of Victoria, Can. 2008

JENSENIUS, A.R.
*Some Video
Abstraction
Techniques
For Displaying
Body Movement In
Analysis & Performance*
Leonardo, Vol.46, 1, 53--60
MIT Press, Cam. Mass 2013

JIN, C. Et al
*A Program Abstraction Method
From Procedural Language To
Functional Language*
Jisuanji Xuebao,
Vol.20, No.8, 731-736
Kexue Chubaneshe, China 1997

JIN, T.Y. Et al
*Theoretical Studies
On Mechanisms
& Kinetics
Of The Hydrogen
Abstraction-Reaction of
CF3CH2CH2OH With OH Radical*
Computational & Theoretical
Chemistry, 1007, 63-75
Elsevier Pblcns,
Amsterdam
2013

JOHANSEN, O. Et al
*Effect of Groundwater
Abstraction
On
Fen
Eco-
Systems*
Journal of Hydrology,
Vol.402, No.3-4, 357-366
Elsevier Pubs, Amsterdam 2011

JOHNSON, J.
*The Nature of
Abstraction:
Analysis
& The
We-
B-
Ern-
Myth*
Music Analysis,
Vol.17, No.3, 267-280
Basil Blackwell, Oxford 1998

JOLLEY, R. & THOMAS, G.V.
*The Development of Sensitivity
To Metaphorical Expression
Of Moods in Abstract Art*
Educational Psychology,
Volume 14, Number 4, 437
Carfax/Taylor & Francis UK 1994

JONES, C.B. & PIERCE, K.
*Elucidating Concurr
Ent Algorithms
Via Layers
Of Abs-
Traction
& Reification*
Formal Aspects of
Computing, 23, 3, 289-306
Springer -Verlag, Berlin 2011

JUE, M.
*Proteus
& The
Digital:
Scalar Trans-
Formations Of Seawater's
Materiality In Ocean Animations*
Animation, Vol.9, 2, 245
Sage, Thousand
Oaks Cal.
2014

URSIC, B.S.
*Exploring
The Potential
Energy Surface
Of The Hydrogen
Abstraction Reaction
From Hydrochloric Acid
With Hydrogen & Methyl
Radicals Using Ab Initio
& Density Functional
Theory Methods:
An Example
Of
A
Polar
Radical
Hydrogen
Abstraction Reaction*
Chemical Physics Letters,
Volume 264, No. 1-2, 113-19
Elsevier Journal, Amsterdam 1997

JUSLIN, P. Et al
*Cue Abstraction
& Exemplar
Memory in
Categorization*
Journal of Experimental
Psychology: Learning, Memory &
Cognition, Vol.29, No.5, 924-41
APA Pubn, Washington DC 2003

KAMII, C. & OZAKI, K.
*Abstraction & Represent-
Ation In Arithmetic: A
Piagetian View*
Hiroshima
Journal
Of Mathematics
Education, No.7, 1-16
Hiroshima University 1999

KAMLER, B. &
THOMSON, P.
*Driven To A-
Bstractio
-N: D
-Oct
-Or
-A
-L
Su
-Per
-Visi
-On &
Writing
Pedagogies*
Teaching In Higher
Education, 9, 2, 195-210
Carfax Ltd, Abingdon 2004

KANG, H. & LEE, S.
*Shape-Simplifying
Image
Abstraction*
Computer Graphic Forum,
Volume 27, No. 7, 1773-780
Basil Blackwell, Oxford 2008

KAO, D. & ARCHER, N.P.
*Abstraction In
Conceptual
Model Design*
Internationl Journal Of Human-Computer Studies, 46, 1, 125-50
Academic Pr, Mass.USA 1997

*Supporting Abstraction In
Conceptual Model Design:
An Experimental Study*
ASAC Annual Conference,
Volume 16, No.4, 12-20
ASAC Publications 1995

KAPLAN, J. & WINTHER, R. G.
*Prisoners Of Abstraction?
The Theory & Measure
Of Genetic
Variation,
& The Very
Concept of "Race"*
Biological Theory,
Volume 7, No.4, 401-412
MIT Press, Cambridge Mass 2013

KATO, Y. Et al
*Young
Children's
Representations
Of Groups of Objects:
The Relationship Between
Abstraction & Representation*
Journal For Research
In Mathematics
Education,
Volume 33,
1, 30-45
NCTM
2002

KATZ, T.
*Modernism, Subjectivity
& Narrative Form:
Abstraction In*
The Waves
Narr-
Ative,
Volume 3,
Number 3, 232
Ohio State UP, Columbus 1995

KAUFMAN, E.
*Levi-Strauss,
Deleuze &
The Joy
Of A
-Bst
-Ra
-C
-Ti
-On*
Cri-
Ticism,
Volume 49,
Number 4, 447-58
Wayne State UP, Detroit 2007

KAWOHL, F. & KRETSCHNER, M.
*Abstraction & Registration:
Conceptual Innovations
& Supply Effects in
Prussian & British
Copyright (1820-50)*
Intellectual Property
Quarterly, No. 2, 209-228
Sweet & Maxwell, London 2003

KAZEMIFARD, M. Et al
*An Emotion Understand
Ing Framework For In
Telli- Gent Agents B-
Ased On Episodic &
Semantic Memories*
Autonomous Agents
& Multi-Agent Systems,
Volume 28, No.1, 126-153
Springer-Verlag, Berlin 2014

KELLER, R. Et al
*Blues For Gary:
Design Abs-
Traction
For A
Jazz
Imp-
Ro-
Vis-
Ation
Assistant*
Electronic Not-
Es In Theoretical
Computer Science,
Number 193, 7-60
Elsevier Pubs,
Amsterdam
2007

KELLY, P.
*When Push
Comes To Shove
: Barnett Newman,
Abstraction &
The Politics
Of 1968*
The Sixties,
Vol.1, No.1, 27-47
Taylor & Francis, UK 2008

KERI, S. Et al
*Abstraction Is
Impaired At The
Perceptual Level in
Schizophrenic Patients*
Neuroscience Letters,
Vol. 243, 1-3, 93-6
Elsevier Pubn,
Amsterdam
1998

KETTLEWELL, N. &
LIPSCOMB, S.
*Neuro-Psyc
-Holgical
-Correl
-Ates
For
Rea
-Lism
Abstracti
On, A Dimens
Ion Of Aesthetics*
Perceptual & Motor Skills
Volume 75, Number 3, 1023
Ammons, Missoula MT 1992

KIDD, I.J.
Objectivity,
Abstraction &
The Individual: KLEIN, O. Et al
The Influence of Soren *Effects of Schooling & Literacy*
Kierkegaard on Paul Feyerabend *On Linguistic Abstraction:*
Studies in History & Philosophy, *The Role of Holistic Versus*
Volume 42, Number 1, 125-134 *Analytic Processing Styles*
Elsevier Pubs, Amsterdam 2011 European Journal of Social
 Psychology, 40, 7, 1095--102
 KING, A. Et al John Wiley, Hoboken NJ 2010
 Automatic
 Abstra-
 Ction
 For
 Co
 -N
 -Gr KNIGHT, C.J.
 -Ue *George*
 Nces *Steiner's*
 Journal *Religion of*
 On Data *Abstraction*
Semantics, 5944, 197-213 Religion & Literature,
Springer-Verlag, Berlin 2010 Volume 28, Number 1, 49-84
 University of Notre Dame, 1996

 KNOX, C. & KOSMAN, A.
 We Have An
 Astounding
KITCHEN, A. Et al *Power Of*
Self-Recognition & Abstraction *Abstraction*
Abilities in The Common Denver Quarterly,
Chimpanzee Volume 39, Number 2, 71
Studied With University of Denver, CO 2004
Distorting Mirrors
Proceedings Of The National
Academy of Sciences of The
United States of America,
Volume 93, No.14, 705-708
NAS, Washington DC 1996

KNUSEL, J. Et al
A Salamander's Flexible Spinal Network For Locomotion, Modelled At Two Levels Of Abstraction
Integrative & Comparative Biology, Vol.53, 2, 269-282
Oxford University Press 2013

KOLPAS, N.
Split Personalities: Some of Today's Top Artists Divide Their Time Bet- Ween Realism & Abstraction
Southwest Art, May, 94-98
Cowles Mag, Minneapolis 2008

KOPLOS, J.
Dematerializing The Canvas: In His Lyrical Abstraction, Painter George Peck Employs A Ra- Nge Of Eth- Ereal Support Materials
Art in America, Volume 87, No.4, 134-137
Brant Publications, N. York 1999

KOPPELMAN, H. & JOYCE, D.
Teaching Abstr -Action Explicitly
SIGCSE Bulletin, June, 1910
ACM Pubrs, New York 2001

KRAMER, H.
Does Abstract Art Have A Future?
The New Criterion, Volume 21, Number 4, 9-12
R.Kimball/Foundation For Cultural Review Inc, New York City 2002

KREMEN, W.S. Et al
Post-Onset Cognitive Decline In Schizophrenia Is Relatively Selecti- Ve For Exec- Utive- Abstract Ion Function
Schizophrenia Research, 60, 1 Supp. 141
Elsevier Pubn, Amsterdam 2003

KROLAK-SCHWERDT, S.
When Do Prototypes Bias Person Memory? Differ-ential Effects of Abstraction Level
<u>European Journal of Social Psychology,</u> No.34, No.1, 85-102
Wiley & Sons, Hoboken NJ 2004

KRUG, H,
Modelling Production Subsystems At High Abstraction Level – Review-ing Summary. 1. Basic Considerat-ions & Approaches
<u>European Journal of Horticultural Science</u>, Volume 73, No.2, 89-94
Eugen Ulmer Pubs, Stuttgart 2008

Modelling Production Subsystems At High Abs-Traction Level – Re-Viewing Summary. II. Crop Parameters
<u>European Journal of Horticultural Science</u>, Volume 73, 3, 138-43
Eugen Ulmer Pub, Stuttgart 2008

KRUG, H. & KAHLEN, K.
Modelling Production Subsystems At High Abstraction Level: A Rev--Iew III: Dev-Elopent Vernalisation
<u>European Journal of Horticultural Science</u>, Volume 73, No.4, 183-87
Eugen Ulmer Pubn, Stuttgart 2008

KRYZA, B. Et al
Grid Organizational Memory-Provision Of A High-Level Grid Abstraction Layer Supported By Ontology Align-Ment
<u>Future Generation Computer Systems</u>, Vol.23, No.3, 348-358
Elsevier Pubn, Amsterdam 2007

Erratum To "Grid Organizational Memory-Provision Of A High-Level Grid Abstraction Layer Supported By Ontology Alignment"
<u>Future Generation Computer Systems</u>, Volume 23, Number 6, 773
Elsevier Pubn, Amsterdam 2007

KUNII, T.L. & OHMORI, K.
Cyberworlds: Architecture
& Modelling By An
Incremen-
Tally
Mo-
Du-
Lar
Abst-
Raction
Hierarchy
The Visual Computer,
Vol.22, No.12, 949-964
Springer-Verlag, Berlin 2006

KUNTZ, A. Et al
Obama's American
Graduation Initiative:
Race, Conservative
Modernization
& A Logic
Of Abst-
Ract-
Ion
Pea-
Body
Journal of
Education, 86, 5, 488-505
Taylor & Francis Pubn, UK 2011

KURNICK, D.
Abstraction &
The Subject of
Novel Reading:
*Drifting Through **Romola***
Novel, Vol.42, No.3, 490-496
Brown University Providence 2009

KWAME-ROSS, T.
Community: From
Abstraction
To Liv
-Ed
Rel
-Ations
Relational
Child &Youth Care
Practice, 17, 2, 49-51
The CYC-Net Press 2004

LABERGE, Y.
Alarco,
Paloma Et al,
Monet & Abstraction
19th Century French Studies,
Volume 41, Number 3/4, 349
University Of Nebraska Press
Lincoln, Nebraska USA 2013

LACEY, N.
Abstr
-Act
-Io
N
In
Co-
Ntext
Oxford
Journal Of
Legal Studies,
Volume 14, No.2, 255
Oxford University Press 1994

LADKIN, S.
Glancing Paintings & Poems:
Figuration & Abstraction
In Clark Coolidge's,
Polaroid *& Willem*
De Kooning's,
Excavation
Textual Practice,
Volume 26, 3, 421-48
Taylor & Francis Ltd, UK 2012

LAMMERS, J.
Abstraction
Increases
Hypocrisy
Journal of Experimental Social Psychology, Vol. 48, 2, 475-480
Elsevier Pubs, Amsterdam 2012

LAHIRI, S.K. Et al
A Symbolic
Approach
To Pre-
Dicate
Abstraction
Journal on Data Semantics, 2725, 141-53
Springer-Verlag, Berlin 2003

LANDI, A.
Prime Cuts:
On The Edge Of
Abstraction, Hinting At
Representation, Ursula Von
Rydingsvard Has Carved Out
Today A Formidable Niche
For Herself In The Fertile
Landscape of Sculpture
Art News, Vol.106,
1, 106, West St,
New York
2007

LANE, S.M.
The Origins
Of Math-
Emat-
Ical
Ab-
St-
Rac-
Ttion
Journal
Of Pure &
Applied Algebra
Vol, 143, No,1-3, 309-11
Elsevier Pubn, Amsterdam 1999

LAM, W. Et al
Learning Good Prototypes
For Classification
Using Filtering &
Abstraction
Of Instances
Pattern Recognition,
Vol.35, No.7, 1491-1506
Pergamon Press, Oxford 2002

LANGE, E.L.
Failed Abstraction:
The Problem of
Uno Kuzo's
Reading of
Marx's
Theory of
Value-Form
Historical Materialism, Volume 22, Number 1, 3-33
Brill Publications, Leiden

LASHENG, Y. Et al
Research On Task
Decomposition
& State Ab-
Straction
In Rein-
Force -
Ment
Lea-
Rni-
Ng
Artificial Intelligence Review, Vol. 38, Number 2, 119-127
Springer Pubns, Berlin 2012

LAVY, I. Et al
Coping With
Abstraction
In Object
Orient-
Ation
With A
Special
Focus On
Interface Classes
Computer Science Education, 19, 3, 155-77
Taylor & Francis, UK 2009

LEACH, F.R. & PLAKS, J.E.
Regret For Errors of
Commission &
Omission
In The
Dist-
Ant
Term
Versus
Near Term
:The Role & Le
-Vel Of Abstraction
Personality & Social Psychology Bulletin, Vol.35, No.2, 221-29
Sage, Thousand Oaks CA 2009

LEBECK, A. & WOOD, D.A.
Active Memory: A New
Abstraction
For Memory-
System Simulation
Performance Evaluation Review, Vol.23, No.1, 220
ACM Journals, New York 1995

LEDEZMA, J.
Carmen Herrera:
Edging on
Silence
- Discourse,
Object & Abstraction
Art Nexus, 58, 70-75
Bogota, Columbia 2005

LEDGERWOOD, A.
& CALLAHAN, S.P.
*The Social Side Of
Abstraction:
Psycho-
Log-
Ica-
L
D-
Ist-
Ance
Enha-
Nces Co-
Nformity To
Group Norms*
Psychological Science,
Volume 23, No.8, 907-913
Sage, Thousand Oaks CA 2012

LEE, A.R.
*Vulgar
Pictures:
Bacon, De
Kooning &
The Figure
Under Abstraction*
Art History, 35, 2, 372-93
Basil Blackwell, Oxford 2012

LEE, M.D.
*Neural
Feature
Abstraction
From Judgem-
Ents Of Similarity*
Neural Computation, Vol.10, Number 7, 1815-1830, The MIT Press, Cam. Mass. 1998

LEHALLE, H. Et al
*Construction Structurale
Et Abstraction
Structural:
Deux
Chemine-
Ments Dev-
Eloppementaux
Imbriques* Enfance,
Volume 66, No.3, 335-364
Universitaires de France, Paris 2011

LEONELLI, S.
*Performing A-
Bstraction:
Two Ways
Of Mo-
Del-
Ling
**Arab-
Idopsis
Thaliana***
Biology & Philosophy,
Volume 23, No.4, 509-28
Springer-Verlag, Berlin 2008

LEOPOLD, H. Et al
*Simplifying Process
Model Abstraction:
Techniques For
Generating
Mod-
El
Na-
Mes*
Inform-
Ation Systems,
Volume 39, 134-151
Elsevier, Amsterdam 2014

LEPPPANEN, M. Et al
Towards
An
A-
Bs-
Tra-
Ction
Ontology
Frontiers In AI &
Applications, 154, 166-85
IOS Press, Amsterdam 2007

LEVINE, J.
Analysis,
Abstraction
Principles &
Slingshot Arguments
Ratio, Vol.19, No.1, 43-63
Basil Blackwell, Oxford 2006

LEVINS, R.
Strategies
Of Abs-
Tra-
Ction
Biology
& Philosophy,
Volume 21, No.5, 741-755
Springer-Verlag, Berlin 2006

LI, B. Et al
Abstraction
Refinement In
Symbolic Model
Checking Using
Satisfiability
As The Only
Decision
Procedure
International
Journal On Software
Tools For Technology
Transfer, Vol. 14, 1, 1-14
Springer-Verlag, Berlin 2012

LI, C. Et al
Research On The
3-Dimensional
Abstraction
Descript-
Ion Of
Rea-
Li-
Ty
I
-N
-Te
-Rna
Tiona
-L Arch
-Ives Of
Photogram-
Metry Remote
Sensing & Spatial
Information Sciences,
Volume 35, No.4, 103-106
Natural Resources, Canada 2004

LI, G.
Et al
*Lazy
Symbolic
Execution
Through
Abstract
Ion &
Sub-
Space
Search*
<u>Journal on Da-
Ta Semantics</u>, 8244, 295-310
Springer-Verlag, Berlin 2013

LI, J. Et al
*Componen
T-Based
Abstra
-Ction
& Refi
-Nement*
<u>Journal On
Data Semantics</u>, 5030, 39-51
Springer-Verlag, Berlin 2008

LI, L. Et al
*Competent
Predicate
Abstr-
Act-
Io-
N
In
Model
Checking*
<u>Science China:
Information Sciences</u>
Volume 54, No.2, 258-67
Springer-Verlag, Berlin 2011

LI, W. Et al
*Market
Failure or
Government
Failure? A Study
Of China's Water
Abstraction
Policies*
<u>China
Quarterly</u>,
No.208, 951-969
Cambridge University Press 2011

LIANG, P. Et al
*Learnin-
G Mini-
Mal-
Ab-
Stra-
Ctions*
<u>ACM Sigplan Notices</u>,
Vol. 46, No.1, 31-42
ACM, New York 2011

LICHTMAN, R.
*Myths of The
Market
Place:
The Terrible
Violence of Abstraction*
<u>Capitalism, Nature, Socialism</u>,
Volume 20, Number 2, 14-21
Taylor & Francis, UK 2009

LIDTKE, V.L.
*Abstract Art
& Left-
Wing
Pol-
Itics
In The
Weimar Republic*
Central European
History, Vol. 37, 1, 49-91
Brill Academic, Leiden 2004

LIND, M.
*The Emergence of Levels
Of Abstraction
In Complex
Systems*
Culture
& History,
Volume 15, 96-107
CH Digital Journal 1997

LINDWALL, O. Et al
*Situated Abstraction:
From The
Particular
To The
General In
Second Order
Diagnostic Work*
Discourse Studies,
Vol. 16, Number 2, 185
Sage, Thousand Oaks CA 2014

LINNEBO, O.
*Which
Abstraction
Principles Are
Acceptable? Some
Limitative Results*
British Journal Of The
Philosophy Of Science,
Vol.60, No.2, 239-52
Oxford University
Press 2009

LINNEBO, O. &
PETTIGREW, R.
*Two Types
Of
Ab-
Stract-
Action For
Structuralism*
Philosophical Quarterly,
Volume 64, No.255, 267-83
Wiley & Sons, Hoboken NJ 2014

LINNEBO, Y.
*III-Reference
By
Abs-
Traction*
Proceedings Of The Aristotelian
Soc. For The Systematic Study
Of Philosophy, V. 112, 1, 45-71
Basil Blackwell, Oxford 2012

LINVILLE, P.W. Et al
Exemplar & Abstract-
Ion Models of Per-
Ceived Group
Variability
& Stereo-
Typicality
Social Co-
Gnition, Vol.
11, Number 1, 92
Guildford Press, N. York 1993

LITTLE, B.J.
Archaeology,
History &
Material
Culture:
Grounding
Abstraction &
Other Imponderables
International Journal Of Histori-
al Archaeology,Vol.1, 2, 179-87
The Plenum Press, London1997

LITTLE, J. & McDANIEL, M.
Individual Differences In
Category Learning:
Memorization
Versus
Rule
Ab-
Str-
Action
Memory
& Cognition,
43, 2, 283-297
Psychonomic Society,
Madison, Wisconsin 2015

LIU, C-D,
& SUN, H-T.
A Method of
Chinese
Text
Aut-
Omatic
Abstraction
Based On Statistics
Hunan Agricultural University
Journal, Vol.27, No.6, 488-90
Changsha, Hunan China 2001

LONG, R.T.
Realism &
Abstraction
In Economics:
Aristotle & Mises
Versus Friedman
The Quarterly Journal
Of Austrian Economics,
Volume 9, Number 3, 3-23
Springer-Verlag, Berlin 2006

LONGAZEL, J.G.
Rhetorical Barriers
To Mobilizing For
Immigrant Rights:
Latina/o Abstraction
Law & Social Enquiry,
Volume 39, Number 3, 580
Wiley & Sons, Hoboken NJ 2014

LUCARINI, M.
Do Peroxyl
Radicals Obey
The Principle That
Kinetic Solvent Effects
On H-Atom Abstraction
Are Independent Of
The Nature of The
Abstracting
Radical?
Journal
Of Organic
Chemistry, 63, 13, 4497-99
ACS, Washington DC 1998

LUCY, W.
Abstract-
Ion
&
The
Rule
Of Law
Oxford
Journal of
Legal Studies,
Vol.29, 3, 481-509
Oxford University Press 2009

LUECKING, S.
Biomorphs:
Organic
Abstraction &
The Mechanics of Life
Sculpture, Volume 19, No.1, 38-43
The International Sculpture Center
Hamilton, New Jersey US 2000

LUJAN, M. Et al
On The Conditions
Necessary For
Removing
Abstr
-Action
Penalties
In OoLaLa
Concurrency
& Computation:
Practice & Experience,
Volume 17, No.7-8, 839-866
Wiley & Sons, Hoboken NJ 2005

LYFORD, A.
Noguchi,
Sculpt
-Ural
-Abs
-Tra
-Ct
-Io
-N
&
The
Politics
Of Japanese
American Internment
The Art Bulletin, 85, 1, 137-51
College Art Assn, New York 2003

MACADAM, B.A.
*A Minimalist In
Baroque
Trappings:
David Reed's
Sensual Paintings
Capture The Power &
Persistence of Abstraction*
Art News, V.98, 11, 158-163
AN West St, New York 1999

MACCHIAVELLO, C.
*Between Abstraction
& Figuration: The
Contradictions of
David Alfaro
Siqueiros',
"Dialectic-
Subversive
Painting"
1932-1942*
Art Criticism,
V. 22, 2, 51-68
State University,
Stony Brook, New York 2007

MAHONY, C.R.M.
*Ministry
Is Not
An
A-
Bs-
Tra-
Ction*
Origins,
Vol.39, 1, 1-8
Catholic News Service,
Washington DC USA 2009

MAINE, S.
*Muehl's New
"Material Actions":
Austrian Provocateur
Otto Muehl Takes
An Unorthodox
Approach To
Abstraction*
Art In America,
Vol.94, No.6, 182-3
Brant Pubns, New York 2006

MALUF, D. Et al
*Abstraction Of
Represent-
Ation
For
Inter-
Operation*
Journal on Data
Semantics, 1325, 441-55
Springer-Verlag, Berlin 1997

MANCOSU, P.
Grundlagen, Section 64:
*Frege's Discussion Of
Definitions By Abs-
Traction In
Historical
Context*
History
& Phil-
Osophy
Of Logic,
Volume 36,
Number 1, 62-89
Taylor & Francis, UK 2015

MANDELBROJT, J.
Abstraction, Action Painting, Ready-Mades & All That
Leonardo,
Vol.35, No.4, 461-462
MIT Press, Cam. Mass. 2002

MANE, R.L.C.
Transmuting Grammars of Whiteness in Third-Wave Feminism: Interrog-Ating Postrace Histories, Post-M-Odern Ab-Bstraction & The Proliferat-Ion Of Difference In Third-Wave Texts
Signs, Vol.38, No.1, 71-98
University of Chicago Press 2012

MAR, R.A. & OAKLEY, K.
The Function of Fiction in The Abstraction & Simulation of Of Social Experience
Perspectives on Psychological Science, Vol.3, No.3, 173-192
Basil Blackwell, Oxford 2008

MARKANT, J. & AMSO, D.
Selective Memories: Infants' Encoding Is Enhanced In Selection Via Suppression
Developmental Science
Volume 16, Number 6, 926
Wiley & Sons, Hoboken NJ 2013

MARTER, J.
Negotiating Abstraction: Lee Krasner, Mercedes C, Matter & The Hofmann Years
Woman's Art Journal,
Volume 28, No.2, 35-40
Old City Pubrs, Philadelphia 2007

MARTINELLI, P. Et al
Neural Substrates of The Self-Memory System: New Insights From A Meta-Analysis
Human Brain Mapping,
Volume 34, Number 7, 1515
Wiley & Sons, Hoboken NJ 2012

MARTINEZ, S.. & HUANG, X.
Epistemic Groundings Of
Abstraction & Their
Cognitive Dimension
Philosophy of Science,
Volume 78, No.3, 490-511
University of Chicago Press 2011

McCORMACK, D.
Geography &
Abstraction
:Towards An
Affirmative Critique
Progress In Human Geography,
Volume 36, Number 6, 715-34
Sage, Thousand Oaks CA 2012

McCRINK, K. & WYNN, K.
Ratio Abstraction By
6-Month-Old Infants
Psychological Science,
Volume 18, No.8, 740-745
Basil Blackwell, Oxford 2007

MAYER, R-J.
Abstraction: Apriori or Aporia?
A Remark Concerning
The Question
Of The
Beg-
Inn -
In-
G
Of
Tho-
Ught-
In Aquinas,
Aristotle & Kant
Angelicum, Vol. 87, 3, 709-746
Pontificia Universitas
A Sancto Thoma, Rome 2010

McCULLOCH, J.
The Poetics of Abstraction:
Antonio Obregon's,
Efectos Navales
(1931) &
The Spanish
Surrealist Novel
Neophilogus, 29, 3, 2008
Springer-Verlage, Berlin 2008

McGINNIS, D. & ZELINSKI, E.
Understanding Unfamiliar Words In Young, Young-Old & Old-Old Ad-Ults: Infer-Ential Proces-Sing & The Abstr-Action -Def-Icit Hypothesis
Psychology &Aging,
Volume 18, No.3, 497-509
APA Pubn, Washington DC 2003

McGINNIS, J.
Making Abstraction Less Abstract: The Logical & Metaphysical Dimensions of Avicenna's Theory of Abstraction
Proceedings of The American Catholic Philosophical Assn, 80, 19-83
ACPA, US
2006

McQUEEN, J.M. Et al
Phonological Abstraction In The Mental Lexicon
Cognitive Science, Vol.30, No.6, 1113-1126
Elsevier Pubn, Amsterdam 2006

MEAGHER, G. &GR-OENEWEGEN, P.
'A Woman Seldom Runs Wild After An A-Bs-Trac-Tion': Feminist Contributions To Economics
Economic Papers, 17, 1, 51-70
Economic Soc. Of Australia 1998

MELHAM, T.F. Et al
Abstraction By Symbolic Index-Ing Trans-Formation
Journal on Data Semantics, 2517, 1-18
Springer-Verlag, Berlin 2002